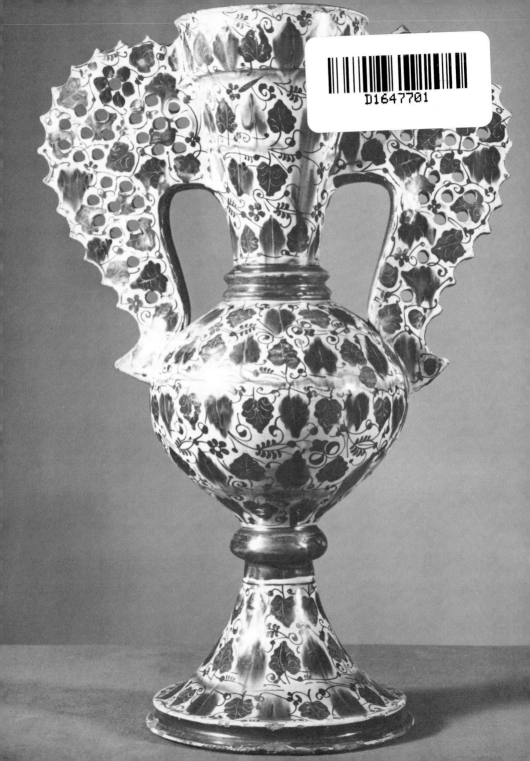

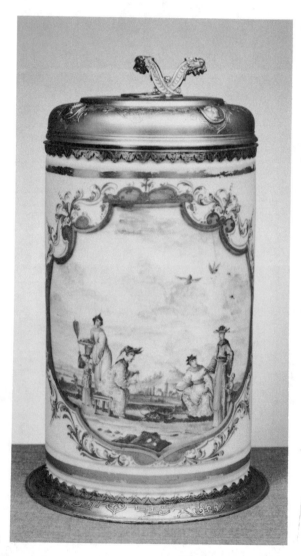

University of Pennsylvania Press

CERAMICS / *Philip Rawson*

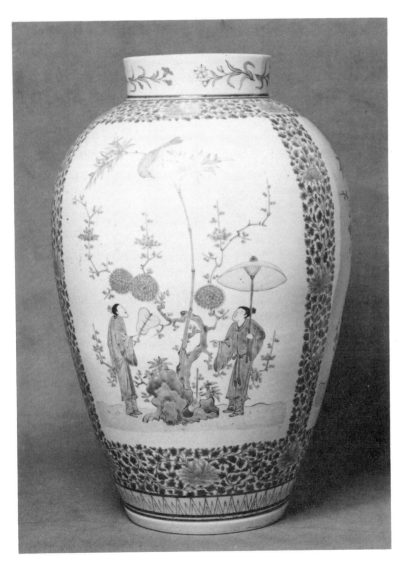

Philadelphia

First paperback edition published 1984 by the University of
Pennsylvania Press
First published 1971 by Oxford University Press, London

Vase, of Hispano-Moresque pottery. Made at Valencia Spain. Third quarter
of the 15th cent. Blue tin glaze and lustre. *Victoria and Albert Museum,
London: Crown copyright*
Meissen tankard, painted in polychrome enamel by Höroldt. *c.* 1725.
Victoria and Albert Museum, London: Crown copyright
Japanese Arita vase, painted in Kakiemon style, in polychrome enamel.
c. 1700. *Victoria and Albert Museum, London: Crown copyright.*

Library of Congress Cataloging in Publication Data
Rawson, Philip S.
 Ceramics.

 Reprint. Originally published: London; New York:
Oxford University Press, 1971. (The Appreciation of the
arts; 6)
 Includes bibliographical references and index.
 1. Pottery. 2. Porcelain. I. Title.
NK4225.R3 1984 738 83-12480
ISBN 0-8122-1156-1 (pbk.)

Printed in the United States of America

10 9 8 7

For Barbara

Contents

Illustrations

The author's drawings and diagrams are not listed here
The numbers in the right-hand margin of the text refer to pages on which relevant illustrations
may be found

Acknowledgements

We should like to acknowledge permission to reproduce the six illustrations of pieces from the Barlow Collection which originally appeared in *Chinese Ceramics, Bronzes and Jades in the Collection of Sir Alan and Lady Barlow* by Michael Sullivan; and Jeffrey Teasdale for the photographs from the Durham Museum of Oriental Art.

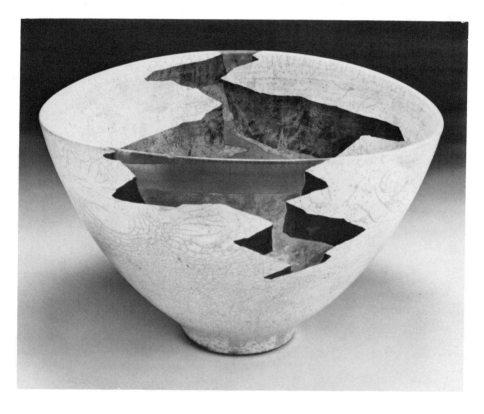

Apparition Canyon. Landscape bowl by Wayne Higby.
Earthenware, raku technique, wheelthrown and corrected. 1982. H. 11 in. × W. 18½ in. × D. 16½ in.
Collection of *Roberson Center for the Arts and Sciences*

Foreword

It is rare to find a book on art that presents complex aesthetic principles in clear readable form. *Ceramics,* by Philip Rawson, is such a book. I discovered it ten years ago, and today my well-worn copy has scarcely a page on which some statement is not underlined and starred.

After reading Rawson's book for the first time, I began to recommend it. As a teacher, I felt that I had finally found a text that I could recommend to students of ceramics without qualification. My enthusiasm was soon tempered, however, by the fact that the book went out of print. Fortunately, it is now once again available, thanks to the initiative of Helen Williams Drutt. Helen has worked behind the scenes for over a decade to advance the cause of ceramic art, so I was not surprised to learn that it was her timely insight that brought Philip Rawson and the University of Pennsylvania Press together in order to republish this important book.

Ceramics offers the reader a balanced viewpoint. It is refreshingly free from the narrowness of a single aesthetic theory. Rawson is not an apologist for ceramics as art. He does not wrap his appreciation in romantic visions of past cultures or in strict matters of function or pure artistic expression. Ceramics, writes Rawson, is the result of a complex interweaving of materials, human action, and symbol. He takes the reader on a thoughtful journey into that complex world, revealing how this interweaving has been accomplished by ceramic artists throughout history. He is insightful when discussing the formative role of nature in Far Eastern ceramics and equally so when describing the psychological effects of the sheen on late eighteenth-century Sèvres porcelain.

Although Rawson uses historical examples to present his viewpoint, he has not written a history book. His text does not trace the development of ceramics in a names and dates fashion. Rawson has written an art appreciation book, and, as such, it outlines what he considers to be the fundamental principles of good pottery. Ceramics in the context of Rawson's book is a type of art based on pottery. Therefore, ceramic art may include a broad range of utilitarian and symbolic forms as

long as these forms have their roots in pottery materials, methods, and a compositional order evolved from the act of containing space.

Rawson writes about the basis of expression in ceramic form in a section entitled "Memory Traces and Meaning." Here he suggests how the simplest pot can carry a complex meaning from one mind to another. He recommends looking at the forms of pottery not just to classify them, but to read them as symbols analogous to sense experience. This recommendation has far-reaching implications since, in our society, critical awareness is primarily achieved by acquiring factual knowledge rather than by developing the resources of intuitive feeling. This emphasis on factual knowledge has isolated art from the general flow of Western culture by reserving it for a relatively small group of "informed" individuals. The very fact that pottery is accessible to everyone by virtue of its immediate connection with human experience has disqualified it in the past as a major art form. Rawson introduces this accessibility factor as an important aesthetic consideration and implies that the power of pottery as art lies in its ability to communicate to a wide audience by expressing human sensuous life. He asks the reader to become more aware of emotional responses to pottery in order to give depth and clarity to learned perception. Rawson elaborates on this idea in other sections by pointing out how such things as tactile quality and response to glaze color can reveal intent.

Glaze color is discussed in depth by Rawson but not in terms of "how to do it." He relates color to meaning and offers technical information as an element in understanding the essential connection between process and product. Rawson writes, "The clay-body from which the pot is made is functionally connected with the way it is made, and hence with its final aesthetic effect." This statement seems quite clear, but it deserves rereading several times. Its implications are obvious, however, the relationship of materials and processes to ideas is often overlooked. In discussing slips and glazes, Rawson emphasizes the way in which these liquids add a major element to the three-dimensional presence of the pot by establishing highlights on the surface that respond to the pot's contours and guide the viewer toward a greater appreciation of volume and shape. This kind of explanation gives serious consideration to

the aesthetic relevance of materials and techniques and confirms the fact that details concerning these aspects of ceramics are an undeniable part of the realization of ideas.

The appreciation of art is always enhanced by an understanding of the details essential to its existence. Informed criticism is founded on such understanding. Unfortunately, in the case of ceramic art criticism a void remains, principally because a thorough understanding of the details that define ceramics is not yet considered absolutely necessary as background for the critical analysis of ceramic art. Too often it is assumed that the criteria for judging ceramics are exactly the same as the criteria for judging painting and sculpture. As a result, attention to the details of ceramic art has been neglected as a meaningful ingredient in determining quality. This neglect has been aggravated by the lack of a good, well-balanced resource guide to the critical appreciation of ceramics. Philip Rawson's book provides that resource. Its republication by the University of Pennsylvania Press is a significant event in current ceramic history.

Wayne Higby

March 1983
Alfred Station, NY

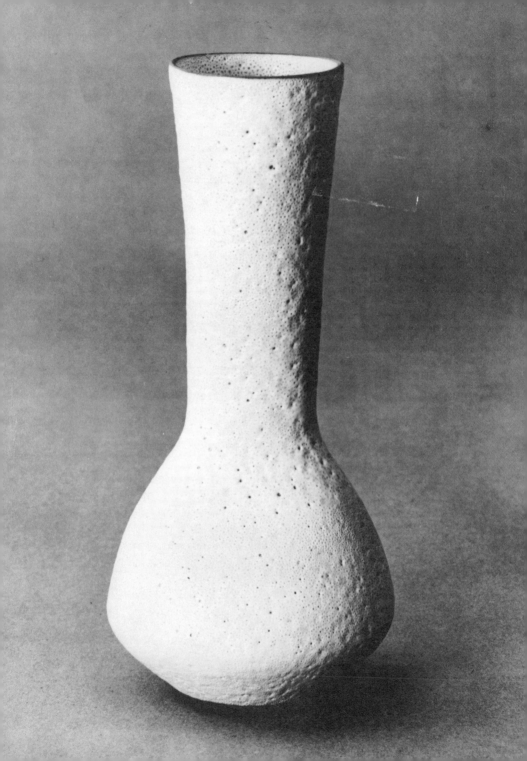

General Considerations

There are many handbooks for the amateur potter. This book aims instead to supply a basis for aesthetic judgement and appreciation both of work the potter makes himself, and of work from the great ceramic traditions of the past. It deals with what can be read from pots, not with what can be read in books, and it may be a useful companion on visits to the ceramic galleries of museums. A few vaguely emotive adjectives—'adventurous', 'strong', 'well-developed'— or phrases such as 'shapes of impeccable merit' are all that the many learned academic writers on pottery have been able to conjure up to define quite definite attributes of pots that have effects upon the spectator which everyone agrees about.

The virtues of pots will probably always have to be recognized as imponderable. At the moment, however, it does seem that ideas on pottery, especially among teachers in colleges of art and education, have fallen into a very narrow groove, which reflects a 'pure aesthetic' attitude. This looks on pottery as an uncertain adjunct to modern sculpture, as more or less functionless decoration, or at best as a mere field for conceptual experiment in materials. In practice most modern studio-potters confine their work within an almost incredibly limited range of technical resource. The only well-established current attitude which does something to counteract this outlook is the 'functionalist' view.

This book, in contrast, tries to take a broad view over the whole field of ceramics; if one does this, both these attitudes reveal their inadequacy. Functionalism assesses works of art by what each critic takes to be their success in reflecting their function; but it cannot explain the enormous number of variations in shape among pots fulfilling very closely similar functions; nor can it explain the imponderable appeal that one pot can exercise, rather than another very like it, through minute and functionally meaningless variations of proportion or surface inflection. Pure aestheticism, on the other hand, concentrates on the 'beauty' or 'expression' of a pot without any regard for its function, and is equally at a loss to explain the whole nature of humanity's pottery which is unequivocally utilitarian whilst also being expressive. More serious still is the fact that the approach of pure aestheticism has not succeeded in appreciating or

Vase by Lucy Rie.
Modern

1

even recognizing the characteristic excellences of many of the world's finest ceramic traditions, whose products are therefore still confined to the ethnographic or archaeological departments of museums.

Nor is functionalism in any better case. Rock-bottom functionalism in action creates, for example, heavy electrical insulators whose surfaces may be designed expressly to obstruct flash-overs in wet weather. We may be impressed by such objects perhaps without understanding precisely our reactions. We may be able half-consciously, or even unconsciously, to make an estimate of their efficiency; and it is perfectly natural to admire and derive satisfaction from fine engineering of any kind. But one finds that artist-potters who may claim to make functional use of forms derived from in-dustrially functional objects do so not for functional reasons but for expressive—perhaps, one could even say sentimental—ones. They may be wishing to associate their products visually and aesthetically with the world of rugged technology whilst not actually making genuine technological objects. For all aestheticism—and it has had great effect on ceramics in many periods—tends to produce objects whose appearance diverges from any possible function they may have. So the artist-potter making insulator-shaped pots must rightly be called a special sort of 'febrile aestheticist'. And it is not at all surpris-ing that so many wares by recent potters working under the impress of a pure aesthetic theory are 'vases'; for vases are meant, generally speaking, only to be looked at, not used in the hands, perhaps not even to contain flowers. Their shapes may appeal to the eye for one reason or another; but they usually seem to lack a foundation in what is here considered to be the most fundamental realm of meaning for ceramics.

This book will try to lay a foundation for both the appreciation and the production of good pottery which avoids the extremes of older ideas, and broadens our view of what ceramics is. There are plenty of excellent books on pottery technique in existence; so here only a brief discussion of the technical factors essential to the purpose will be given. There are, as well, innumerable historical surveys of different pottery traditions. Those dealing with ancient ceramics have a natural archaeological bias; those dealing with later European or Far Eastern traditions may be more interested in history, with some concession to aesthetic value. This book, however, is in no sense a history of ceramics or of any particular ceramic tradition. It takes as its basis the fact that, despite their differences, all the ceramic traditions of the world rest upon a common substratum of meaning which is remark-

ably consistent. For pottery has always been one of the necessary attributes of civilized life. We still take it for granted, and even if we ourselves use plastic tableware, the odds are on its being made in modifications of shapes which are original to pottery techniques, even though plastic is formed by totally different processes. Pottery has, of course, been used to make a wide variety of other things, from Middle Eastern goddess figurines and writing tablets to sophisticated sculpture and those heavy electrical insulators. But far and away its most important function, underlying all the historical evolutions of separate traditions, has been to contain food or drink. In tropical countries big jars may have been used to store clothing as well as other fragile objects to protect them from pests; and jars have very often been used to bury the dead in. But the constant relationship with food has probably played the most vital part in endowing pots with their special symbolic qualities.

THE EXISTENTIAL BASE This intimate connection with a potent aspect of daily life and experience is what gives ceramics its particular aesthetic interest. Even though pottery must be based on a technology of some kind, if it is good pottery it always eludes the tyranny of its technology. Even when it employs a technology so elaborate that its processes can only be called industrial, as when ceramic chemists like Höroldt at Meissen were employed on refining glaze colours, good pottery can never use technology in a scientific way, for the sake of calculation, of questioning the material world within a framework of abstract concepts, of seeking causes and logical explanations for results. Instead the resources are deployed and improvements sought ultimately for the sake of living needs; the manufacturing processes and investigations serve a purpose which lies not within their own terms of reference, but within the life of the human beings who use the pots.

The great French poet Paul Valéry has made an apt observation.

Works of the mind exist only in action. Beyond this action what remains is only an object that has no particular relation to the mind. Transport the statue you admire among people sufficiently different from your own, and it becomes an insignificant stone. The Parthenon is only a small quarry of marble. And when the text of a poet is used as a collection of grammatical difficulties or examples, it ceases at once to be a work of the mind, since the use to which it is put is entirely foreign to the conditions of its creation.

It is easy for us in our day to believe that once we physically possess an object, and can visit it maybe repeatedly in a museum, it is ours in

3

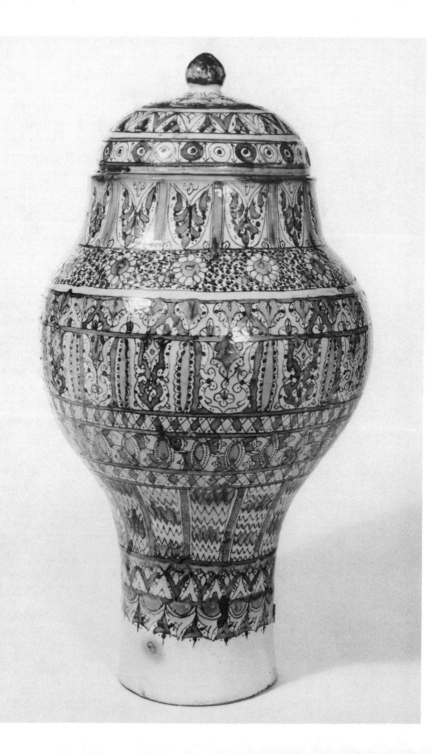

every sense. We believe that we can understand the uprooted works of art we may have wrenched out of their bed in the culture of other peoples. We have even developed a special theory to persuade ourselves that we are missing nothing in works drawn from what was once grotesquely called '40,000 years of Modern Art'. The theory rests upon one misunderstanding or another of that familiar notion of 'pure form' or 'abstract structure'. It is, of course, ridiculous to believe that only the method of arrangement used in an art was of any significance even to the original makers—though they may not have known it! This conception of form will, I hope, be very clearly distinguished from the conception which will be proposed here. Ceramics are, in Valéry's sense, works of the mind; and since this book is devoted to the appreciation of the arts it is their modes of action in the mind we have to explore. If possible we must try and discover, through active use of imagination, how the live meanings of works of ceramic art which played some role in the life of every patron can be revived in our own minds.

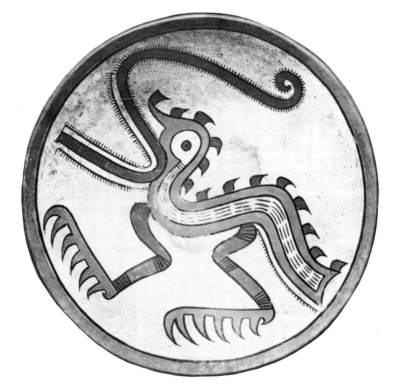

Storage jar from Meknes, Morocco. 18th cent. Painted with stereotyped designs in black, blue, green, and yellow tin glaze. *Durham University Oriental Museum*

Polychrome earthenware bowl from Cocuyal de Sona, Veraguas, early style. Painted with a composite monster in red and dark brown on white. *Museo Nacional de Panama, Panama City*

There are, of course, many ceramic traditions which have produced works so sophisticated that it is hard to see how they can possibly be called useful. Some of the most elaborate eighteenth-century Meissen 201 fantasies or sixteenth-century Bernard Palissy wares may seem to be 178 impossibly remote from any conceivable life functions. It would, however, be a mistake to interpret such sophistication as 'art for art's sake', as one may be tempted to do. For it is always possible to trace back even the most elaborate of ceramic extravaganzas, perhaps through its historical development, to a point where its feet stand, as it were, on the ground of daily experience.

Thus one of the prime reasons why ceramics is such an interesting art is that it fills the gap which now yawns between art and life as most people understand their relationship. To explain the meaning of ceramics can be, in a sense, to explore the historical roots of art as such. For whereas ·other arts, painting and sculpture in particular, have come for centuries now to resemble cut flowers, separated from the living plant which produced them, in the case of ceramics we are everywhere brought face to face with the root. This appears in the primal interweaving of matter, human action, and symbol that each pot represents. Inert clay, from the earth, is made into something which is directly and intimately related to active craft, to the processes of human survival, and to social and spiritual factors in the life of man, all at once. None of the elements is lost; all are reflected in some sort of balance in each successful work. This then becomes what one may call a 'transformation image', something undeniably material, wearing the evidence of its material nature in its visible and tangible forms and attributes, which at the same time contains so much projected into it from man's daily life and experience at all levels that it can seem to him almost like a projection of his own bodily identity. It thus becomes an external testimony to his existence. By taking an existential back-step, so to speak, we are enabled to witness in humanity's pots a virtually unlimited variety of concrete realizations which uncover and authenticate his life and action in his world of meaning.

The earliest and most important evidence we have about the history of Neolithic man, after his tools, is usually the remains of his pots. Archaeology may even call whole cultures by the name given to the pottery the peoples made and used—e.g. the 'Beaker people', 'the N.B.P. culture'. This, of course, is because pottery is very permanent, even when broken, resisting corrosion. But archaeology—and even art history—look only at the external characteristics of pottery, to

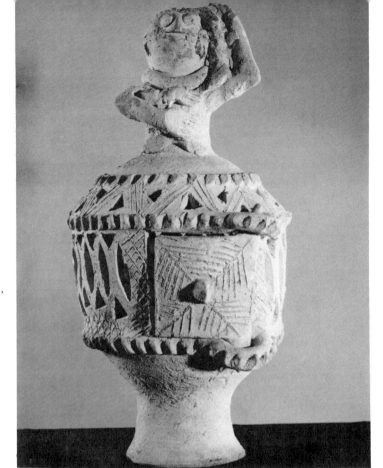

Earthenware 'soul-house' (?), with a small hinged door in the front. Probably Anatolia, 1st millennium B.C. *Durham University Oriental Museum*

classify them according to modern categories of significance, and locate them in a historical system of thinking, which is a special mental phenomenon of our time. This seeks to give to the past a kind of uniform conceptual continuity with our conceptual world of the present, an activity which has its own reason for existing but which can have no bearing in itself on the actual meaning of a pot to its maker or its users. Ortega y Gasset (among others) has pointed out that to create a concept you must leave the sensuous multiplicity of reality behind. A concept is in the mind, one element in the mental order among all the other ordered elements of the world. Pots, however, have always been bedded firmly into the world of their makers' reality, at all sorts of different levels. They *are* far more than they can ever appear to be as concepts in our academic analyses of 'ceramic history'.

How to make pots by firing clay shapes was one of Neolithic man's

discoveries; and pots fall into the category of primary discoveries involving the use of transformed elements of the world. Such discovery and such use are both ingredients in a fundamental act of self-projection, which enables men to look at and manipulate 'things' they have made. It may well be that the very notion of the 'thing', as a unit which exists and is independent of other 'things', is based in some way upon that fundamental experience of transforming elemental material out of the unbroken tissue of outer and inner reality. What he creates as a self-contained usable object, upon which a man projects his experience of himself, may show itself to him as a separate vehicle of individual being. Whatever the actual case may be, it is certainly clear that pots, even the simplest, can only be 'mere facts' to those of us who classify them academically. To their makers and users they have always been a kind of two-way revelation, first of man to himself as a creative and independently working agent, and second of the world to man as a medium, imbued with 'reality', which he is able to transform. A pot thus 'contains' both the reality of materials and process, and the inner realities of man's sense of identity in relation to his own world of meaning. Ceramics may thus be an important element in the 'world order' created by a culture. In manipulating 'forms' a potter is manipulating and correlating complex meaning-entities.

Since at bottom every pot thus presents what I have called a 'transformation image' of some kind, which lies at a focal point where strands of meaning related to life, use, and symbolic thought are knotted together, it reflects back into the mind of each owner or user an image of himself as existing in his world. A work of high ceramic art may even connect to itself whole chains or circuits of thought, feeling, and value, particularly those related to social status and identity (also valid ecological concepts), by means of the formal symbolism in its elaborated shapes and carefully treated surfaces. All these may be added, perhaps unconsciously on the potter's part, into the transformation image represented by the pot, and may raise it far above the category of primary utensil into a region of sophisticated expression. It may thus reflect into the mind of its owner an extremely complex image of his own identity, status, and personal value.

But here delicate issues of truth and falsehood may be raised. For whenever it has become possible merely to purchase brilliant images of other people's cultural identity without any knowledge of their meanings, first a loss of authenticity, later perhaps corruption and

pretence, have inevitably followed; and it has become possible to treat what was originally a live existential discourse with a condensed meaning, as pure convention at the level of mere chatter. This has happened especially, of course, when one culture has adopted the forms and symbolisms of an alien culture (e.g. when eighteenth-century Europe adopted Far Eastern patterns). But it is also possible for people to cease to be aware of the full meanings of the forms used by their own tradition. Potters may then begin to follow mere convention or fashion. Such a failure shows itself in their work, which may slide in the direction of mere dead 'ornament'; this has certainly happened at various times. Even the Meissen decorators often failed to make their Japanese imitations more than 'curious'. But it has happened far less often than we, in our sceptical age, and with our slackened imaginations, may tend to believe. The general plan of this book will be to follow the potter's thought step by step, to trace out the levels and degrees of symbolism involved in the transformation of clay into art, of inert objective matter into a symbolism of being, passing from the simpler levels of fact and use towards the sophisticated expression of clear non-verbal meanings which may rightly be called aesthetic.

109

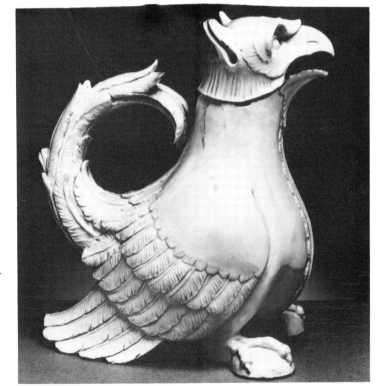

Chocolate-pot. Adapted from a Mosan Romanesque aquamanile. Mark: impressed shield. Vienna (early State factory). 1744–9. H. 7 in. *Victoria and Albert Museum, London: Crown copyright*

THE ROLE OF
TECHNOLOGY Recent books which deal with the processes whereby pots are made
naturally see ceramic art as easier than in fact it was in pre-industrial
ages. Nowadays we have electric wheels, with a range of smooth
constant speeds, and electric or gas furnaces for firing, which can be
thermostatically controlled to exact temperatures. Our clays are
refined compounds which will do what we want them to with rela-
tively little uncertainty or trouble. But this industrialized facility
which prevails even in 'studio potteries' takes us out of contact with
the circumstances under which potting has been done during most
of the history of the human race, and makes of our ceramics an art with
overtones of meaning that have far more in common with other
modern 'planned fabrications' than with the ceramics of the past.
One of the most fundamental factors is that modern materials are now
produced to high standards of purity. That is to say, we buy in-
gredients for pot bodies and glazes ultimately from industrial sup-
pliers by their chemical identities, and get substances whose
behaviour in association with other substances at specified tempera-
tures can be prescribed according to intellectual formulations and
varied only according to conceptualized intention. We are thus
able to achieve a considerable range of calculated 'effects', each
one of them being capable of accurate realization tens of thousands of
times over. The purified materials become the slaves of human will
and intent. The same is true of modern commercially manufactured
painters' pigments, and of the stained glass supplied for windows or
mosaics.

Every potter knows that when using modern materials it is im-
possible to imitate with any truth the achievements of old major
pottery traditions. Research workers have been able to make approxi-
mations to Greek fifth-century B.C. or Chinese eighteenth-century
monochrome bodies and glazes which are sufficiently accurate to
enable them to describe the elements of the technology by which the
wares they are studying were manufactured. But they have not been
able to make pots which actually convey the aesthetic impression of
the original. There are too many imponderables involved. In fact
the chemistry of ceramics is nowadays so intensively studied that the
big commercial companies have accumulated a great body of know-
ledge of how things may be done and have been done. But it seems that
they are themselves bound by the very nature of standardized in-
dustrial mass-production to produce wares of their own completely
out of touch with those variations and effects of hazard which are

inevitable in manual techniques using 'natural' materials, and which have always been an important part of the 'life' of ceramics as an art.

Under pre-industrial conditions the qualities, inseparably technological and aesthetic, of clays and glazes are produced not only by the main ingredients—which modern technology would use in a refined state—but by the 'impurities', the very things which are nowadays removed from the chemically identified substances supplied by the chemical industry to industrial users. In the past the potter's materials have most often been the compounds and mixtures of many chemical substances given to him personally by nature. Potters have used what has been available to them, dug out of the ground or produced by relatively inefficient technologies from earths, rocks, and pebbles. They may have washed some materials to remove substances harmful in firing, such as humus or sulphur. They may have imported metallic ores to give colour to glazes. But in principle traditional ceramics has used what the earth gave, in a chemically unrefined state. This even applied to glaze-colouring materials. For here, too, imponderable and variable quantities of impurities, and variations of particle size among the impurities, have been responsible for the characteristic tones, overtones, and endless variations found in many of the most beautiful classic glazes, such as the Chinese peach-bloom or celadon. Potters were thus accustomed to making what they could out of the available substances, washing them, grinding them in different ways, learning their behaviour as they fired them, altering and adapting ingredients and not expecting a totally predictable or uniform result. They worked by co-operating with the materials to hand, not by subduing them. Wedgwood's work with coal-mine 'car' for his basaltes ware, and his many personal searches for available substances, from spath to baryta, illustrate very clearly the way in which technology pursues and refines upon desired aesthetic effects.

It is thus possible to argue that in a sense every potter was always to a limited extent a scientific chemist, in that he purified his materials as best he could, and recombined them in experimental fashion; and that the difference between the primitive and the modern potter is only one of degree. This is obviously right. But that difference of degree is crucial. For even in the great Chinese pottery city of Ching-te-ch'en during the seventeenth and eighteenth centuries the Chinese potters worked with materials whose behaviour they understood from practice, and whose existential-aesthetic consequences were what mattered

to them, not the advancement of a chemical theory to which their ceramic practice was subservient.

Potters the world over have varied their techniques only slowly. Sometimes, like the Classical Greeks with their fine red and black, 56 they have used the same well tried and limited methods for many centuries; this must have been partly because they had learned how to handle their available substances so as to produce an effect which, once it was enshrined in tradition, had come to be generally accepted as an indelible element in social identification. But another issue is involved. As Bernard Leach has well described it, the firing of a batch of pots in a traditional kiln is rather like a battle. The potter has to control his capriciously blazing fires, changing his tactics from moment to moment according to how the wind alters and how the pots and his glowing kiln behave. He is striving continually to minimize his casualties and to come through with the smallest possible number of spoiled pots and the largest number of fine saleable pieces. An unsuccessful firing can result in the loss of weeks of hard, perhaps inspired work. The potter is likely therefore to stick to materials he has learned how to handle and that he can rely on. Economic pressure from fashion or the demand of his patrons may prompt him to try to imitate the achievement of other potters, perhaps using the same materials as they, perhaps makeshift substitutes, as European eighteenth-century potters tried to copy the Chinese. Maybe what he does, because he does it with different materials, will differ from what he is trying to imitate in an interesting way. This has been common in the history of ceramics. But he will achieve his effects by trial and error, applying his knowledge of the behaviour of materials, and assessing results by his judgement of their value in many senses, and by the response of his patrons.

In their attitudes towards their basic material there is an important major polarity among ceramic traditions; it has no hard and fast distinctions, but the poles are real. They reflect degrees of familiarity with the qualities of clay and the earth accepted by the potter and his patrons. It is very obvious that some ceramics are made for people who accept clay for what it is—a variety of mud. There is no attempt to hide its affinity with the earth, to transform it beyond the reach of ordinary understanding, or to disguise its surface. One could, perhaps, find in this a natural attitude of 'primitive' people; at any rate of people who have come existentially to terms with their physical environment, not merely accepting mud floors and earth on their hands, but actively

appreciating direct contact with the surface of the soil. Thus there are 80
many pottery pieces illustrated in this book which positively revel in 83
all the physical attributes of wet clay, and whatever they make out of
it they do not attempt at all to conceal the accidents, the smears, slurry,
and pinches that happen when one squeezes together earth and water.
(Here I think facile Freudian interpretations would be wide of the
mark.)

At the opposite pole are those ceramics which attempt to trans-
cend so far as possible the earthy nature of ceramic materials, to make
the transformation so extreme that the patron is, metaphorically,
removed from all physical contact with the dirty realities of clay-
making. At this pole ceramics incorporates into its imagery the financial
and social values implicit in refined manufacture, as well as the sym-
bolism of whiteness and glassy purity. Superb examples can be found
among the Chinese eighteenth-century Yung-cheng famille rose egg- 184
shell porcelains, or the products of the Sèvres factory in the second 134
half of the eighteenth century. One of the chief virtues of these
fine wares is their perfection of accomplishment; and there can be
little doubt that the sheer financial value of the porcelain substance
itself, precious almost as a precious metal, as well as the high cost of
production, were ingredients in the symbolism. We may feel inclined
to deplore this on moral grounds; but we would, of course, be
completely wrong to reject all such works on artistic grounds.

The finest wares, of course, could only be made in what we must
call an industrialized technology, with the division of specialized
labour which only the highest aristocratic or rich bourgeois patronage
could support. But they remained emphatically the product of personal
craft, in that the men who played their parts in making them were each
using their own different skills, even in the minutiae of form, for an
aesthetic effect which may have included smooth, unblemished
facture but was never a merely mechanical norm. Such facture is
probably a legitimate ingredient in any art up to a point, so long as it is
never allowed to destroy but only add to the metaphorical life,
existentially and aesthetically suggestive, of the forms it embodies.
This is especially difficult. Near the limit of technical proficiency
ceramics runs into a double danger. It may pursue luxury of materials
beyond the point where this becomes morally offensive, where
material opulence overbalances all the other elements of the imagery.
Then too the technology may become so efficient—as it did, for
example, at Sèvres in the later eighteenth century under Brongniart's

chemical direction—its output so uniform, that the material is lost sight of *qua* material and becomes a glossy refinement of *chic*. It can no longer serve as a proper symbol for the world of the environment which is transformed. Instead it becomes a symbol of dissociation from and rejection of the raw material of the transformation. The work, in attempting to conform to the conventional superficialities of fashion and current codes of taste, may become 'genteel' rather than original, reflecting mental abstractions rather than the concrete symbols of authentic existence.

It should, perhaps, be added that precisely this effect of dissociation from and rejection of ambient reality is deliberately sought by modern arts which make use of plastics and planned production, as well as by certain modern 'arty-commercial' ceramics. The symbolism may seem still to be related, by a reaction of studied remoteness, to the earth from which all materials ultimately derive. There can be no denying, however, that the great majority of active potters feel, rightly, according to the ideas expressed in this book, that pottery, to be authentic, must convey some direct sense of its material, and that even at the limits of finesse the sense of the material as symbol must never be submerged.

Strung out between these poles is the variety of ceramic techniques represented and discussed in this book, which the conceptions represented by the poles may help to interpret. Attic pottery of the fifth 56 century B.C., for example, aims at a high degree of formal refinement, elaborating its handles and painted surfaces. But at the same time it never presses sophistication beyond the point at which its materials or techniques lose their existential value; clay remains clay, even with a special firing technique; surface ornament—however pictorial it may become—does not infringe upon utility; handles remain useful handles. In late Hellenistic ceramics these limitations begin to be relaxed, and inventive elaboration conflicts with the natural qualities of clay and with use. English slipware of the seventeenth century may, 77 perhaps, keep the essential clay-nature boldly visible; while the blue and white and coloured tin-glazed floral fantasias of Delft and Rouen carry surface decoration in the direction of that social display of domestic substance for which the kitchen dresser was expressly designed.

A special complication of the polarity arises when potters in a sophisticated culture adopt a moral-aesthetic role and swim against the current of sophisticated taste, pursuing a cult of return to 'the

essential nature of materials'. This, in fact, imposes a further layer of sophistication upon a ceramic culture; for those who follow this kind of aesthetic always regard themselves as in some sense an élite. This phenomenon was well exemplified by the Japanese ceramics made for 83 the tea-ceremony from the later sixteenth to the nineteenth centuries. Their example was followed by many art-potters in twentieth-century xii Europe, some of whom were inspired by Bernard Leach, who was himself trained in Japan in the tea-ceremony aesthetic. This aesthetic was, in fact, based upon a Buddhist theory of simple directness and a cult of poverty, with a strong moral bias against any display of wealth. Ironically, fine tea-ceremony wares have long been some of the most expensive works of art in Japan. It is nowadays fatally easy for practis-ing potters brought up in this atmosphere to allow their attitudes to be so far influenced by this cult that they are blinded to the real value of the transformation images embodied in some of the best fine porce-lains. It is all a question of the relative balance among the elements in the image.

It has become an excellent common practice in modern art educa-tion to help students learn pottery by returning to the most primitive level of ceramics, using clay they dig out themselves, and firing their pots in bonfires. It may well be that such activities have revitalized existential experience in some children. The problems, in our culture, will be not only to prevent the adults those children become from fall-ing back and accepting passively products devoid of authentic imagery, but also, what is more difficult, to prevent their falling victims to any type of mock-primitive ceramics, mass-produced expressly to capture the 'back to the materials' market. That is exactly what happened in industrial Japan; and something like it happened during the decline of the late Art Nouveau Crafts Move-ment in Europe and America during the first four decades of the twentieth century.

MEMORY-TRACES AND MEANING The basis of expression in ceramics—as in the other arts—is the way the forms of a pot implicate in their presence a wide range of the spectator's personal experience. Different traditions operate in different ways, giving weight to different aspects; but, broadly speak-ing, one may define the roots of artistic meaning as follows.[1]

[1] I have argued the thesis in more detail in my previous book in this series, *Drawing*, London, 1969.

As we live our lives we accumulate a fund of memory-traces based on our sensory experience. These remain in our minds charged, it seems, with vestiges of the emotions which accompanied the original experiences. The overwhelming majority of those experiences belong within the realm of sensuous life, and may never reach the sphere of word formation or what are usually regarded as concepts at all. And yet they probably provide the essential continuum from which evolves everyone's sense of the world and consistent reality, everyone's understanding of what it means to exist, and are even the ultimate 'compost' from which scientific abstractions spring. It is in the realm of these submerged memory-traces that creative art moves, bringing them into the orbit of everyday life and making them available to the experience of others by formalizing and projecting them on to elements of the familiar world which can receive and transmit them. From the artist's side the projection is done by his activity in shaping and forming. From the spectator's side it must be done by active 'reading' of the artist's forms.

What this art and its 'reading' depend on is the human analogizing faculty which lies at the root of all our mental achievements. It is probable that when our memory records an experience it recognizes also its analogical resemblance to other experiences of a similar kind and 'accepts' it under the heading of a 'form'. It may also record connections between experiences, many of which may seem to be of different orders or from different sense-fields, crossing the boundaries between the accepted categories of the world, as when it recognizes that a certain splash resembles a flash, a rose petal resembles a cheek, or a plant stem in spring a burning fuse. The textured bodies and coloured shapes the potter makes can thus suggest very remote indescribable intuitions. By projecting into one pot different classes of form with different fields of reference he can awaken sleeping areas of our mind, and make us see connections between our experiences which we would not otherwise recognize. Those connections and relationships are his aesthetic meaning. They can thus never be closed and abstract but always remain open and sensuously concrete. The simple everyday object, the pot, upon which all the feeling responses are focused is able to carry a complex meaning from one mind to another. The object of the everyday world acts as an immediate vehicle.

In ceramics we will find that the object may awaken resonances in the following different fields of sensuous memory. First, it gives to our hands a specific patterning of experience; this will evoke memory-

traces of certain responses which have special emotive overtones. Then the visual aspect of the shape will do something similar by its own characteristic memory-traces. Finally, the surface texture, glaze colours, and surface ornaments will all operate in similar ways. Thus the pot stands at the convergence of all the different physical attributes it has been given, each of which contributes a special aura to our appreciation of the single object. So we have to read outwards from the pot in several different directions, allowing different areas of memory and feeling to be vitalized and, so to speak, 'tasted' in the mind. Paul Valéry has pointed out that art's tendency towards the infinite, rather than towards the logically closed and descriptive, is what distinguishes it from everyday, functional, single-valued communication.

The result is that a pot, like any other work of art, is capable of opening out for our contemplation structures of form which we could not otherwise know. To most of the pot's forms feelings may be the only key; by being made to respond through feeling we can be made aware of the meaning of form. We must therefore learn to look at the

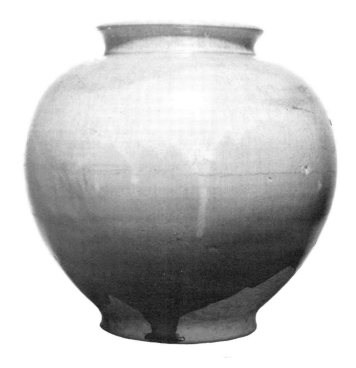

Chinese funerary jar.
T'ang dynasty (618–906).
Earthenware with an
amber glaze. *Barlow
Collection, University of
Sussex*

forms of pottery not just to classify them mentally, but to treat them as symbols and read from them a meaning which will consist of the whole range of analogous possible realities of sense experience each form evokes. This is probably what Valéry meant by 'aesthetic infinity'. And so the problem for this book will always be that it is dealing with imponderables and unnameables. The text must amount to a sustained and varied invitation to the reader to use his own intuition.

It may be the case, as well, that naturally produced objects can be looked at in a somewhat similar fashion; though in practice very few people are capable of doing so, because it needs both tranquillity and concentration, together with the belief that the world offers a formulated language of symbols. The Ch'an-Zen outlook of China and Japan does this. With most people, however, the circuit of interest closes once they make a simple conceptual identification of the object's place in their everyday world, and they are not able to keep their minds open to all the possible fields of memory which the physical attributes of the object might awaken. A work of art, however, specifically invites the beholder to keep his attention open to realms of association within different sense-fields and across their boundaries. And this is what we must do when we approach a pot, especially one from a remote culture, to try to grasp its meaning. We need to question in turn its different physical attributes and try to discover their echoes in our funds of emotively charged and formally ordered memory-traces.

Since we live in a culture which nourishes itself from alien sources of imagery and art through museums and book publishing, we may need to guide our intuitions by conscious knowledge of what the exotic potter was aiming at. But in the last resort we will find the meaning rising, like a kind of inner vapour, among the recesses of our own memory. The only senses to which ceramics may not legitimately appeal directly are, perhaps, smell and taste. It is true, however, that certain visual and tactile qualities can evoke, by synaesthetic suggestion, memories from those other two sense-fields which may strongly reinforce the total effect of the object. It is no accident that, for example, apple green glazes, 'fruity' pinks, or powder blues can evoke strong resonances of perfume and taste to which the actual smell or taste of a pot could never refer; and some visual shapes evoke direct memories of things with vivid suggestions of taste and smell. We must also recognize that among these forms of our experience

will certainly be the forms of other pots, with the experience they have given us. Such so to speak 'second degree' appreciation has played a very important role in ceramic traditions, especially those which have undergone influences, by way usually of trade, from the wares of other cultures. Part of the meaning, for example, of certain early Meissen 109 decoration is that it recalls admired Japanese Kakiemon work whose iii true significance was not properly understood; or of some Japanese Seto wares that they reminded their patrons of profound Chinese Honan black wares.

Very important, too, among its physical attributes are those which relate a pot to other arts in the culture to which it belongs, and constitute part of the repertory of value-indicators which that culture recognizes. These, in post-1700 Europe, have been incorporated in and diffused by printed publications. Pottery, as a relatively humble art, very often reflects formal imagery originating in culturally central arts such as architecture, precious metalwork, or sculpture.

What will be done in this book is to discuss first the technical, then the mental aspects of the different physical attributes of ceramics in turn, to indicate the kind of answers certain pottery traditions may give to our questioning of those attributes, and unashamedly to speculate upon the nature of those hidden funds of response to which a pot's forms may appeal.

TACTILE VALUES First, however, we must pay particular attention to one element in both the making and appreciation of ceramics, hinted at above, which plays a crucial part in many ceramic traditions: tactility and the sense of touch. In fact the sense of touch is vitally important in the appreciation of any plastic art, sculpture no less than pottery. But we Westerners are not allowed to handle things in our museums; we have been brought up in a culture dominated overwhelmingly by graphic images addressed solely to the eye. Nowadays, as well, we live out our lives besieged by arts based upon various kinds of photographs, often chemically treated by granulation or exaggerated contrast, so as to appeal to purely visual experiences of other photographs and make no appeal at all to any other senses. In addition, many of the other artefacts by which we are surrounded are made from materials which by their surfaces communicate virtually nothing to the sense of touch. Even our kitchens are lined with that ultimate in touch-repellent surface, formica. Car-bodies, stainless steel gadgetry, and especially television images all conspire, by a sort of sensuous castration, to

destroy for us the whole realm of touch-experience. We live in a state of divorce from an entire *world* of sensation. And by this I mean not merely generalized texture-sensation but a fully formulated structure of touch and grasp concepts. For that is what the term 'world' implies. A primitive sculpture or a good pot may well have even more structures to offer to the attentive hand than to the sense of sight.

This is especially easy to understand in relation to pottery. For a potter produces his forms by placing his hands and fingers in particular positions to make the clay shapes. And when we are able to find these positions with our own fingers a pot can spring to life in an extraordinary fashion. With more standardized and repetitive ceramics these positions may be rather stereotyped; with mechanized ceramics they don't exist at all. But with all primitive pots as well as with the most sophisticated tactile works, such as Japanese teawares, we can 83 find palm holds, spread-finger grips, and double-hand clasps, with matching palm and finger-pad positions, which the potter certainly intended his users to find. For these pots were meant to be nursed in the cupped hands and virtually assimilated to the person of the user. Even very large hand-made pots offer experiences of the same order to

a moving hand, even to wide-open clasps of the paired palms.

We Westerners are in the unfortunate position, as many people now realize, of being obliged to banish from our lives an enormous quantity of touch-experience. Far too many of us use our hands like inert flippers. Only recently have a few beginnings been made with methods of touch-therapy. But these are the barest rudiments. In practice each one of us does have a fund of touch-images stored in his mind. However, the more actively a person uses his hands, with their grips and clasps, upon objects he encounters in the everyday world, the more vivid will his reservoir of touch-experience be. Nowadays, one reason why our own may be somewhat impoverished is that by convention we are permitted only to experience, for example, our food indirectly by spoon, knife, and fork, and other people's bodies by touch only when we are lovers. Most ordinary men in Western cultures have an ingrained feeling that to use one's hands to explore the things around one is at best immature, at worst indecent and even illegal. However among most other peoples, especially 'primitives', the hand is a live instrument of experience. As well as human bodies, it knows the objects of the natural world, the earth, rocks, and branches, together

with its implements, food, and objects of daily life, intimately by their hand-shapes, which are conceptualized as a pattern of grips, clasps, and finger-palpings. New Guinea Sepik-river exhibition-goers even carry behind their ears a piece of chewed stick with which to experience the shapes of grooves and undercut forms in the wooden sculptures they examine.

It is impossible to prove in a book which is itself a product of the graphic culture in which we live the existence of this world of touch-structure. Photographs can only be interpreted with the greatest difficulty to suggest how the objects of which they are shadows of shadows should be handled. The way to find the proof is actually to handle objects made for the hand. These are very difficult indeed to discover in a modern city environment. Our tablewares are now mostly shaped mechanically. And museum curators need a lot of persuasion before they will permit the public to fondle their pieces, although it is what his hand tells him that helps a good museum man— or an experienced dealer, say—to detect genuine pieces of plastic art from forgeries. The proof of this pudding is only in the eating. No one who has had the chance to experience by touch the forms of good pots will ever forget the impression they give of life under his hand, of direct communication with the maker. And we must go further and accept that only by the hand can the sculptures of many great traditions be understood properly, including African, Indian, Sumerian, South-seas, even Greek and medieval European. These last two cases are interesting; because, of course, most Western sculpture was made to be placed on buildings well out of hand's reach. But the *sculptors* who made it have always used their hands to formulate their surfaces far more than modern gallery-goers dream. Again, only personal experience can provide the supporting evidence for this.

Techniques

THE MATERIAL Clay is found in beds and strata in the ground, produced naturally by decomposition from the granite and gneiss rocks which constitute about 85% of the earth's surface. All potters, and most relatively primitive people using pottery, are very much aware of the nature of clay, as coming from the body of the earth, the mother of all; for they may use it with virtually no further preparation. In ages earlier than our own, which were more keenly aware of symbolic correspondences, their feeling for this origin of clay in the earth, symbol for the most concrete objective reality, which was passed through fire, symbol for celestial transmutation, certainly contributed a great deal to people's feeling for ceramic artefacts.

The clay-body from which the pot is made is functionally connected with the *way* it is made, and hence with its final aesthetic effect. The substance which gives to clay its properties of plastic cohesion is an alumino-silicate whose plate-like crystals readily slide against one another when wet, whilst also adhering to each other, very much as two wet sheets of glass do. This alumino-silicate is produced by the action of humic acids upon feldspar, which is a principal component of the granite and gneiss mother-rocks from which clay is derived by decomposition. But it is only one component. By itself 'pure clay' is almost a slime, hardly workable. Beds of pure feldspar are very rare. Beds of suitably decomposed pure feldspar are rarer still; in fact they form those beds of white kaolin which are so important in the history of porcelain manufacture. Most clays, however, contain in particle form the other components of the original mother-rocks, especially silica, i.e. sand; so the working properties of clays are really the result of the varying proportions of all those other components, which are bonded together by the alumino-silicate content.

Likewise the firing properties of a body (as also of glaze) depend on the mutual 'fluxing' action of its components. Different substances melt at different temperatures; and, broadly speaking, any two substances will melt together at a lower temperature than they will alone. Each acts as a 'flux' to the other. Many together, in a crude clay, make it melt and fuse at a very low temperature. Fine clays contain fewer substances, each with a high melting point. Some substances, such as silica and alumino-silicates are 'refractory' and

have a high melting point. Others have a particularly strong fluxing action; the chief such ceramic fluxes are calcium, borax, lead oxide, potassium, and soda, which all occur in readily available natural materials, and can be used to control the firing qualities of clays and glazes.

Clays from primary beds, that is from the locations where they were originally formed out of decomposed rock, will have particles of widely different sizes, including probably a high proportion of large particles. But secondary beds, that is those laid down in the lower reaches of rivers which have invaded and washed out primary beds higher up their courses, are likely to be composed of far more uniform particles. For the larger particles will have been dropped upstream when the river first began to slow down and deposit its sediment. This natural process of selection by particle size in water can be carried out artificially by the potter through a series of ponds or tubs, in each of which he agitates a watery slurry of clay, allowing some of it—the larger particles—to settle, pouring off the liquid with its suspension of the finer particles into the next tub; and so on. This process is called levigation.

Such a washing process also removes some of the potentially injurious components of a primary clay, for example organic humus or lime. But the colour and the working properties of even a washed and levigated clay are due to all its components, especially to the iron, whose oxides are buff to red or grey, and to the silica sand, whose presence gives a solid bulk to clay-body. These 'impurities' are extremely important not only in the forming, but also in the firing, which is the process by which a dried-out clay form is made permanent. In many technologies coarse particles of sand, crushed flint, or ground-up potsherds are deliberately mixed with the clay-body to give it the bulk to stand up to the processes of manufacture, especially the firing.

Before it can be shaped clay usually needs to be 'beaten up' or 'wedged'. This was, of course, always done by hand, by foot, or with wooden beaters, in pre-industrial technologies; nowadays it is done by mechanical mixers and extrusion machines called pugmills. The beating up consists of repeated kneading, cutting (perhaps with a string or wire), and restacking of each batch of clay. The aim is to eliminate all air-bubbles and foreign bodies, such as twigs or fibres, trapped in the clay, and reduce it to exactly the right consistency for working. So it may start off a little wet and be both worked and then

set out on absorbent surfaces, which will dry it slowly towards an ideal texture. Performing this task gives a potter a most intimate familiarity with and control over the working qualities of each separate batch. In industrialized but pre-mechanical technologies, such as eighteenth-century European and Chinese, beating up was often performed, like the other processes involved, by specialist workmen.

The quality of clay that makes it workable is the result of the shape of the alumino-silicate crystals described above. When these minute flat sheets are lubricated with water they will easily change their arrangement under a squeezing hand and yet, up to a point, hold any shape they are given. The drier a clay becomes the less malleable and ductile it is, and the more strongly it will keep its shape. When quite dry it is strong enough to stand up to a good deal of handling, though it will crack quite easily.

For practical purposes there are three degrees or states of wetness in clay at which it is worked. First is the fairly wet state in which it is shaped by hand (nowadays mechanical) pressure. At this stage it must be wet enough to be easily squeezed, but not so wet as to collapse. Second is that state when it is partly dried out and has become fairly tough, still workable by tools but strong enough to handle without spoiling the shape. This is called the 'leather-hard' or 'green-hard' state. Third is the dry state in which it is fired. When clay is so wet that it is running like a thick soup (maybe helped by something added such as urine) it becomes a slip; a bit less runny, and it is a slurry. Both slips and slurries are used for surface treatment and decoration. Dry-hard clay wares may be given a preliminary firing to earthenware or stoneware temperatures to enable them to stand up to glaze-painting procedures. Wares thus treated are usually called 'biscuit-fired'.

One important factor which conditions ceramic work of all kinds is this: to be fired safely without cracking, especially to high temperatures, a ceramic object should not have too wide or abrupt a variation in thickness anywhere. Objects made of a coarse, open body with plenty of large particles in the clay will tolerate more variations of thickness and fire with less risk than a fine-bodied ware with small particles. At the same time a highly developed firing technique with sophisticated kilns can, by slowing down its temperature-increases, accommodate variations in thickness which a less advanced technology could not cope with. There are, nevertheless, broad limits of variation in the thickness of their particular clay which most

pottery techniques have been designed and aesthetically adapted to meet.

There are various attributes that the clay-body itself can possess, or be given, which have aesthetic significance. If we are to appreciate the pottery of historical traditions we may need some insight into the meanings of these qualities in their historical contexts.

The most important consideration is the fineness of the clay itself. Making all due allowance for the other technical factors involved, there does seem to be a general human tendency to value especially highly pottery which is made of a small-particled, well-washed clay, potted thin. The buff-firing secondary clays used, for example, in the Palace wares of Assyrian Nimrud (c. 600 B.C.), even though they were not fired at a very high temperature, have an unmistakable courtly finesse which, within the limits of its age, has something in common with eighteenth-century aristocratic wares. In the history of post-Renaissance European ceramics one might say that European white wares were continually 'aspiring towards the condition' of the finest white porcelain body achieved at Ching-te-ch'en under the Ch'ing Emperor Yung-cheng in China. The Chinese, of course, were fortunate in discovering early their deposits of kaolin which had long been worked and used—intermittently earlier, it is true, but continuously since the twelfth century. The relative difficulty and expense of firing a fine ware, and the degree of transformation away from its earthy origins this seems to offer, both help to make it suitable to express elevated social status.

The composition of the true hard white Chinese porcelains is based upon kaolin and pure feldspathic rock, plus fine quartz sand. Helped by lime flux this fuses to the white vitreous body called in the West 'hard paste'. It was this hard paste which European potters long tried to imitate without knowing what the true ingredients were. The white soft-paste porcelains they produced were based upon white clay, not true kaolin, compounded with powdered glass-frit instead of sand. This made most of them amenable to hand-throwing. The earliest was probably produced in Florence during the sixteenth century; but the finest were those produced at Vincennes and Sèvres in the earlier eighteenth century, and could not really be thrown, but needed to be cast. The glass-frit was compounded of sand, seasalt, soda, and alabaster. The English bone porcelains added to this body bone-ash which produced a characteristic fine fusion. The essential point is that the body had to be free of any iron or other 'impurity' which would

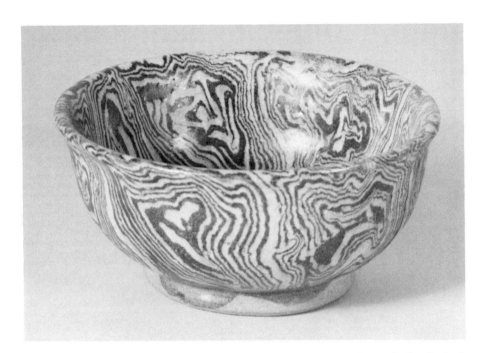

contaminate the colour of the thin white overglaze. The kaolin beds
which made it possible for European potters to make true hard
paste were discovered in Europe and made available to potters as a
consequence of chemical research. The first beds were found at Aue in
Austria in 1709 (the kaolin used by August the Strong's Böttger) then
in 1756 on Bornholm in Denmark and in 1765 at St. Grieix in Central
France. Thereafter, especially under the direction of Brongniart at
Sèvres, refined and vitreous hard pastes came to dominate upper-
class European ceramics.

A beautiful but rarely used clay-body technique is marbling. Clays
of different composition, and hence of different colours when fired,
are rolled and beaten up together. When the pots are finished, they
are carefully shaved down, given either a transparent, maybe tinted,
glaze (Chinese T'ang wares) or none at all (nineteenth-century
Japanese), and fired. The marbling then shows as linear streaks and
whorls in the surface of the body. The acme of sophistication in this
technique was probably achieved in nineteenth-century Japan, when
hand-made pot bodies with very strong tactile qualities were com-
posed of little pastilles of different marbled shapes, resembling mille-
fiori glass. This represents an ultimate degree of refinement of

material, whereby ornament and substances are assimilated, blending into each other.

FORMING: The ways in which clay has been shaped for ceramics are either direct
GENERAL or indirect. The direct methods are modelling, building, throwing, turning, and cutting. The indirect are based on moulding techniques. Far the most important of the direct methods is hand-modelling. A glance through the illustrations in this book will show that there are many things that can be done by direct modelling that can be done by no other technique. It is among modelled ceramics that the most vivid and lively touch-structures can be incorporated. Patted, squeezed, pinched, and pressed clay objects speak a language like no other. And as in all other arts, there are two important aspects to this language. First is the sheer suggestive variety and wealth of the forms that are modelled by and addressed to the hand. Second is the order and unity which is given to those forms—an idea most difficult to conceive for

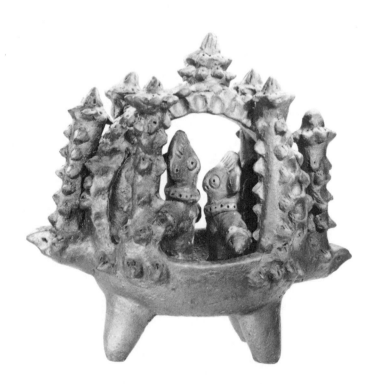

Radha and Krishna in a
flowered boat. Small
terracotta from Bengal,
India. Modern

someone unaccustomed to this language. But the experienced hand can judge touch-formal expressions which the eye cannot even see.

HAND-MODELLING AND BEATING By squeezing clay one can, of course, make almost any shape one likes; though solid-modelled forms often tend towards those slightly rounded bun or button shapes which result naturally from contact between the soft flesh pads of the hands and the yielding substance of clay. Many primitive figurines—icons, toys, and offerings—have 28 been made by squeezing and pinching solid clay. (Smearing over with 195 the wet hand, as many amateurs perform it, is a virtually worthless technique.) They may be completed by little balls of clay being pressed on to the surface, perhaps then cut or impressed with a shaped stick to add representational attributes such as eyelids, creases of flesh on, for example, a bull's neck, or decoration suggesting jewellery. Direct modelling by hand can also be taken to an extreme level of sophistication in the clay sculpture of high traditions such as the European Mannerist, Baroque, and Rococo, or the Japanese medieval Buddhist. But in such work tools—usually wooden spatulae or knives—play a far greater role in working the surface than in more primitive traditions. One special technique found in the clay *bozzetti* of Italian Mannerist sculptors is to use knobs of harder, less wet clay to form the principal nodules composing the body volumes, and to bed these in a matrix of clay closer to a slurry which welds and links them.

Wet-hand pulling is a modelling technique which will be familiar to 30 potters mainly as a way of making the handles which are to be attached to thrown pots. These are 'milked' out of a clay knob with the wet hand. In fact this technique was developed to a high point for clay sculpture by the potters of T'ang China, who made tomb figurines displayed at funerals and buried with the dead. With their wet hands they were able to 'pull' or 'milk' up out of a clay nodule—perhaps hollow—figures of female dancers, for example, giving an extraordinary sense of motion and life. This sense is so vivid partly because the hand gestures, the actual movements of the wet hand pulling on to the wet clay by which the figurines were made, are fixed into the fired-clay forms. And they really only reveal themselves to the touching hand. Very often, however, the original handwork in these sophisticated sculptures has been jointed, undercut with tools, or overlaid with indirectly formed additions such as a face which has been cast in a mould. In certain T'ang figures may be found the true epitome of the art of hand-modelling.

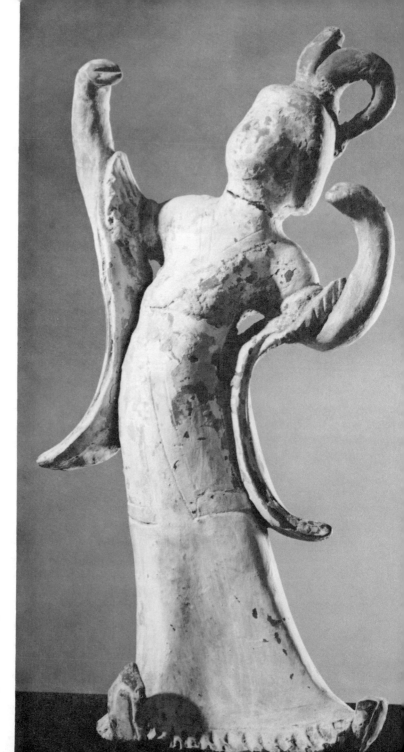

Chinese tomb figurine of
a dancing girl. T'ang
dynasty (618–906).
Earthenware, once
painted with unfired
colours. *Barlow Collection,
University of Sussex*

The most familiar technique of hand-modelling is in vessels called 'thumb pots'. These are made out of a simple ball of clay opened, maybe with the thumb, and worked into a container-shape by pinching up the walls between the thumb and the fingers. Clay vessels of this kind can give a most intimate contact between the hands of the potter and of the user. There are, of course, many possible standards of achievement; and there is a more or less common maximum size such pots can attain, governed by the reach of the fingers and the wet clay's willingness to stand up to handling. Most of the world's most 'primitive' pots were made in this way. But it is especially important for making those additions to pots which suggest in their shapes the forms of other, maybe irregular, analogous objects which can enhance 99 the pot's meaning; as, for example, when protuberances resembling 32 female breasts are modelled on to food vessels (Iron Age Europe). The technique seems to go into abeyance once a certain level of technical sophistication has been reached in a ceramic tradition, being used only to make accessories such as handles, spouts, or decorative excrescences. It has, however, been revived in traditions with a very sophisticated ceramic technology as part of an artistic cult of 'naturalness' and 'simplicity' which rejects the pretentiousness and vulgarity of current routine technological products. The classical example of this phenomenon is in the Japanese teawares made between the fourteenth and the late nineteenth centuries. Various types of direct hand-modelling may be used as decorative treatments for pots either themselves hand-modelled or made by other techniques. Lips, for 32 example, may be foliated with fingers and thumbs or a thrown pot body vertically fluted. Representational or symbolic pieces may be modelled 193 virtually in the full-round and luted on (stuck together with slip), as with certain African or Classical Greek pieces. But perhaps most interesting and important are techniques of grooving or finger-combing in strong patterns which add greatly to the presence and 32 expression of the pot without conflicting with its forms. African, Iron Age European, and Japanese Jomon pots may show this. An additional technique much used in Europe for very fine wares is modelling by strokes of a wet, soft brush on the clay.

As well as hand-modelling there are several further ways of working clay without a wheel. Pots may, for example, be 'carpentered' from flat sheets of clay cut out to appropriately shaped panels. These are fitted and luted with slip, so that they fire into a continuous body. Rectangular pots may be made like this, but far more complex shapes

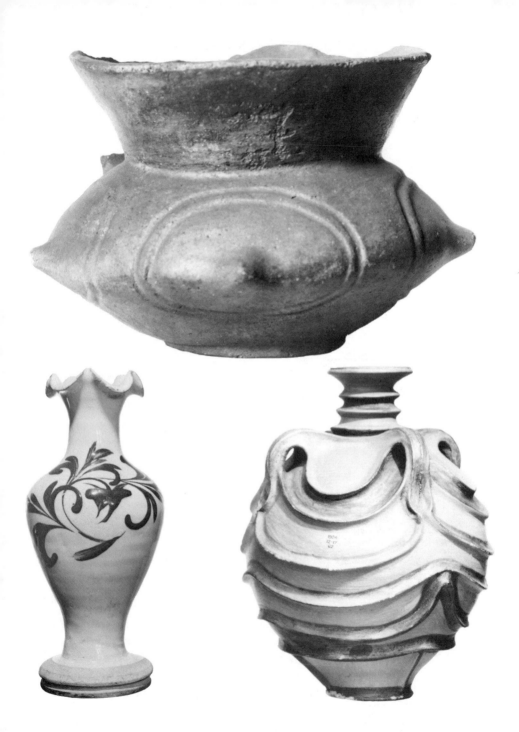

can also be made, especially if the clay panels are curved or twisted in three dimensions. In practice complex constructions can also be assembled from segments made by any of the other basic methods and luted. Rococo table centrepieces include classic instances. 201

The best known supplementary method is coil-building. By this method, used especially for large pots, a continuous rope-like sausage of clay is coiled round and up to make the basic wall of the piece. Some potters and teachers take great pride in making a fine even coil. But this has little ultimate aesthetic value. For coiling is really a sophisticated version of the simpler, universal method of ring-building, in which squeezed-out rings of clay are stacked up. And the point of both these methods is that they are only preludes to the really important part of the technique, the beating out. Something such as a smooth stone is held against the interior of the pot; the exterior is beaten on to the stone, either by hand or with a beater such as another 77 flat stone or a wooden bat; and the whole pot body is carefully squeezed outward and up to its final thickness and shape between the two beating hands and their implements. This technique has produced many superb large pots in many parts of the world. And although it may—as, for example, in Central America before the European conquest—antedate all knowledge of the potter's wheel, potters using the method seem sometimes both to aim at and attain shapes circular in section that have contours functionally related to the circle. When this technique is used by an experienced and skilful potter it is capable of very direct expression; for between his (or her) rapidly beating hands the clay squeezes out evenly in all directions into a homogeneous body of even thickness, responding to the pattern in the potter's mind; and the palms of his hands run continuously over the curvature of the surface, checking its inflection. When really big pots are being made by this technique the clay may be allowed to dry somewhat and gain strength between the various stages of thinning out the wall.

BURNISHING One important group of direct manual techniques, actually quite common in certain stages of ceramic evolution, is often ignored in books which deal with pottery making. They are surface treatments, technically related to beating; but they have, like so many other ceramic techniques, a value at once functional and aesthetic. They are various methods of burnishing the surface, usually exterior but some-

times interior. With a smooth object, such as a river-pebble or a 136 tooth, the clay surface may be rubbed repeatedly when it is in the green-hard state. This has the effect of pressing the faces of the larger particles in the clay back into alignment with the faces of the smaller, thus consolidating the surface, making it relatively impervious to liquids even if it is fired only at earthenware temperatures, and perhaps giving it a fine gloss. On occasion (as in ancient Iran and India) the burnishing was completed with a nodule of haematite, which rubbed off on to the surface, giving it when fired a strong reddish or black skin. Careful scraping with a shell or sherd can produce effects somewhat similar to burnishing. But all of these techniques serve primarily to refine the surface into that unbroken continuity which is one of the formal criteria of ceramic aesthetics (see pp. 121ff.).

WHEEL-THROWING Throwing on the wheel is perhaps the most important method of making pottery. Nobody is certain precisely how the technique developed; but it does seem that the idea of making circular pots antedates the invention of any kind of wheel. It is a possibility, accepted in archaeology on the evidence of practices among modern primitive peoples, that an intermediate stage is represented by techniques for finishing off the lip of a hand-modelled or beaten pot, when the wet hand shapes the lip as the pot is spun standing in something concave, such as a gourd, shell or sherd.

The basic, simple wheel has served even the most sophisticated pottery traditions. There are three important technical elements. First: the circular wheel itself, which rotates lying flat. Second: the bearing or bearings on which it rotates. The simplest type of these is a cup and spike-bearing, with the wheel balanced on the tip of the spike. A double-bearing variant, with a sleeve and collar-bearing running lower on the shaft of the spike, has long been used in Japan. But far more sophisticated, and probably belonging to the period after c. 1550, is the more complex double-bearing wheel fixed to an axle the butt of which rests in a cup, and which is steadied higher up by a collar-bearing. Third: the means of spinning the wheel. The important points here are that the potter needs to have both hands free to shape the clay, and must also be able to get well over it to pull it up. So the wheel needs to be heavy enough to keep spinning steadily for as long as possible. Wheels are thus usually weighted with anything available and a helper is often called on to keep it going. The most primitive means of spinning the wheel is to set it going by hand. But if

it is a good big wheel this is difficult to do; so a pole may be stuck into a notch on the top surface and the wheel accelerated from above. A disadvantage of all these methods is that the wheel keeps slowing down and needing a fresh impetus. Better perhaps was the technique of mounting the wheel in a shallow pit where the potter himself could give it repeated shoves with his bare feet to keep it going. This made the wheel itself rather low, so such wheels have often had an elevated throwing-head at the centre. If a gantry is set up across the pit for the potter to sit on, the wheel itself can be made very big and heavy— hence steady—and the potter does not have to reach for his clay across the entire radius of the wheel.

The more sophisticated type of double-bearing wheel used from the sixteenth century onwards had a separate flywheel below to be shoved by the feet, joined by the axle to a circular throwing-head above, all mounted in a wooden frame with a saddle for the potter to sit on. This wheel, with the addition of a crank-treadle and a box-container under the head, became the standard European kick-wheel of the nineteenth century. Made of metal with a stirrup crank, it is now normal art school equipment. With all wheels that are operated by the potter himself, especially those more roughly made, he has to be careful that his kicking action does not kink the pot he is making. This is especially a risk with very fine thin-bodied wares, which may be sensitive to the slightest tremor of the potter's hand. So in both East and West during the eighteenth and nineteenth centuries wheels for fine wares have been driven by belts run either from a separate wheel hand-cranked by a labourer, or from a water wheel. Nowadays such difficulty is removed by power wheels with variable-speed electric motors.

To throw a complete pot on the wheel may, in fact, need several different speeds. The basic mass of clay is first centred on the wheel by running it fast against the wet hand or hands. It is common practice now to centre a single ball of clay for each pot; but many pottery traditions have pulled several pots out of a single clay lump. The spinning clay mass is raised, opened maybe with the thumb, as the clay spins fairly fast against the potter's wet hands. The pot is then, at a slower speed, drawn up and out first perhaps into a rough cylinder and then into its final shape as it runs between various combinations of palm, finger, and knuckle pinches, one hand inside, the other out. A pad of soft leather or cloth may be used to smooth the exterior surface, and obliterate finger marks without spoiling the tactility. The neck

may be closed over the open interior. The lip may, perhaps, be cut level with a wire, string, or blade before it is consolidated into its final shape. To this lip shape a specially complex pattern of finger and thumb positions may give the final inflection. In all good pottery this last phase is very important and on big pots may need a very slow steady speed; when we handle a pot the complex grips at the lip are one of the most important elements of communication.

From the visual point of view the height of the potter in relation to his clay as he is throwing it has some relevance to the expression. As I said, a potter needs to be able to get above his clay mass—especially if it is large and heavy—to control it during the early stages, and then later on if his form is a tall one. In most relatively 'primitive' traditions a throwing position poised somewhat above the clay corresponds pretty closely with the position of the user of a food vessel; and so the visual forms 'work' best from such a view. But in more sophisticated traditions, especially those influenced by later Ming and Ch'ing Chinese ceramics, the profile-elevation of the pot becomes very im- 67 portant; the potter has clearly been at pains to achieve a viewpoint that brings his own work nearer eye-level. This can be done best with a two-bearing wheel having a raised throwing-head, at which the potter stands in the phases of throwing when he needs to be above the clay and sits while he checks the profile. Certain well known photographs of Bernard Leach at work show this very clearly.

Generally speaking, the higher the pot the more important does its 114 profile become: though, of course, there are certain traditions (e.g. the Greek fifth and fourth century B.C.) in which quite low pots share in a profile-based aesthetic. Height as such increases the difficulty of potting; for the longer one pulls the clay up with wet hands the softer it gets, and the greater the risk of kinking the pot or weakening the upper end and lip. A high pot with a fine lip is the potter's *tour de force*; though that does not mean to say such a pot need by any means be the most expressive aesthetically. The difficulty, however, does add a dimension to the work. Some of the immensely tall German seven- *Fig. 4, 70* teenth-century beer tankards, for example, convey a semi-humorous and boastful extravagance in their towering cylindrical shapes.

There are, of course, other ways of achieving height in a pot with less difficulty. One is to build and beat the pot by hand-modelling and throw it afterwards into its final shape. A second is to throw it in sections—usually base, body, and neck—which are luted together 175 green-hard. This entails throwing to accurate dimensions so that the

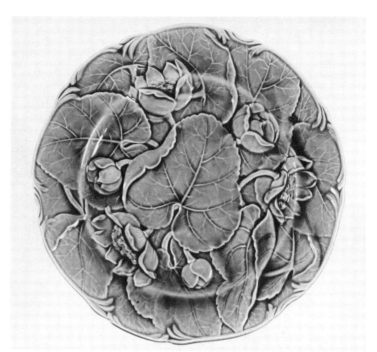

Green-glazed plate. Hand mould pressed, English earthenware. Wedgwood. Early Victorian

sections match accurately when dried (and hence shrunk). It is a method which may well have been used far more frequently than is often realized in the Far East for fine shapes which would be inclined to warp in the drying if they were made as a single piece.

Throwing to accurate dimensions is also often necessary when making a set of pieces—cups or bowls. The usual method has been for the potter to fix a pointer—say a stick—in a clay lump to which he brings the lip of each individual piece. Such a necessity belongs to societies with fairly strict formal ceramic ideals; but even so a fair amount of leeway has usually been accepted. Even nineteenth-century European teacups from the same set can vary much in size. Nowadays, however, when numerically measured exact repetition (with scientific overtones) has become a social criterion of value, the dimensions of pieces making up sets have come to be controlled by purely mechanical means.

When a pot has been shaped on the wheel it is removed in one of two ways. First: it may be cut from the wheel-head, after the wheel has been stopped, with wire, string, or blade. It has then to be lifted off

carefully so as not to damage the wet clay form. The foot, as the pot comes from the wheel, is thus roughly cut flat; it may receive further treatment (see p. 46). Second: the pot may be left with a rounded bottom, which is pinched through as the wheel still spins and the pot is caught as it drops off, to be set aside inverted on its rim. This is especially common when several pots are pulled from a single clay lump. The catching sometimes leaves small indentations on the surface of the pot. In certain of the fine sixth-century B.C. Palace ware goblets from Assyrian Nimrud the group of deep finger indentations from this catching were supplemented with others deliberately added to convert them into a decorative motif. Oval bowls may be made by cutting a lenticular section out of the base of a circular bowl when wet, and pressing the two sides together.

Throwing, of course, cannot be done without leaving some trace of hand marks, especially the spiral ridges the fingers and knuckles make as they pull up the clay. Needless to say, the mere presence of such marks, maybe even exaggerated, does not automatically guarantee that the pot is a good one. In the tactile sphere no less than in the visual there are good and bad, well structured and poorly structured, subtle and crude, as will be seen later.

Two important techniques of bulk production are mould-throwing and jiggering. The first has been applied to throwing since quite early times. Roman Samian wares which have relief figures on them were sometimes made by throwing into concave moulds; Chinese Sung ch'ing p'ai and other wares were sometimes thrown on to convex 71 moulds. In a sense mould-throwing is an indirect technique, since it is used especially for bulk production to a higher standard than the individual potters who use the moulds might be able to achieve on their own; but it has affinities to throwing which justify its being discussed here. The technique is as follows. Original moulds, with either their concave or convex surfaces carefully inflected to the final form, are thrown by skilled potters in fine clay, usually thick and thus heavy and strong to stand up to use. They are then fired. Since a mould-thrown object has to be removed from the mould after it has hardened and shrunk somewhat, only objects or parts of objects with open profiles can be mould-thrown. And it is into the careful and expressive shaping of the single surface, concave or convex, that the maker of the original mould puts his inventive effort.

Before use moulds may be treated with a cutting-off substance, such as light oil, or dusted with mica dust, for example, to prevent the

thrown clay sticking to them; although if the mould is sufficiently absorbent, this need not be a problem. To throw into a concave mould the potter, after centring his mould on the rotating wheel, drops in a ball of clay and as the wheel spins spreads it with his wet hands against the inner surface of the mould, taking care to match his thrown surface to the surface of the mould. To use a convex mould he sets his clay ball on the top of the mould and spreads it down over the outer surface. In both cases he shapes and trims what will be the rim carefully, then lifts the mould with the clay still on it off the wheel, setting it aside to dry a little. When the clay is hard enough and has shrunk away from the mould face, it can be lifted easily.

One of the most important uses of these moulds is to produce in bulk bowls with sophisticated relief decoration. In these cases the original moulds, while still wet before they are fired, are incised or impressed with the patterns intended to appear in relief. The obvious limiting factor is that the design-concavities must be just shallow enough and correctly bevelled to allow the bowl, when it has dried and shrunk, to be lifted out of or off the mould without damage to the relief design, which the potter will have pressed into the concavities. This plays an important role in the aesthetic aims of such pottery. For the artist who produces the original concave designs on the mould must take it into account. It usually means, at best, that his design will be given a kind of linear extension across the surface, or even *bravura*, since it can have little plastic prominence. This is true of even the best of the very subtly modelled figure reliefs on concave mould-thrown Megarian bowls and Roman wares.

Jiggering is a mechanized industrial procedure based on mould-throwing, and is again more or less indirect, since the original invention for the shape produced goes into the convex mould and together with a template of the external radius shape which matches it, is made by specialists. The actual process can be carried out by a worker who is not a true potter, operating a mechanical device correlated with a solidly constructed wheel. Since the mould is usually convex, the technique is best suited to open tablewares. A pancake of clay is laid over the centred mould; the template for the convex exterior shape is then lowered on an arm centred over the spinning, wetted clay until it has pressed and shaved the clay to the final thickness—usually ensured by a mechanical 'stop'. Jiggering can also be used as an adjunct to the processes of turning, described below (pp. 45ff.). There is, of course, no reason at all why jiggered work should not

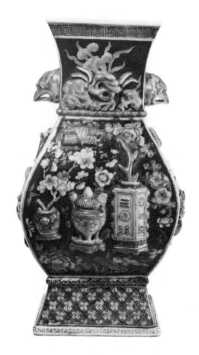

Chinese famille noire vase, in the shape of an ancient bronze, with some of the 'precious things' in relief. K'ang Hsi period (1664–1722). The reliefs were modelled on to the faces. The whole vase was pressed in moulds. This represents an interesting compendium of cultural value-symbols

be visually satisfactory provided its linear invention (see p. 121) is adequate. There is, however, every reason why it should be dead to the touch, since the final surfaces are not formed with the hands. The mould may sometimes bear the traces of throwing; but usually these are removed in the interests of mechanical finish.

MOULDING Moulding (including what is called in England 'pressing') is a most 37 important technique, and the indirect methods all use one or another form of it. The basis of it is that shaped concave shells (called valves) are made, into which the clay is put, allowed to dry somewhat, and then removed as a convex form. There are many variations on this basic technique, and it has often been combined with the other methods of shaping. Moulding is also a most important sculptural technique for casting materials such as bronze, plaster, and plastic. For these purposes it was elaborated to a very high level of sophistication and a tradition of ceramics has often benefited from highly developed casting procedures used for other arts in its own culture—notably in eighteenth-century Austria and France.

The two chief materials for making the valves of moulds have

usually been clay itself and gypsum plaster. Nowadays various plastics are available. Clay was naturally the earliest material used. Gypsum plaster belongs in the first place to Egypt of the New Kingdom; then, after about the second century B.C. to post-Hellenistic Europe; but from the ceramic point of view its widespread use dates from the late seventeenth century and after in Europe.

If clay is pressed into an indentation in any object, it will take and retain the shape of the indentation. We have from the ancient Middle East stone moulds cut with hollows which were used to form parts of terracotta figurines. (This is a bronze-casting technique, too.) If the mould is itself made in the first place of clay (later to be fired and made hard), the hollows in it can be shaped either by an artist working directly in intaglio, i.e. cutting out hollows as a seal-cutter does, or by pressing the clay over a ready-made object—perhaps itself modelled in fired clay. Sometimes both techniques were combined, the clay being used first to take a hollow impression, which was then worked on with the hands or with tools. In this way sections of what was to be fine relief were often added as channels in the hollow mould. Elaborate linear invention could thus be added. A hollow mould, when fired, would serve to produce numerous duplicates without any further invention being needed. But since a clay positive has to come easily out of the hollow negative mould without damaging its relief, there can never be much undercutting on the mould. We therefore often

Chinese tomb tile of grey earthenware. Pressed in an incised negative mould, and painted in unfired colour. 5th–6th cent. A.D. *Durham University Oriental Museum*

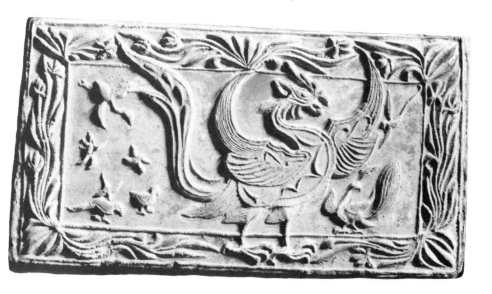

find that individual mould products have been undercut and tooled (say with wooden or bone knives and spatulae) after they have come out of the mould; so that pieces from the same mould may differ in detail. But in principle moulding is used to distribute the skilled work of a single inventive artist into the executive hands of craftsmen who either cannot match his skill or who need to produce large numbers of a ceramic product which is either of a high standard, or ritually correct as an icon or ceremonial object must be.

Single valves are the simplest and earliest of ceramic moulds. They were used all over the ancient Middle East, in Greece, Rome, China, and India, to mention only the most important regions. They produce what is essentially a relief, for the clay is pressed into the back of the open mould, usually with the hand, and has only one significantly shaped face, though the back may be hand finished to round off the volume of a figure as if it were full-round, as was often done in pre-T'ang China with ming-ch'i funeral figures. Quite large relief compositions can be made in this way as well; especially with additional working on the moulded product it can produce art of the highest quality. One usually finds, however, as a matter of practical fact that moulded work taken, say, from a previously modelled figure prepared especially for the mould, particularly if the mould itself has been worked in intaglio to smooth out and finish its forms, loses a very great deal of its appeal to the hand. The finger grips and hand holds natural to direct working, although they may be residually present, tend to get obliterated and smoothed away.

One of the most frequent uses found for single-valve moulding is to make appliqué finishing pieces for other ceramics. Small moulded fish-badges, lion-head handles, and so on may be added to pots. And hand-modelled figurines may be given face-pieces made in moulds following a sophisticated or courtly type which would be beyond the capacity of the potter.

Double-valve moulds for clay are probably classical in origin. Some 194 of the most beautiful examples are the fifth-century B.C. Greek headed rhytons and the third-century B.C. Tanagra grave-figures, though the technique was used for casting bronze axe-heads earlier. In principle double-valve moulds consist only of the addition of a back shell to complete the rear of a figure. At first the two halves, which need not fit each other closely, probably had their clay pressed into them separately without being put together. The two clay positives would then be jointed. But this is rather a rough and unsatisfactory procedure.

To close such double moulds containing pressed-in clay can produce unsightly seams from the joins or, worse still, gaps. The solution to the problem of closed-mould sculpture, especially if its open base is small, is slip-casting. This means that the mould is used dry and absorbent; and although porous-bodied fired clay valves can indeed be used, gypsum plaster is ideal. Into the mould clay is poured in the form of slip, and perhaps swilled round the interior of the mould. As the mould absorbs water from the slip a crust of drier clay of even thickness is gradually deposited all round the interior. The excess is poured out; then when the clay is drier it shrinks away a little from the mould, which can easily be opened, and the casting seams pared off— although the careful spectator can usually find their traces. Even very complex Chinese blanc-de-chine (Te-hua) figures were made in 198 double-valve moulds, and worked up later. But the technique was much elaborated in the complex multiple piece moulds from which fine porcelain figures were made in European factories. Whole assemblages of slip-cast figures were built up and luted together into those stupefying confections of which the prototypes were made at Meissen 201 and Nymphenburg. Obviously this technique has a very close 203 functional relationship with the other application of casting to sculpture; and the more sophisticated it gets, with the moulds being divided into an ever greater number of pieces to accommodate all possible undercuts in the models from which the moulds are taken, the further it departs from what may seem to be the intrinsic nature of ceramic art in the direction of sculpture and commercial fabrication. Indeed specialized variants of slip-casting are used now to make most industrial and commercial wares. We may be able in the last resort to draw the definite line beyond which a genuine transformation image is no longer preserved by using our hands to judge the forms. For it is indeed possible that good piece-mould casts faithfully preserve virtually all the tactile qualities of their original ceramic models.

To return to the double-valve mould, we find that it has three important applications in ordinary ceramic practice, most especially for tea and coffee pots. The first is to make slip-casts from the exterior shape of a thrown pot which has a closed form. The second is to produce closed forms which have an eccentric shape—oval, faceted, or square—from an original which could not be simply thrown on a wheel, but had to be carefully fabricated as a unique object. The third is to enable quite elaborate relief decoration to be applied to any slip-cast object by working the mould in intaglio. During the eighteenth

and nineteenth centuries teapots, many of them quite beautiful, were made by the ton by one or more of these methods in all the countries of Europe. And although such pieces may be found to have thrown rims with a genuine finger grip—basically circular examples with wider mouths may be found which were actually thrown into a double-valve as into a concave mould—the shapes of such wares are, as indicated, usually devoid of any of the true tactile expression natural to the direct methods. That this should be so is probably the result of the mechanically perfectionist aesthetic—which the methods both produced and inspired—rather than a strict necessity. One of the things that gives their special charm to the eighteenth-century so-called Whieldon-type English ceramics and nineteenth-century English rustic wares is that they relied on throwing rather than casting in refined and over-worked moulds.

CUTTING, ETC. When pots have been initially shaped by any of the methods so far discussed they can be trimmed and altered in various ways before the clay is dry. Cutting has been mentioned several times, and this can be done while the piece is still fresh wet, or after it has dried to green-hard; for powerful or delicate work it is usually the latter. Of course it is possible to pinch out or squeeze wet clay objects by hand, as has been described under modelling. But this present group of techniques involves the use of tools. Wood, bone, shell, or metal knives (bamboo is especially good) can be used to cut designs into green-hard clay. Almost any suitable implement can and has been used in practice. 143 Beautiful examples of knife work can be found among the Japanese tumulus-period Haniwa figures, where expressive eye-, mouth-, and nose-holes have been cut into the faces right through the pot body. There are many beautiful techniques of fretting lattice patterns through the body, for example Seljuq twelfth-century white wares 75 from Northern Persia, Chinese Ch'ing-dynasty porcelains, and of course eighteenth-century European porcelain. Knife cutting has been used to shape scalloped lips or decorative cartouches, either applied to the surface or to stand raised like cresting over the edge of a ı pot, perhaps as a handle; and handles themselves may be cut to elaborate shapes either with a knife, or by drawing a profiled wire through a clay mass. Cutting has also been much used by modern artist-potters to work on 'carpentered' shapes or to carve out elaborate variations from ceramic shapes made by any of the previously mentioned traditional methods. In all such three-dimensional cutting

the best examples will always retain their interest to the world of touch; their shapes, hollows, and textures will offer forms that the hand can appreciate.

The knife can, of course, be used to incise designs, either small and simple elements like the slits on the applied pellet-eyes of early Middle Eastern goddess figurines or elaborate details such as hair or jewellery. Specially shaped impressing-tools, including beautiful seal-stamps (Japan), can supplement this sort of decoration. Roulettes can be used to make cursive impressed patterns (Roman wares) or to texture entire surfaces (Japanese nineteenth-century wares). But the knife can also be used for an elaborate method of surface designing on a pot body; incised motifs can be 'drawn' which may afterwards be inlaid with slip, as in many superb Korean tenth- to fourteenth- 106 century celadons, or filled with the general body-glaze, as in some fine Chinese Sung-dynasty Ting bowls, allowing the design to appear only as an intensification of the glaze quality undetectable to the touch.

TURNING　Far and away the most important use of the blade on green-hard clay occurs in the process of turning (this word is often wrongly used to refer to throwing). Green-hard pots can be shaved with a blade as they spin on the wheel, very much as wood or metal is turned on a lathe, save that they spin on a vertical not a horizontal axis. Ceramic turning has two main applications: first to the body of the pot; second to the foot. When the pot body is turned it is invariably done in order to refine the shape at the same time as thinning the body. For many highly refined wares are fired much thinner than they can be thrown, or even cast. Eighteenth-century Chinese eggshell porcelains are the classic example, in which the interiors as well as the exteriors of flat ware—plates and dishes—were pared down, green-hard, to an almost unbelievable thinness.

Large pots with narrow feet, such as many Classical Greek mixing bowls, need to be turned down, especially around the base, since the clay would never have stood up when still wet in its final shape and thickness. If a pot has been thrown in several sections, turning may 175 hide the luted joins. In the course of turning, too, the final inflections are given to the surface with sculptural finesse; stroking hand and eye combine to criticize the emerging surface. Needing special attention would be the ends of profile-curves, raised flanges, shoulder-angles, and rims. But it must be remembered that turning can only be done when it has been allowed for. The interior curves which the potter has

Fig. 1

thrown into a vase or closed bowl must have been inflected to match the intended final pared-down shape so as to ensure the necessary even body thickness. The craftsman who turns must know exactly where the supporting thickness he is to pare away lies, and must correlate his paring with the thrower's inner curves. Thus, as a special aesthetic point, the outer profile of a turned pot may reflect its inner concavity as a convexity with exceptional faithfulness, whereas immediately thrown pots with heavy bodies may have quite widely differing inner and outer profiles.

The turning of a pot's foot, sometimes called 'excavation', is also done, in principle for finer wares, so as to eliminate the extra thickness at its base where it was cut off the wheel. Excavation is done with the pot green-hard, upside down. Following Chinese precedent many Western connoisseurs regard the foot as the culmination of the potter's invention. The hollow, the exterior, and the interior of the rim should both supplement and consummate the whole shape of the pot. There are many possible variations of excavated profile. But there have, of course, been ceramic traditions in which the turning out of the foot has been more casually conceived; and with many earthenwares and stonewares the base was either not excavated at all, or separate foot rims were thrown and luted on to the rounded bases of pots completely pinched off at the end of throwing.

DRYING When the physical shaping of the clay is complete a pot or figure composition needs to be thoroughly dried to give it the strength to be handled. Since as it dries clay shrinks, if the design is complex or the pot is fine, the drying is usually done slowly to prevent cracking. Very fine pots are usually dried inverted to avoid splitting the lip. Terracottas which have been modelled solid may need to be cut in two with the wire, then excavated inside to ensure as even a thickness as possible both for drying and for firing. Afterwards the shells may be luted together and pierced with vent-holes. Pots made of a coarse-bodied, open clay need less care than fine-bodied ones. Japanese Raku clay-bodies, filled with ground flint, can even be put into the kiln slightly wet; but most normal clays would shatter under such treatment. The very finest wares may be dried slowly in an environment with controlled humidity, and finally gently warmed. Sometimes, a fortifying biscuit firing is given—a preliminary firing, which is designed to fuse the pot in preparation for elaborate glazing processes. This was often, with Chinese wares, carried out at a high temperature,

46

the glazes afterwards being fired on, each at its own appropriate lower 58 temperature. (A slightly misleading phrase often used of porcelain body deliberately left unglazed when glazing is the norm—e.g. Sèvres eighteenth-century figurines—is 'in the biscuit'.) When it is either dry or biscuit fired the pot may then be slipped or glazed.

FIRING Firing is the process whereby the clay of which ceramics are made is induced to retain its shape permanently. The pottery is heated, either in an open fire or in one of the many varieties of kiln, to a point where the particle structure cannot be altered by water or pressure. The clay has to be raised to a temperature of about $650°$ centigrade at least. This drives off first the water which remains in a clay even after it has been sun- or oven-dried; and second the water of chemical combination in the crystals. In both these phases the water has to escape from deep inside the clay-body. If the heating is done very fast, the waters will turn suddenly to steam, expand, and may shatter the pot. An open, porous-bodied clay with plenty of big silica particles in it will allow its waters to escape far more easily from its interior, and so can be fired more quickly. Thus one finds that primitive pottery types, which are put directly into contact with open fires, tend to be very coarse-bodied. Some types, such as Japanese Raku teawares, which are often made by amateurs during an aesthetic evening and may be fired very fast indeed in a kind of brazier, are made of a clay to which ground-up flint, old sherds, and sand have been added, expressly to 'open up' the body. Such clays can never be made to appear 'refined' according to perfectionist canons. Their virtues are always those of plastic bulk; and they often bear the marks of their firing adventures, which may add what can only be called an element of drama to their aesthetic effect.

Fine clays, however, must be fired slowly, in kilns. Well-levigated clays of fine particle size may be fired carefully at relatively low temperatures, provided they are not deprived of too many of their original impurities, or provided they have added to them certain substances such as borax or lead oxides. This is because the different substances of which clay and glazes are composed act as flux to each other, together melting at a lower temperature than any of them would individually. Their content of lime (calcium), perhaps the most powerful flux, is one reason why ground bones were used to reduce the temperature at which otherwise high-firing English ball clays fused, to produce eighteenth- and nineteenth-century 'bone china'.

Really fine wares, especially those with delicate glazes, may be baked inside those protective boxes of special refractory clay, resistant to heat, called 'saggars'. But it is only the most highly refined clays devoid of many fluxes which can be raised to the very high temperatures. Ordinary clays, with many fluxes, would liquefy and collapse into slag.

What happens as a clay is fired is that at a certain temperature the particles, where they touch each other, begin to melt at their surfaces and flow together. A pot body fired only to this point will have the 'sintered' characteristic of earthenware. To both touch and sight it will still appear granular. Its individual particles will not have lost their shape; there will still be pores of space between them and they will only have fused together where they are actually in contact. After this stage, if the heat is raised further to stoneware temperatures, the particles will melt yet more, beginning to fill the pores. Finally, at porcelain temperatures, they will lose entirely their individual shapes, flowing into each other and producing a homogeneous substance. Small particles fuse more quickly than large ones. Ultimately all bodies will reach the totally fluid state of molten slag. But then, of course, they will collapse and lose their ceramic form. The point at which this happens depends on the composition of the clay. The more mixed its composition the greater the fluxing power upon each other of the components, certain of which, such as calcium, can lower the fusing temperature drastically. The purer the clay, the nearer it approaches to kaolin, the higher the temperatures needed to fuse it. A really high-fired fine porcelain approaches the condition of glass. Its body is fused to a homogeneous, non-granular structure; and like glass it rings when tapped.

Clay and glaze materials naturally fuse at roughly the following temperatures, though these may be reduced by the addition of fluxes:

'Pure clay'	$c.$ 1770° C.
Refractory clay (fireclays used for saggars)	$c.$ 1650°–1770° C.
Kaolin	$c.$ 1600° C.
Purish secondary clays (e.g. ball clays)	$c.$ 1500° C.
Vitrifiable clays with some fluxes	$c.$ 1200°–1350° C.
Fusible clays with fluxes	$c.$ 1000° C.

With the use of appropriate fluxes the standard types of glazed wares fire at the following temperatures:

Oriental porcelain	$c.\ 1300°\text{--}1350°$ C.
Oriental stoneware	$c.\ 1250°\text{--}1300°$ C.
Salt-glazed stoneware	$c.\ 1220°\text{--}1280°$ C.
Bone porcelain	$c.\ 1200°\text{--}1250°$ C.
Lead glaze for stoneware	$c.\ 900°\text{--}1100°$ C.
Oriental glazed enamels with a high lead content ($c.\ 30\%$)	$c.\ 750°\text{--}800°$ C.
Soft faience earthenware with very high lead content ($c.\ 60\%$)	$c.\ 750°$ C.
Raku ware, opened with quartz or flint which does not fuse	$c.\ 750°$ C.

Glazes which are expected to liquefy and spread over the surface of a pot, and so fuse to it whilst the pot body retains its form, usually contain more flux than the body itself. Many of the finest Oriental stonewares were fired biscuit at a high temperature before being given their glaze, which fluxed at a lower one. Slips, however, may fuse nearer the fusing temperature of the clay itself; so although their additional colouring matter may itself act as a flux, helping to fuse the slip to the body a little ahead of the melting process in the body, they also will need fluxes to make them glossy if the body is to remain granular. The firings which are to be given thus have a great effect on the working, shaping, and surfacing qualities needed in the clay. A well-washed clay with many components of the small particle size which will take a very closely finished form and surface, may be fired slowly only to quite a low temperature and emerge sintered but relatively smooth-looking. It would still be classed as earthenware. Given a tin-glaze coating with enough flux in it to melt at a temperature below that of the body, it would be faience. A lead glaze gives its own characteristic opaque surface to earthenware or stoneware. But both these glazes are so different in composition from the body of the pot that they do not fuse completely together with it, and may flake off quite easily. The essence of advanced ceramic technology is, as we have seen, that its pot body and glaze should be similar enough in composition to fuse together completely at the firing temperatures used. As the materials suitable for colouring glazes and slips change colour at certain temperatures, ceramic traditions which know only a limited number of glaze-colouring pigments may be obliged to fire their wares to a temperature lower than their firing technology could in fact give them.

The atmospheres in which the pots can be fired are called 'oxidizing', 'reducing', or 'alternating'. Both oxidizing and reducing may be produced by bonfire firing, but a kiln is needed to control the effects accurately. An oxidizing atmosphere is produced when the fire burns brightly, with all the oxygen it needs plus an excess passing over the fire and reaching the pots. The colouring metal compounds will then remain as oxides. When the fire is suffocated, that is when it burns smokily with insufficient oxygen for itself and none passing through to the pots, a reducing atmosphere is produced. The atoms of oxygen in the pot ingredients then leave them to combine with free carbon in the atmosphere. The colouring materials will then be the metals themselves. Reduction is done mainly by controlling the air supply in the fire-mouth; it may be hastened by putting organic matter into a kiln chamber to carbonize and further exhaust the oxygen, or by dowsing the fires with water at the end of a firing to fill the kiln with steam. An alternating atmosphere can produce speckles or patches of both oxides and metals according to the fusing temperatures.

The simplest way of firing raw clay is to put it into a bright wood fire. There may be splitting or flaking if the temperature change is too sudden; but with care, and by using a clay opened with coarse sand, perhaps even having chaff or flour mixed in to make it yet more porous, quite good results can be obtained, with very interesting colour effects. Bonfire firing, used by many primitive peoples, is a special kind of open firing. Dry raw pots are stacked up with alternate layers of fuel; fuel is heaped over the stack; and as it all burns more is piled on. After about two hours the pots are left encased in a glowing heap of ash, which will protect them from draughts as they cool. Pots fired upside down in a bonfire are often parti-coloured; black on the interior and rim where they have been reduced by sitting in a layer of ash, red on the exterior where they have been exposed to the air and oxidized. Very well-fired wares, which are always reduced grey or black (since air cannot reach them to oxidize them), may be made by prolonged 'soaking' in a packed mound of slow-burning dung or charcoal. This is technically analogous to primitive methods for converting iron into steel by cementation.

KILNS The most primitive kind of kiln is simply a hole in the ground or a wall to enclose a bonfire; air is fed in by ditches or vents, perhaps facing the prevailing wind, or aided by bellows. The decisive stage in the evolution of the kiln is the separation of the fire from the pots by

confining them to different chambers—the pot chamber and the combustion chamber. One factor governing the design of kilns is the need to pack and unpack the pot chamber. With small kilns this is done through the open top, which is roofed for firing with sherd-tiles; with large kilns it is done through side holes which are built up after packing, and then broken open after firing. There may be several fire-mouths ranged around the pot chamber of a big bottle-kiln, like those used in eighteenth- and nineteenth-century Europe. In the long bank-kilns used in seventeenth- to eighteenth-century China there may be a single fire-mouth at the bottom of the bank, with as many as twenty pot chambers arranged in series up the hill through which the heat travels; these give in a single firing a series of successively cooler temperatures appropriate to different groups of pots undergoing different processes. It is typical of their respective attitudes to technique that Europe has always tended to favour single, compromise technological processes, while the East has taken advantage of the several possibilities inherent in a single process.

In many even very sophisticated pottery traditions one variant or another was used of a small, simple kiln with a domed pot chamber, a roof vent, and one or two fire-mouths whose draught could be controlled. Some have had the heat led along gullies around a central pedestal on which the pots stood (medieval English; archaic Greek). Others have had iron or ceramic floor-gratings to stand the pots on—though these can cause fluxing and colouring problems. But the chief problem with any kiln has always been to distribute the heat evenly around the pot chamber, and avoid the situation where some pots lie in a flame-track and burn to slag, while others are scarcely fired. A very delicate adjustment of proportions between fire-mouth and vent has been the key. In these proportions is also the secret of kilns which can give the high porcelain temperatures. A tall chimney may help the blaze and keep the fire steady; down-draught kilns—slightly more complex in design—are usually somewhat better in their heat distribution. The actual firing of the kiln with specially prepared wood is a matter calling for skilled and delicate judgement. The pots must be taken at the right speed to precisely the right temperature, which the potter may judge from their appearance through spy-holes in the kiln. Throughout the fires must be kept burning evenly by systematic fuelling, the ashes raked, and the draught evenly controlled. Then, after firing, the cooling pots have to be protected from draughts coming through cracks in the kiln or the fire-mouths which might

split them. Finally the kiln has to be broken open, and the pot stacks carefully dismantled.

Inside the kiln pots have usually been stacked for firing. Often, to allow even heating, they have been spaced from each other by means of small refractory (heat resistant) chocks. These may fire on to the glaze at the foot, or elsewhere, and have to be chipped off, leaving characteristic 'spur marks'. If, under the stress of heating, when the kiln glows and expands, a stack of pots topples or collapses, this presages disaster. The potter can then be left with a kiln full of warped, darkened, and fused-together wasters. A normal unprotected firing can produce kiln blemishes such as heat streaks and blow-holes; but these have on occasion in the East been felt to add to the aesthetic qualities of the ware. Most highly sophisticated traditions, however, make use either of a muffle-kiln, whose pot chamber is insulated from the flame, or of saggars to protect fine wares, especially enamels, from direct heat. Saggars, those boxes made of high-temperature-resistant refractory clay, act as lids for each other when stacked, the top one having a separate lid. For fully oxidized firing both muffle-kiln and saggars must, of course, have adequate vents to allow the access of the correct atmosphere to the pots. For a reduced firing they may be closed tight, and even have organic matter put inside them to carbonize and exhaust the oxygen.

Modern industrial kilns are, however, radically different in conception, and are usually electrically heated. A completely even firing is produced by having the wares packed on trolleys, which pass slowly along a tunnel, through progressively hotter and then gradually cooler reaches, without any contact with flame, until they emerge evenly and identically fired.

SLIPS AND GLAZES Slips and glazes were used for two chief technical reasons. First: to make porous, low-fired pot bodies impervious to liquids. Second: to enhance the appearance of the pot and so add to the transformation image. Both, however, are immensely important aesthetically, in that they add a major element to the three-dimensional presence of the pot by offering to the eye highlights on the surfaces whose relation to contours enables its plastic volume and shapes to be powerfully appreciated. The difference between a slip and a glaze is essentially that the slip is a liquid suspension of clay-body in water—as such it is used for luting—and a glaze is compounded of other substances,

including especially fluxes, which fuse into what is virtually a coloured glass. A slip will thus always have a natural affinity with the clay-body and will fire at more or less the same temperature as the body, if allowances are made for alterations in texture produced by an excess of the colouring matter or an added flux. A glaze, on the other hand, need not have this affinity; many lead and tin glazes will easily flake off. The Chinese, who first invented glazed porcelains of all kinds, recognized that the crucial point in the evolution of their invention was not the whiteness, which is implied in the European term 'porcelain', but the development of clays and glazes with the natural affinity of relatively pure substance which made them fire into a continuous fabric. Wares with this quality, which the Chinese class together, include both what we recognize as porcelain and what we would call high-fired stonewares.

Both slips and glazes may be applied in several different ways. Since they are usually liquid suspensions they may be poured on or swilled around the interiors; the pot may be dipped into them, perhaps upside down, held by the foot, with a special jerk to make the liquid splash up into the interior; they may be sponged, sprinkled, or painted on, or blown on with an insufflator. The Chinese eighteenth-century 'powder blue' technique may have required the blue glaze to have been blown as dry powder on to a wet glaze base. Silk-screen printing is a process for applying a glaze pattern still used far too seldom. Stencils, however, have often been used commercially, especially in Japan. Patterns may be produced by reserve or resist techniques. In the first of these flat, shaped sheets, such as cut paper or leaves, are applied to the pot before slipping or glazing, and then picked off, so as to leave bare shapes of clay-body. In the second designs may be painted in wax or oil which will fail to pick up the glaze, and the resist will burn out in firing to leave bare body. Further ways of producing designs which allow the clay-body to appear through slip or glaze are either to cut through it, or to scratch it off—'sgraffiato'—a method which gives lines and edges an interesting texture.

Salt glazes and wood-ash glazes are two special cases. Both of them are used to bring out the natural character of the clay-body itself. In salt glazing, salt is thrown on to the burning fire (which then emits highly dangerous chlorine gas from the chimney). The vaporized salt acts as a powerful flux on the surface of raw clay exposed to the kiln atmosphere, which fuses it far ahead of the rest of the clay into a continuous glassy surface whose colour is an enhanced version of the

clay-body's own colour—usually a speckled brown (e.g. German sixteenth-century Bellarmine wares and English eighteenth-century Whieldon). Wood-ash glazes are somewhat similar in their action, though the ash may be dusted as a layer on to the pot before it is put into the kiln. Both these techniques produce wares whose general effect is rustic and unsophisticated in that the character of the underlying earth is not concealed but amplified. Vegetable ash is also used as a flux for high-temperature glazes. Lime (i.e. calcium), a most powerful, even a dangerous flux, can be used in a similar fashion.

Slips, even though they may fire to a fairly glossy surface by the addition of a flux, always tend to resemble fired clay in appearance, and to show the natural range of clay colours produced by irons and manganese, from black to red, yellow, and maybe the white of relatively pure English ball clays. It is possible to colour slips with other glaze-colouring materials; but this does not seem to have been often, if ever, done. The beauties of slips are the beauties of clay, fired, perhaps, by special techniques. And they do not represent so drastic a transformation of the surface of the pot away from its original clay nature as do glazes. The variety and contrast of colour and texture they offer is, compared with glazes, less pronounced, and their natural 'impure' or 'killed' colours present no problems of colour combination. Elaborate treatments such as combing and marbling are possible either with implements or by using slips of different consistency. But usually slip is employed either to make a design in one colour on the raw clay-body, in combination with other slips, or sometimes as an underlayer—usually white—for a transparent glaze. One special technique is inlaying slip into incised hollows on the pot body. Slips can be used either thin or thick. If they are thin, they can be brushed on so as to allow the underlying body to show through. If they are thick (thickening can be hastened by adding a little acid to the slip), they can be used to give actual relief to designs, either by adding layer upon layer of creamy slip, by pouring it, or by squeezing it out of a bag through a hole, a quill, or a bamboo tube, in one of the many versions of the trailing technique, as in English seventeenth-century slipware. Slips may also be blended or combed into patterns. All these different techniques serve differing formal conceptions, which will be discussed later on. One special technique is that of the black slip used in the painting of Classical Greek wares. Its blackness depends upon a special firing technique. Oxide is applied to an iron slip deliberately decayed to a colloidal fineness, perhaps derived from

blood, so that its particles will instantly lose their oxygen to a reduced atmosphere.

Glaze materials have been the subject of an immense amount of research, especially during the recent industrial past. Many different criteria have guided this research, usually following the dictates of changing fashion. For, by and large, glazes and the designs carried out in them have come to dominate the aesthetic of pottery, partly as a result of the growing tendency, in the West at any rate, towards a narrowly visual appreciation of ceramics. Fineness and purity have chiefly been wanted at certain times, complexity and 'killed' colours at others; perfect slickness of surface in one place, an admired irregularity else-where; and so on. The common technical basis behind all these modifications is that a glaze is essentially a powdered mixture, suspended in water, of a colouring pigment—a metal or metallic oxide—with a glaze substance; this latter is itself a glass, consisting basically of: silica, in the form of quartz, flint, or sand; a flux such as lead, soda, wood-ash, borax, or magnesia, which helps the silica melt at a reasonable temperature (alone it needs more than $1650°$ C.); and those substances which give a glaze its body or 'fatness', such as a complex frit, feldspar, one of the finer clays; and one of those substances such as lead or tin oxide which make the glaze opaque enough to hide the underlying body colour. Frits are important since they fix certain of the colouring materials and fluxes which are water-soluble (e.g. soda, borax) into a non-soluble substance that can be made into the water-suspended glaze. These are first melted together with silica or feldspar into the frit, which may then be ground and remain insoluble in water. The final colour will depend upon the character of the firing (see pp. 49ff.) and if it is to be a reduced firing one form or another of organic carbon may be added to the glaze to absorb oxygen from any oxides incorporated in it.

Among all the many different glaze traditions certain technical factors stand out. First: most major traditions have relied in the first place upon materials available 'as found' in the form of rocks or pebbles. Thus Bernard Leach has described how for their subtle blue glazes Japanese potters long ground up dark green asbolite pebbles from riverbeds, which contain 10–30% of cobalt oxide as well as silica and many other chemicals. In contrast refined cobalt oxide of a high purity, especially when produced to industrial chemical standards, gives a harsh clear blue that lacks colouristic overtones; and no 'controlled' mixing of the refined chemical ingredients identified in

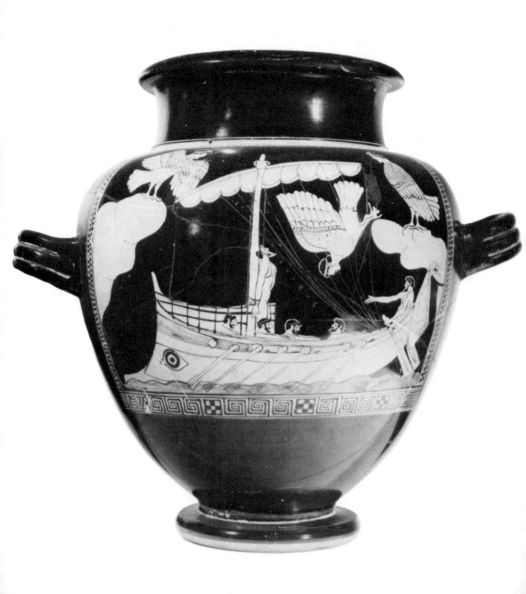

eek stamnos, painted
the Siren painter with
ustration of Odysseus
und to the mast while
ssing the island of the
rens. 490–80 B.C. Red
ures on black ground.
itish Museum, London

the asbolite pebbles has yet been able to produce the subtle blue so much admired and desired. Leach has described also how an important element in Oriental colour effects is the irregular size of the particles given to the glaze when it is ground by hand (by an old lady who chatters to amuse the potters) rather than by machine. It is also probable that some of the subtlest of the other Oriental glazes, such as the Chinese peach-bloom, gain their effect from the way in which complex glaze ingredients, perhaps derived from other natural stones, were ground to differing particle sizes, which melted in fusing and so disseminated unevenly in the glass. Similar considerations operate, as has already been suggested, in all the other materials, as well as glaze materials, available to the potter. Of course glazes which are meant for delicate brushwork must be ground far smaller and finer than those meant for rougher handling.

Another important element in glaze techniques is the limitation imposed on the possible colour combinations of bodies and glazes by the chemical interactions which take place when different components are fired together. Some will destroy each other's qualities altogether. A potter cannot use his glaze materials as a modern painter uses his carefully selected pigments—although in the mid-eighteenth century both in China and Europe it may seem as if the glaze-painters were almost able to do so. The limited range of colours that anyone will notice who surveys the pottery of any ceramic tradition, or even of many different traditions, is not a matter of choice alone. The potter has always had to make what he could with the glazes that are available and will work. These are relatively few. All these considerations mean that even where sophisticated glazes are concerned the potter is bound to preserve in his transformation image some direct contact with the material aspect of his technique. It is, perhaps, worth mentioning as a general aesthetic point that until the middle of the nineteenth century considerations of a comparable though less restrictive kind bore upon painters as well.

The principal colouring ingredients, which are metallic compounds, in ceramic glazes and in clay bodies are affected both by the temperature reached in firing and by the atmosphere prevailing in the kiln at any given temperature. The atmosphere, as we have seen, may be either oxidizing or reducing; and it may be alternated or varied at different temperatures according to the sophistication of the firing technique. An oxidizing atmosphere produced by a brightly burning fire with more than enough air entering allows oxygen to the metallic

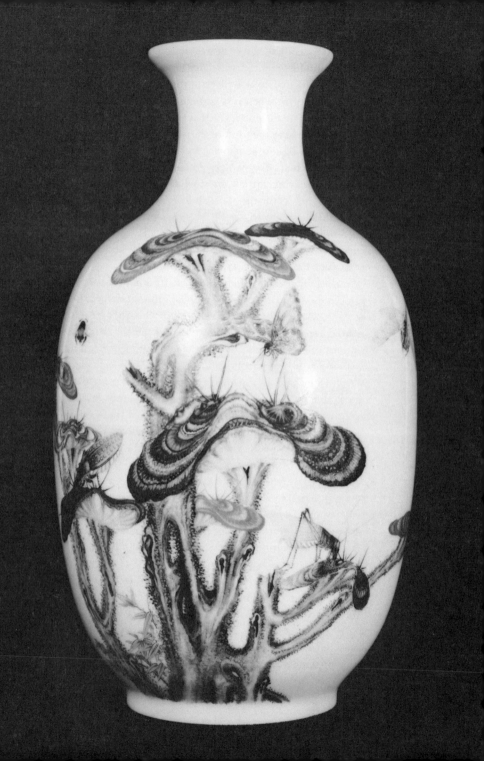

compound, so that its colour is the colour of the full oxide of the metal; a reducing atmosphere with the fire burning smokily, consuming all the oxygen in the atmosphere and liberating into the kiln free carbon which combines with any oxygen there may be, will remove the oxygen from chemical combination with the glaze materials, and the final colour will thus be the colour of the pure metal itself. For example, copper oxide is green or blue, pure copper itself is red. An intermediate atmosphere, with only a little free oxygen, may allow those metallic oxides to form which have fewer oxygen atoms, and which are different in colour from those with more. For example, ferrous and cuprous oxide have less oxygen than ferric or cupric. When a glaze is anyway meant to be fired reducing, and to be coloured by the metal, the low-oxygen ores are best used as glaze materials, since they have less oxygen to be removed.

The final colours of glazes, their speckling and even their textures, are so much the consequence of kiln conditions that many academic connoisseurs—especially those studying Oriental ceramics—have been led to believe that wares are typologically different, or come from different kilns, when they are, in fact, different only because of variations, sometimes accidental, in the kiln atmospheres in which they are fired. It seems to have been customary at certain periods in China and Japan for happy firing variants to have been admired and sought after. But, in addition, deliberate variations in firing technique are able to produce from the same glaze materials, perhaps with some alteration in the proportions of their ingredients, a very large number of different colours and textures according to the demands of Imperial ritual edicts. Chinese Sung greenish celadons and blue Chün wares are prime examples.

When glaze has first been applied to a dry pot and has dried it is in the form of powdery particles adhering to the surface. So in this condition both it and the body can easily be oxidized. But once the glaze layer has melted and fused it seals off the body beneath it from all but very slow chemical change, and will not itself change easily. An alternating firing can thus give interesting mixed colour effects to glazes such as iron glazes, when different elements in the glaze fuse at different temperatures and at different stages of oxidation. The sealing effect of melted glaze was used especially to produce the red pure copper (i.e. reduced) fish-shaped flashes under the glaze of a white fully oxidized firing in Ming times in China (e.g. stem-cups). Just be-186 fore the glaze was due to fuse the kiln atmosphere was suddenly re-

Chinese eggshell porcelain bottle-vase, decorated in overglaze enamel; black, red, brown, yellow, violet, and blue design of fungus and insects. Fine four character Yung-cheng mark (1723–35) beneath. *Durham University Oriental Museum*

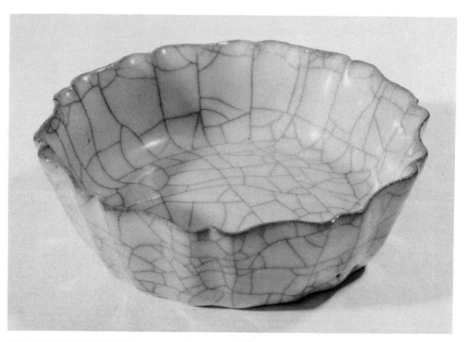

duced, de-oxidizing the copper to red. Then when the temperature reached fusing point the reduced copper was safely sealed in by the fused-over glaze, and the kiln atmosphere could be returned to oxidizing to finish the firing. Another special technique was the Greek reduced black slip painted on a red oxidized body, both of fundamentally the same iron composition. The slip for the black (containing quartz) was, however, 'peptized' by a special process of decomposition into exceptionally minute particles. This slip fused earlier than the body, of normal clay, and was fused with the atmosphere reducing, giving black. Once it was safely fused the atmosphere was returned to oxidizing, and the body where it was exposed naturally oxidized itself to red.

The principal colouring metals are these: iron gives many orange-reds and browns oxidized, blacks and greys with ferrous oxides or reduced; copper gives blues and greens oxidized, reds reduced; manganese gives black, purplish, or blue oxidized, black reduced; cobalt gives blue oxidized, black reduced; and tin gives opaque milky white oxidized. Yellows are iron and antimony oxides, and the famous eighteenth-century pinks and violets come from the gold-chloride process, fired oxidizing, known as the purple of Cassius, after Andreas Cassius, whose discovery was first published in 1684 or 1685. Knowledge of this gold rose enamel was transmitted to China, probably by Jesuits, by the 1720s. Chrome oxidized gives a heavy green, which may be used when more than one green is needed as in some Chinese ceramics *c.* 1800. Variations and combinations of some of these colours are possible, with trial and error, and most colours may be mixed with white fine porcelain body to pale them. Lustres may be produced when very finely divided metal over a fusing slip or glaze is reduced to a continuous almost pure metal skin. Copper, gold, and platinum are the commonest; silver is rarely used, because it tarnishes so easily.

Coloured glazes—which, because they are essentially glass may also be called 'enamels'—have been used to paint designs of all kinds usually on a white ground. Many of the colouring pigments reach their maximum brilliance at differing temperatures. And so while it may be relatively easy to adjust the composition of one glaze to another so that they fuse in a single firing, it may be impossible so to adjust five or six colours. Thus underglaze enamels, in which one colour—usually blue, but sometimes red as well—is used under transparent glaze, may be fired to their optimum in one process; overglaze

Small Chinese basin, of Kuan ware, with greyish crackled glaze. *Barlow Collection, University of Sussex*

Small cup, soft-paste, with a blue transfer design on white. Thrown by hand. Leeds. Late 18th cent.

enamels may have to be fired on a descending scale of temperature several times over, each enamel colour being applied only when its turn comes in the temperature scale. With the glazes used in faience or majolica (tin-glazed earthenware), which anyway are fired at lowish temperatures, this problem is not serious since the colours have so much substance in common. Some overglaze enamels, because they are not entirely fused on to their glaze-bed—which melts only at a temperature higher than they do—have a tendency to scrape or peel off with hard use. In some cobalt glazes from China the overglaze blue can fuse so well into the ground glaze that it can appear to the eye to be underglaze.

When pots are being fired they shrink. If there is too great a disparity between the degrees to which pot and glaze shrink, there can be trouble and most pottery traditions try to avoid it. This is another limiting factor on ceramic materials. If the pot shrinks more than the glaze, the glaze may cease to adhere and flake off. If the glaze shrinks more than the pot, it will craze or crackle. *This* particular effect, however, may be deliberately sought for; certain Chinese Sung and Ch'ing wares of the Kuan type, for example, make an aesthetic virtue 60 out of their beautifully patterned crazing, which may even be emphasized by colour rubbed into the crevices. The Japanese Satsuma burnt cream glaze is also characterized by its crackle. What this means in aesthetic terms will be discussed later.

Slips and glazes may, of course, be used in many decorative ways. They may be brushed into designs of many kinds, discussed later, and perhaps combined together. They may be used to tint parts of plastic designs or be built up thick themselves to give relief. They may give different effects if the ware is in different states when they are applied, 77 e.g. slightly damp, dry, or biscuit. In all these processes they play a major role in the transformation image of the pot; and these will be discussed in due course. A variety of implements may be used in this work, the chief of which is the brush, which is normally a version of the type of brush used for graphic work in the given culture. A turntable may also be used on which the pot is revolved so that the decorator can follow out his design. To make a continuous ring around the pot the turntable may be spun while the potter holds his loaded brush still against the pot wall.

Transfer printing, one of the most important industrial techniques 60 for glazing designs on to ceramics, was first applied to Worcester and 181 Liverpool soft-paste wares in 1756. This really consists of an adapta-

tion of the techniques of copper-plate engraving to ceramics, with all the facility it offers for multiple reproduction under industrial conditions. A copper plate is engraved in grooves with the design. The glaze pigment is then applied with, e.g. a roller and the face of the plate wiped clean, the glaze remaining in the grooves. The plate is printed on to thin paper, which is then pressed face down on to the dry ware. The glaze adheres, and the paper is soaked off.

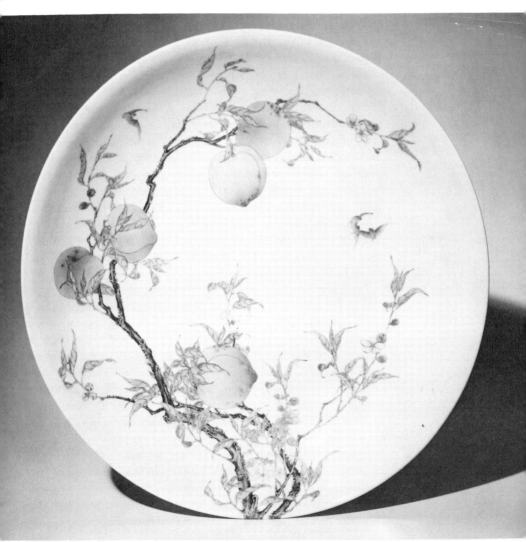

Chinese plate, painted in polychrome overglaze enamel with a spray of peaches. Yung-cheng period. *Victoria and Albert Museum, London: Crown copyright*

CERAMICS AS
TREASURE

This third part of the book will deal in order with those various formal aspects of a pot which one may question for their symbolic value, and to which one has to allow one's active imagination access (see pp. 15 ff.). Under each heading outstanding examples from particular pottery traditions may be mentioned; though, of course, the discussions can be in no sense exhaustive. We must never allow ourselves to forget that pottery, like all art indeed, was meant to occupy a place in an actual world of life and activity. When we see it inert in a showcase it lacks dimensions of reality very much as, say, a motor car in a museum does. We therefore always have to try and reconstruct in our minds a model for a pot's life use before we can begin interpreting the aspects of inner life its symbolism also includes; and this means interpreting the functional symbolisms which have been incorporated into the basic transformation of the clay. When we look into these in detail we may find that some pots seem actually to have been made for a kind of visual appreciation not too remote from the kind we can give them as they stand in a museum case; they seem to have been meant just to stand and be admired from a distance. And we may therefore think we can get closer to them than we can to other pots which were not meant to be appreciated like that.

There may be some truth in this. But we may in some such cases be deluding ourselves. It is also unfortunately true that many modern potters, studio and artist, have been led to believe—and work accordingly—that pots should be made for exactly that kind of distant, untouchable appreciation. An air of perfect, complete-in-itself visual self-sufficiency, especially when radiating from a 'vase' which never contains anything, has become one of the status characteristics, associating ceramics with 'noble treasure', that many modern patrons look for. To a considerable extent, as has been suggested, this must be an inheritance from that tradition in which we, as Westerners of European descent, belong; we must always therefore try to be aware of the fact that we are likely to be conditioned by our tradition, either accepting it fully or dissenting from it.

When Duke Charles Eugène of Württemberg in the middle of the eighteenth century said that a porcelain factory was 'an indispensable accompaniment to splendour and magnificence' his words had behind

them a galaxy of unspoken assumptions and implications, the force of which is still with us, as auction prices show, and which it might be as well to elucidate. It was no accident that the greatest European porcelain factories were patronized by powerful hereditary princes and aristocrats. Among them were August the Strong, who set up the Meissen factory near Dresden, and whose alchemist Böttger discovered true hard-paste porcelain for Europe, the Empress Maria Theresa, who patronized the factories at Tournai, Doccia, and Vienna, and Louis XV of France, who moved the royal factory from Vincennes to Sèvres in 1756. Some consumed fortunes in running their potteries, whose products were so expensive that few could afford them; and aristocratic debts were very hard to collect!

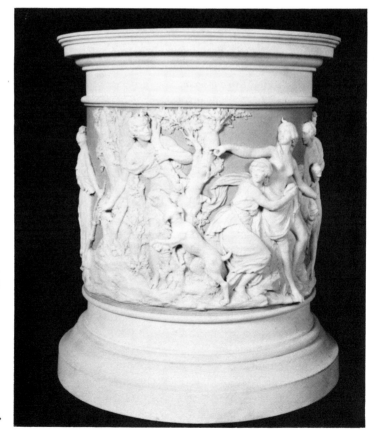

Sèvres porcelain pedestal with a relief of Diana and her nymphs, modelled in lively French style, *c.* 1785, in white and pale blue ground. The studiously static Wedgwood silhouette designs, which it imitates, are replaced by a thoroughgoing three-dimensional invention. *British Museum, London*

Why 'splendour and magnificence'? Fine Oriental porcelain has been collected in Europe since at least 1650 as treasure, something intrinsically precious, a substance valuable virtually in itself very much as gold and silver are. It is interesting that Böttger was also trying to make precious stones for August the Strong, and that he had some of his early fine, hard porcelains cut on the jeweller's wheel in the manner of gems. Ming enamels and even Sung celadons had occasionally been collected yet earlier. But by 1800 most great houses had their porcelain stores; and on a humbler scale, with a somewhat different range of interest, the members of the British Oriental Ceramic Society still follow a rather similar custom; although nowadays, of course, there may be a bias towards earlier wares which the Chinese themselves regarded as aesthetic rather than physical treasure and nobody really *uses* the wares in their collections any more. The Rococo and Chinois- ii erie extravagances of eighteenth-century European porcelain, how- 109 ever, clearly had a special function in relation to what the nobility felt about themselves and their lives. For outward 'splendour and magnificence' were probably experienced as a kind of exterior testimony to that inner virtue upon which their hereditary aristocratic rights were believed to repose. It may have been related ultimately to the 'divine right' of kings, which was itself physically symbolized in the coronation ceremony by the unction and crown in which the holy spirit was conveyed.

The whole symbolism of light and colour as reflected from the radiance of the divine, which can be traced back into the aesthetics of the medieval and Byzantine worlds, must also have been involved. For in eighteenth-century Europe porcelain enamels probably offered the most intense colouristic experience available anywhere. No painter's pigments, no stained glass, or dyes produced substances as lustrous, varied, and intensely emotive; and most ordinary people in that pre-aniline printing era would have lived out their lives without ever encountering colours anywhere near as brilliant, not even in the flowers then commonly seen. The Far Eastern porcelains, themselves known to be produced under direct control of the Emperor of a mythical and sublime Cathay, thus provided natural patterns both in shape and design for Western aristocratic splendour; though their oblique symbolism—much of it sexual—was probably never understood in Christian Europe. This colouristic brilliance, combined with the vital formalism of rocaille ornament, and with iconographies based on heroic identification and the life of privilege (see pp. 198ff.)

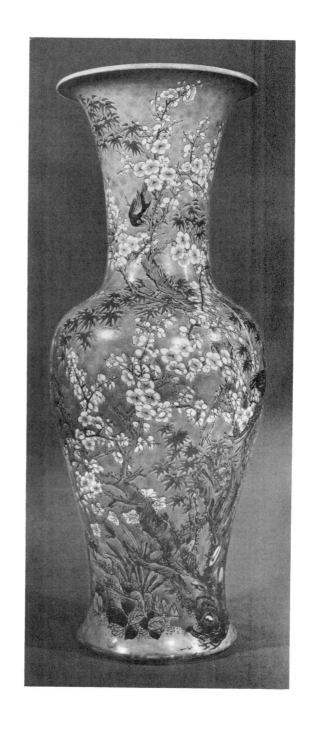

Baluster vase, China.
Ch'ing dynasty. 18th cent.
Fundaçao Calouste
Durham University
Oriental Museum

together amounted to a visible patent of nobility as it was then understood. And armorial porcelains, decorated for example in China with family coats-of-arms in enamel, were a natural function of the whole complex of imagery.

Such ceramics, we know, were used as a special kind of tableware. But certain fine garnitures—sets of vases—were certainly used also' for pure display on those consoles and inset buffets which formed such an important element in eighteenth-century interior décor. Madame de Pompadour's Salon decorated with Chinese powder blue and gold porcelain in the Petit Trianon was a special instance. To a certain extent our present-day museums have inherited the functions of the old 'display-castles' of the nobility; many of them, indeed, actually *are* such castles taken over by a democratic authority and maintained in a 'fossil' condition. No one nowadays truly understands the topics of discourse which eighteenth-century designs and arrangements purvey, and which noble patrons of the past would have assimilated with ease. Indeed, there is little certainty as to what the arrangements were. In practice Western scholarship concerning Far Eastern ceramics was based initially on the contents of these aristocratic collections. And although during more recent decades archaeological and art-historical research has extended our knowledge of both ceramic wares from other countries and the aesthetic ideals of those countries, it is sometimes surprising to discover how much our classifications of Chinese porcelains are still governed by the 'export categories' (e.g. famille verte, noire, rose, and many others) which were used two centuries ago, when the Chinese themselves were interested in artistic effects rather than categorization. It is, perhaps, less surprising that the more sophisticated élite of collectors learned— by about 1925—to combine aesthetic and 'curious' interests, and to regard the cabinets in their mansions as pure showcases, stocked with what Chinese connoisseurs themselves valued most, their own Sung stonewares. These were never meant to be 'vulgarly' displayed as T'ang tomb wares were at funerals. Nowadays the aesthetic values attached to individual pieces of more robust and primitive wares have been inextricably interwoven with older notions of a personal glory. Museums, however, still invite us to look, to be awestruck, and not to touch; the contents may be 'ours' in one sense, but in a most important sense they remain 'treasure' not to be used. It is not surprising therefore that many potters working today for wealthy modern aesthetes feel obliged to aim at a visual, aristocratic, purely showcase

Fig. 2
Tiltable storage jar

brilliance which will fit in with one or other of the recognized branches of 'visible virtue' which the individual collector wishes to attach to his person.

This, however, is only one possible aspect of the many existential experiences which ceramics as an art may serve; and we must beware of reading precisely this kind of bald exhibitionistic and self-congratulatory meaning—which has been limited in its historical range—into the wares of all great ceramic traditions. And we must be especially conscious of how we allow any reaction against this attitude which we may feel, a violent *parti-pris* for the bold and outwardly primitive, to colour our approach to the ceramics of the world. We must accept that, generally speaking, potters devoted their efforts to making wares which were technically and existentially the finest of which they were capable and, instead, try to find the basis for our appreciation in a more fundamental questioning of the nature of each pot, not in a superficial and biased estimate of its most obvious characteristics.

LIFE FUNCTIONS

To begin with, one may wonder to what extent a pot's forms are the result of conscious art. Obviously many pots—very beautiful ones—were made without any aim on the potter's part to make a work corresponding to a consciously documented aesthetic canon. We may be able to judge that pots will differ strongly in the degree of 'focused attention' or symbolic projection put into them. The point of this book, however, is to dissolve the question into its various component issues, allowing especially for the fact that aesthetic canons are never themselves simple, but involve many different combinations of symbolic structure.

A basic question therefore is: How did this pot (or its historical ancestors) function in daily life especially in relation to food and drink? Obviously it is difficult to be definite about this with every pot. But one can always remember two chief factors: first, the weight of a pot when it is full of food or liquid; second, consequently, the way in which it may or must be stood, tilted, or held. Far the commonest type of vessel in every country (before the coming of modern piped water) was the large jar meant to contain a day's water for a single family, yet not too large to be carried conveniently from the well when full. There are, too, many pots which can each be used for a wide variety of functions, mainly connected with storing food. But many goblets fit cosily into one hand and some bowls are obviously meant to be held in

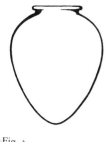

Fig. 3
Large tiltable storage jar

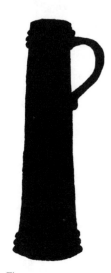

Fig. 4
German beer tankard

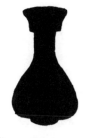

Fig. 5
T'ang bottle-vase

both palms; indeed they may be regarded as a kind of transformation 21 substitute for the hands. So, too, may many charger dishes. Bowls may have fine lips which would not take the strain if they were often lifted by the leverage of the thumb on the lip when they were full. Eastern rice-bowls meant to be held under the chin centrally balanced in the conically-splayed fingers, while the rice is ferried on chopsticks direct to the mouth, may address themselves to those fingers and the chin. Conversely, many medium-sized bowls have thickened and flattened lips expressly designed to take a thumb crooked over them. 83 One may also ask: Can this pot really have been lifted, full, by its handle or handles? In the Far East one most important function for small jars was as scholar-officials' water-pots for use with the brush when writing. These shapes are often archaizing in form; and they may well have been meant to be a focus on which the scholar could contemplate as he wrote. According to fashion and the time, he may have wished to be reminded of nature and the virtue of modesty, or to be emotionally stimulated. The chief use of the purely cylindrical pot in the Far East was as a writing-brush container, the brushes being stood in a bunch heels down.

There are, too, such oddities as the delicately ornamented Bourda-lou, made in a carefully squeezed shape, originally for early eighteenth-century Parisiennes to relieve themselves during the excessively long sermons preached by a famous Jesuit of that name. While all over the Classical Mediterranean world small bowls either pinched over to a spout when wet, or roofed with a decorated moulded lid, were used as lamps. And then some pots have interiors shaped specially to allow for particular implements to be used in them, such as spoons with curved edges, or bamboo tea-whisks, as in China and Japan. This last may give an extraordinary visual illusion of increased depth as one looks into such a pot, when its interior shape opens out below as it does in certain Japanese tea-bowls. Many pots, when seen in pure profile, seem to have a kind of unconsidered squatness round the bottom, which generally indicates that they were habitually used on the ground, or at least low down, and were normally seen from above at an angle of at least 60°. A clean flat foot rim asserts that a pot belongs on well-made and flat-finished furniture.

Large storage jars were made in the ancient Middle East with rounded bottoms, which sat in depressions in the ground or on thick *Figs.* ceramic rings. When such jars were full they would be heavy, and a 69 $\frac{2, 3,}{}$ rounded bottom would make them easy to tilt. In addition the profiles

Fig. 6
Indian type of water-pot
with water levels in
tipping

Fig. 6
Indian type of water-pot
with water levels in
tipping

Jug; salt-glazed earthen-
ware. Found at Holborn,
London. 15th–16th cent.
*Victoria and Albert
Museum, London: Crown
copyright*

Chinese dish with
moulded relief design of a
mythical beast under a
Lung-ch'üan celadon
glaze, bluish green. Yüan
dynasty. Diam. 17·6 cm.
*Collection Edward Chow,
Hong Kong*

of their lower parts may be graduated so as to allow their weight to tilt progressively on to their sides as they are emptied. Some North Indian water-pots have shapes which are virtually diagrams of their whole pattern of use. Each can tilt on the rounded base to spill into an open mixing bowl; its neck is high enough to stop spilling; its open mouth can be poured into; its main weight is at the right height for handling; and the curve of its base fits snugly on to a head carrying-ring or the mouth of another pot. These pots are hand-made for people who use their hands for everything; and although no attention is paid to their visual beauty by their owners, they may have a most powerful appeal to all the senses of touch and balance. The small Classical Greek *Fig. 7, 72* alabastron also had a rounded base and solid flanged lip. But it was used as a bottle to carry body-oil to the bath, strung maybe in a loop of cord on the wrist, and hung, not stood, when not in use. It was meant to be sensuously welcome to the hand and body as well as socially effective— for bathing was a public activity. German sixteenth- and seventeenth-century tankards will hold gigantic quantities of beer, a highly significant fact which contributes greatly to their expression. Contrariwise, and perhaps to other people offensive for another reason, is the expression of the nineteenth-century gilded teacup holding very little tea,

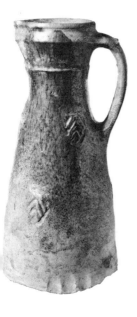

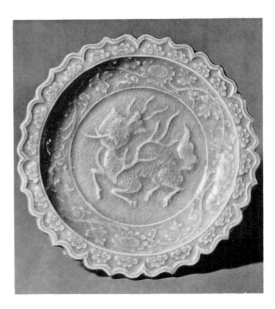

Fig. 7
Greek alabastron

Fig. 8
Greek kylix

Fig. 9
Eighteenth-century teacup

whose handle will not take even a lady's finger through it, and whose curlicues are formal analogues to the crooked-out little finger of genteel bourgeois society.

There are occasions when we may find it very hard to discover in ourselves a sympathetic appreciation of the way pots have been used. For example the broad, flat kylix-type with wide-flying handles which the ancient Greeks used for drinking wine will give an uncomfortable feeling to most people used to handling beaker-like containers for liquid. But if one recalls the extraordinary popularity in the classical world of the game called 'kottabos', the shape becomes easier to understand; drinkers in competition used to flick their wine-dregs at a standing bronze disc with a Hermes head on it as a target. For this the kylix may be a most suitable shape. Other shapes may have had different *raisons d'être* which may be difficult to discover without forming in one's own mind a model of the reality into which they fitted. The typical concave waists of the otherwise cylindrical Persian, Hispano-Moresque, and Italian 'albarelli' or drug-jars, for example, 109 may have something to do with the need to lift out one with one hand from a row of similar jars on a shelf. Some shapes may specifically recall other familiar objects with which they are associated or for which they are substitutes. For example, Yüan Chinese bottles are sometimes shaped like the goatskins which were used in the Middle East to hold water; English medieval jugs may have squat, seamed 71 shapes reminiscent of their stitched leather prototypes; wall cisterns, with bungs or taps, may resemble the architectural mouths given to fountains which may go back to an originally sacred ornament. Many containers will refer back affectionately to natural objects, such as gourds, which may be used as containers at more primitive levels of the same civilization; Chinese and Japanese waisted or double-gourd *Fig.* bottles are very common. Yet again, fairly common are those handled 100 bowls shaped like baskets, and drinking vessels based on cattle-horns, the latter sometimes, as in Greece, significantly much over life size.

IMITATION As has been hinted, we can never overlook the close affinity there may well be between the forms of pots and the forms used in other major arts of the same culture produced by different technical means. Not often has pottery been an art consciously playing a leading aesthetic role. This is not to say that it is not artistically *important*, as should be sufficiently clear. But the everyday domestic usefulness of pottery and the modesty of the potter's status have often led ceramics to adapt the

72

ig. 11
implified examples of
ypical metal forms used
n ceramics

inventions of arts which enjoyed a superior status. People who either could not afford the finest gold and silver wares (as in eighteenth-century Europe) or who were debarred from using them by religious scruples (as in parts of the Muslim world or under certain Buddhist emperors in China) would adopt ceramics made in the forms customary for metalwork. It is thus very common to find pots imitating the shapes and decoration proper to the precious metal wares used by the high aristocracy. During the eighteenth century European ceramic shapes, e.g., of coffee pots, and similar items made in China and Japan for the European market, accurately reflect the changes of fashion in silver tablewares. In the Americas archaic pots may imitate the forms of the highly esteemed, superb native basketwork. All such imitation naturally adds specific overtones to the expression of forms, which one can only pick up if one is on the alert for them. And, of course, qualities of texture and colour will play a major part in evoking such associations. But it is worth mentioning that some pottery traditions may even, by a kind of 'refused association', claim for themselves qualities of 'robust sincerity' by standing out against an aristocratic or 'genteel' code of form practised around them by other craftsmen, which they feel to be foreign to the nature of their own craft (e.g. eighteenth-century Japan, twentieth-century Europe).

There are many forms which are, in a sense, more 'natural' to metalwork than to ceramics but which have been imitated in clay, often with great difficulty. In fact the makers of metal tablewares and of pottery share an important element of technique. For the throwing of pots on a rotating wheel is generically similar to the technique whereby circular metal shapes are made by pressing a tool against a disc of the metal as it spins on a lathe, using the natural ductility of gold, silver, or copper to impart a contour to it. However, the goldsmith and silversmith have a large number of other techniques natural to their craft which are not natural to clay. Since, for example, much of their work may be done by hammering their ductile sheet-metal over a shaped 'stake', they can easily produce forms which are not circular. They can make oval or rounded rectangular bowls, flutings, spiral facets, gadroons, or foliations. By cutting they can trim lobes and points on to the flanges, 'cresting' on to handles, lids and profiles; by drilling, piercing, and filing they can produce fretted work; they can granulate; by working with soldered strands they can weave open 'basket' forms; by hammering up and by chasing they can add freely-moving repoussé relief ornament; by chiselling they can incise deep

free-flowing designs; they can make far slenderer stems, broader bowls, and linear handles far longer and slimmer than are natural to soft clay. The effects of all these techniques have been adapted and imitated by potters in their more pliable material, even to openwork fretting, 'basketry', and applied relief 'badges' copied from repoussé jewellery work. It is certainly true that ceramics have sometimes exercised a reciprocal influence upon the forms of metal wares. But the value and status of gold and silver work have usually led the potters to imitate them, rather than the reverse. In fact, as in early eighteenth-century Germany and late eighteenth-century France, the sheer difficulty of imitating in clay craftwork not natural to it (or even working from models supplied by goldsmiths) has often gained for

Large Chinese jar of bronze form, in grey earthenware, with a greenish glaze. 3rd cent. A.D. There are even imitations of bronze ring-handles. *Barlow Collection, University of Sussex*

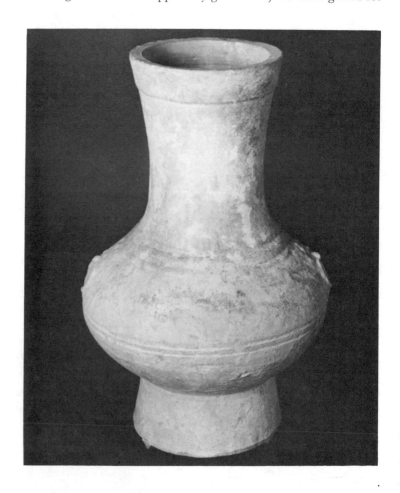

the potter a most unusual social esteem. The Vincennes-Sèvres factory, indeed, adapted its skills to numerous categories of object which originated in quite different crafts, such as cane and sword handles, clock-cases, thimbles, and telescopes.

Gold and silver are not the only metals whose shapes have been imitated in clay. In Han China, particularly, cast and turned bronze shapes (bronze cannot be spun) have been copied in clay, even contemporaneously, glazed with a copper oxide lead glaze resembling a bronze patina in colour. In China, of course, bronze was literally cash; so the element of value was again distinctly present. Later wares frequently imitate in archaizing styles the forms of the valuable and much collected early funerary bronzes. It seems probable, too, that in Greece of the sixth to fifth centuries B.C. many of the shapes

Glazed fretted bowl of Seljuq white earthenware. Rayy, Persia. 12th cent. *Durham University Oriental Museum*

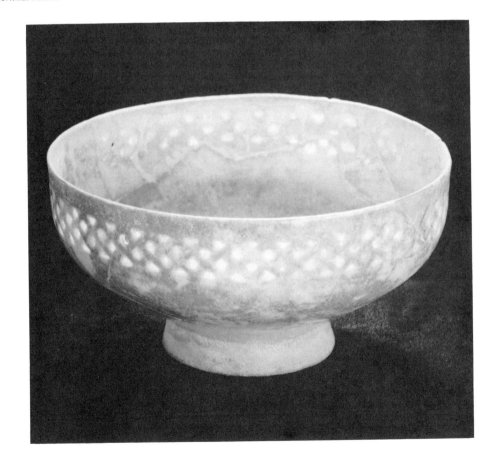

mallet-vase

bubble-vase

Fig. 12
Characteristic glass shapes

incorporated into the larger mixing vessels (krateroi), especially the thickened angular sections at foot and lip, were also derived from bronze-cast prototypes (so far as we can judge from the bronzes which survive, such as the Vix cauldron). Although here again it is impossible to be sure how much each craft owes to the other, bronze was a medium of cash exchange. Immensely common in metal wares the world over are, however, those typical bronze ring handles, often held in the mouths of animals, which were imitated on ceramic wares of all possible kinds.

Of the other particularly valued techniques whose forms have influenced ceramics, perhaps the most important is glass. The shapes naturally produced by glass technology are those based upon the malleable blown bubble with hollow or solid stalk. Glass bottles may be flattened, smooth-curved, squat-based ovals: these have been imitated in clay, stylized into the circular shapes natural to throwing. A glass bubble-vase or bottle may be marvered—rolled on a flat slab— which gives it a flattened cylindrical outer face and perhaps flanges; these special effects have also been imitated (e.g. Chinese celadon mallet shaped vases). Glass goblets are naturally and easily produced with solid or hollow stems and a spreading foot. Trailed strand-relief ornament is also natural to glass; and this technique has often been imitated in slip. And it is no accident that high techniques of glass enamelling and of enamel glazing on ceramics have often gone hand in hand (as in seventeenth-century Bohemia) since the two use fundamentally related technologies and virtually the same materials. Wedgwood's imitation in his Jasper reliefs of the late Classical 175 Portland vase in cameo-glass is a central, but not isolated, case.

Generally speaking we tend to feel nowadays that potters should not imitate shapes from alien crafts, that they should stick to doing what is 'natural' to the 'character' of the clay. But in practice the entire range of formal ideas prevalent in any civilization has usually been so much interfused, ideas intrinsic to particular crafts permeating others, that it would be virtually impossible as well as highly undesirable to disentangle and banish from a ceramic typology all 'foreign' forms—though some modern purists have tried. To begin with, it is more than probable that virtually every angled shoulder, sharp horizontal flange (e.g. a wide plate rim which would never stand up in wet clay), and applied moulded handle in ceramics is in some sense related to an original metal idea. And then there is the further important consideration that in any given culture certain

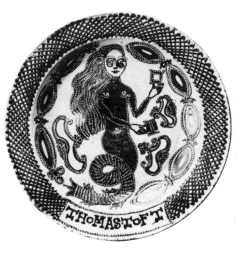

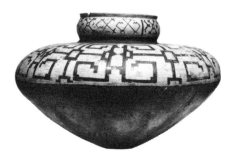

Dish, of English slipware, with raised design in thick slip. Made by the Toft family. Late 17th cent. Yellowish and reddish brown slip. *Victoria and Albert Museum, London: Crown copyright*

Colossal festival drink-jar, painted in red on white, from Iquitos, on the upper Amazon. Used for the preparation of drink or festivals. Entirely hand-modelled. *British Museum, London*

characteristic shapes tend to dominate formal thinking, probably acting as direct indicators of aesthetic value and published, perhaps, as a guide to taste appearing in all the different arts produced in that culture, from architecture and furnishings to figurative sculpture and textiles. For example, there can be no mistaking the special type of coniconian curve which appears both in Persian domes from the twelfth to the sixteenth century and, inverted, in ceramic bowls; the shell- and wave-curves of rocaille design condition eighteenth- 190 century European arts of all kinds; and the variable rectangle dominates the profiles of Maya pottery, as it does their other arts. More subtle and convincing parallels will be found by anyone who studies all the artistic manifestations of a particular culture in detail, and further parallels will be mentioned in later sections of this book.

CEREMONIAL There are ceremonial uses which influence ceramic forms; indeed they frequently provide a major incentive for potters to extend and expand their aesthetic aims. Most are related to social customs, and not all involve obvious display; some will be discussed later on. But a few general ones must be mentioned here, since they reflect fundamental attitudes to pottery, conditioning its types, and are embodied in its transformation images. First, and most general, are the two poles between which the attitudes towards serving food are strung out. At one extreme, in recent high-caste Hindu India, pottery food or water vessels may have been made expressly to be smashed and thrown away

after being used, or at least to be treated as mere utensils, principally for reasons connected with caste purity. This has meant that the potters have had no incentive to develop a ceramic type of food vessel embodying high aesthetic values. At the other extreme, we can read in Chinese literature of servants being severely flogged for breaking precious porcelain food vessels. Partly as a function of this latter attitude Western collections contain fine pieces which have been repaired in China with malleable gold along the breaks, thus subtly indicating the value of the piece, even when broken, and at the same time allowing the repair to contribute to our understanding of its inner structure and individual history. The former of these two attitudes reflects a preoccupation with caste purity directly related to food customs, which treats the vessels as dangerous, not just valueless. The latter reflects an attitude which regards a work of ceramic art as a high aesthetic treasure, but a treasure to *use*, which gave a special kind of aesthetic pleasure to the user. For the Chinese were much concerned with all the possible aspects of sensuous enhancement, as will soon be abundantly clear.

Between these two poles we can find a wide range of possible attitudes. Many of those which have produced lively ceramic traditions have generally regarded domestic ceramic wares as in some sense part of the family's 'public face'. Where domestic hospitality has fulfilled a major role in social ceremonial, the ceramics used have tended to aesthetic elaboration and ornament. In, for example, Classical Greek pottery the fact and symbol of the feast played a major role in the highest grade wares. The friable and splash-glazed tomb wares of the 17 Chinese T'ang dynasty, both containers and figures, were meant 30 expressly to create a vivid social impression, being carried through the streets in funeral processions which emphasized the social eminence of the deceased. The vessels were so fragile that they could only have been meant for spiritual use, beyond the grave. The Sung Imperial stonewares, on the other hand, must have played an important role in the ceremonies of hospitality; and some may have been used in family shrines. The admiration they received would have been reserved and centred on their modesty and subtlety. They would have been seen only in leisurely and attentive use. Ming and Ch'ing wares seem to have been made partly to create an environment of ceremonious courtly splendour. Large vases and ceramic fish-tanks were certainly 67 used to demonstrate domestic status within the privacy of the home, and the iconography of their decoration played a part in this.

Fig. 13
Humped bull libation jug; from Guilan Marlik, Iran, c. 1000 B.C. Earthenware. A compendium of conic forms, of varying sections

78

In Europe, after about 1450, within those extended households common in both peasant and bourgeois societies, into which relations and servants were integrated, the pottery used was kept on semipermanent display demonstrating the family's substance and playing an important role in promoting the family's inward and outward sense of identity and social status. The immense importance of ceramics in the aristocratic domestic context during the eighteenth century in Europe will be discussed more fully below (pp. 198ff.). It would, however, be wrong to suppose that relatively simple, undecorated ceramics like those made by many peoples in a broadly Neolithic or Bronze Age stage of civilization such as pre-dynastic Egypt, early Iran, India, Fiji, or the Transvaal, are devoid of socially ceremonial significance. Their makers and users—especially the 32 women—must have gained a strong sense of existential value and communication as they used and handled them in their own domestic settings, from the vivid tactile and shape expression many of them embody.

These aspects are ceremonial in a domestic sense. There are, however, many ceramics which are ceremonial in a strictly religious sense, and display their ceremonious nature in their actual forms. Again details will be discussed later; but here it must be mentioned that everyday potting has been adapted to make: in the first place, funerary paraphernalia such as six-legged coffins (prehistoric Southern Arabia); plain cremation jars (Neolithic Kansu in China) and cremation jars perhaps displaying a modelled image of the deceased (pre-Inca Peru); funeral 194 offering vessels (Jomon Japan): and in the second place, objects for use 7 in religious rituals such as jars for the storage of ritual objects in temples (Peru); vases for flower offerings on Buddhist altars, and wares for shrines (in the Far East); spouted libation ewers (in ancient Iran, India, Buddhist China, and Japan); and large ornate 80 jars in archaic forms as well as small libation cups or jugs for family altars (in Confucian China). All of these functions may affect the conception of the forms into which a vessel is shaped, and must be taken into account as a 'life use'. They may, in fact, be the cause of exaggerations of form corresponding visually to the ceremonious exaggerations of ritual behaviour (e.g. Cypriot funerary wares, third *Fig.* millennium B.C.).

We also find very often indeed, especially in Chinese Sung ceramics, that a form developed perhaps initially as a piece of religious ceremonial equipment, say a libation ewer, may be taken over into ordi-

g. 14

79

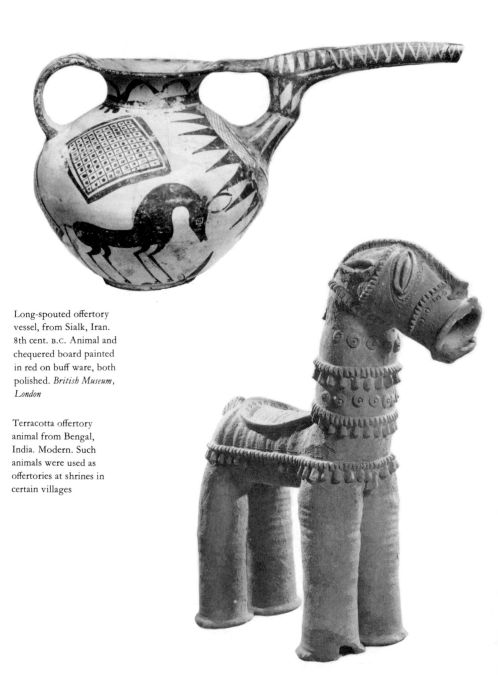

Long-spouted offertory
vessel, from Sialk, Iran.
8th cent. B.C. Animal and
chequered board painted
in red on buff ware, both
polished. *British Museum,
London*

Terracotta offertory
animal from Bengal,
India. Modern. Such
animals were used as
offertories at shrines in
certain villages

nary domestic use to decant, say in this case, rice wine. It is more than probable that the very custom of using flower vases in the home, with all its variations, while worked out mainly in the Chinese context, is actually descended from and authenticated by the custom of offering flowers at Buddhist and Christian altars during the early Middle Ages —fortified in Europe, perhaps, by the domestic use of posies of medicinal and apotropaic herbs. Essentially a vase is a water container with a neck narrow enough to prevent its flowers flopping. Certainly the early European representations of altar flowers (e.g. Hugo van der Goes's Portinari altarpiece, c. 1476) show them placed in pots of quite a general type, e.g. an albarello, but clearly objects of value. There are types of ceramic objects which have been made as implements for actual use in religious ceremonial, including icons themselves. These, naturally, will have a special, separate identity. Among these types are the little figure-pots used by women in certain African tribes to instruct female initiates in sexual mysteries; thrown and modelled pottery images of women with children, of horses and cattle used as offerings at Indian village shrines; pottery icons of deities, which in India, for example, may be ordinary pots adapted by ornamental painting or relief, or humanoid images made up of thrown assembled sections, which figuratively may 'contain' the divine essence; or, as in Catholic Italy, images for adoration which outwardly represent holy persons or saints, the best known being the glazed earthenware sculptures of the fifteenth- to sixteenth-century della Robbia family. This type gave rise ultimately to the 'independent' sculptural work of art, the ceramic object whose forms were not meant to be manipulated or to contain, but only to be seen as part of a significant environment, to confirm the patron in his sense of identity.

Some of these ceremonial objects will be handled and manipulated; some will be no more than symbolic tokens; others may be required to testify visually and at a distance to the splendour and significance of the ideas or persons they represent. By pious assimilation—and perhaps by secularization—memories, echoes, or versions of any of these ceremonial originals (and others) may appear in purely secular ceramic traditions. We must therefore be aware always of the possibility that vestiges of deep-laid religious feeling may belong to apparently secular or 'merely decorative' conventional designs in many ceramic traditions.

The tactile qualities of pottery have been mentioned several times. But it has not yet been made clear how these qualities can be structured into genuine ordered form, and how they can be judged aesthetically. Obviously, of course, it is not enough that a pot should bear a mass of tangible finger dints, dimples, and throwing striations for it to be 'good'. Plenty of messy amateur pots do; and mere roughness has often been used to hide poor shaping, which would be revealed by more precise handling. Structure implies intelligible 28 consistency, continuity, and relationship; it is not uncommon for a potter to throw on to a finished pot a lip well structured by a finger grip, but which he has allowed, in the throwing, to destroy the tactile continuity of the pot's neck and body. In the case of a well-structured pot, however, the appreciator's hand will be able to find and understand the whole sequence of grip patterns the potter used to make it, which will be continuous and consistent with each other, and relate the interior to the exterior. In a good shallow-thrown, soft-paste English blue and white cup, to take a simple example, one may dis- 60 cover the exact grip relationship of the thumb which shaped the wall on the interior and with its tip the angle-curve inside the foot, to the index finger which ran in throwing over the exterior. This is a single grip on a small pot. On a larger pot a sequence of such grips will have been used, which should make their organization tangible. In the case of a closed vase it may, of course, be impossible in practice to reach the interior with one's hand. An important expressive element in a pot which has detectable—even emphatic—striations on its surface will be the rhythm or interval-sequence to be felt between the striations. This should, of course, be alive. A good potter will automatically give such striations a metre which relates to the general proportions of the whole piece (see p. 117) and is not pointlessly even, or merely repetitive.

The mechanical action of the wheel in throwing is an immense help in creating grip continuities. For as the clay runs between the fingers the revolution automatically imparts the shape of that grip to the clay. So a single sequence of grips running from top to bottom vertically along one inner and one outer profile is sufficient to formulate every part of the pot, without leaving any 'dead' or unformulated surface. The linear inflections of the upward pulls and closing grips will have been given to the whole body of the pot. This explains why good hand-modelling or beating is far more difficult to do than good throwing— although amateurs usually start with thumb pots. For in a hand-

modelled pot every single reach of its surface has to be given inflection and continuity as an act of deliberate creation. Whereas the surface of a thrown pot may be described as the mechanical function of revolution of an unchanging line, the surface of a modelled pot can only be achieved as an invented sequence of continually changing lines. This means that in a modelled pot the transitions from one grip to another on horizontal circuits of the pot must be calculated as carefully as those on the vertical axis.

All these ingredients of touch-order may be found beautifully consummated in innumerable pots from humanity's 'primitive' peoples, 136 as well as among European plebeian wares and American eighteenth-century Pennsylvania red wares, which may seem at first sight somewhat drab and uniform to the casual museum visitor, and may not reveal their qualities through a photograph. One must also be prepared, however, to find both good and less good even in this sphere. As hinted above, one may also find—perhaps unexpectedly—beautiful touch-structures in hand-thrown or modelled pots made during the last few centuries in Europe—notably among the sixteenth- and seventeenth-century faiences of Italy, France, and Delft, and even, as mentioned, among late eighteenth-century soft-paste blue and white 181 wares from English factories. It is, unfortunately, impossible to point to any documentation which will prove that such a touch-order was consciously sought by European potters. We Europeans have been taught that it exists and should be looked for mainly by our education in what can be called for convenience the Japanese 'teaware' tradition,

Japan teaware. Tea-bowl, Shino ware, called 'Uno-hanagaki'. *c.* 17th cent. White glaze with red and blue spots. H. $3\frac{11}{16}$ in.

Meat-mould; English plebeian pottery. Recent. Entirely hand-formed. Exterior brown, interior grey-green glaze. This is an exceedingly tactile object

which we have so thoroughly assimilated into our current aesthetic of ceramics (and of many other arts).

The greatest of these tearwares were made between the fourteenth and seventeenth centuries, but many fine pieces are more recent. Originally the 'cult of tea' (Cha-no-yu) formed part of a conscious attempt on the part of the Japanese nobility and bourgeoisie to bypass and overcome the ceremonious paraphernalia of their highly status-conscious society in the interests of a specific religious and moral outlook. The monks of the Japanese Zen Buddhist sect, which was adopted virtually as a state cult by the military dictatorship in Japan during the thirteenth century, standardized their lives and customs upon patterns they learned in the Zen monasteries of Sung China, especially that at T'ien Mu on the southern coast. In the reception rooms of these Chinese monasteries simple but extremely beautiful peasant pottery was used, in accordance with the principles of Zen poverty and anti-formalism. This anti-formalism, with all its trappings, was adopted in Japan, and itself then formalized. The simplicity of the pottery was imitated (e.g. at Seto) and probably combined with a cult of direct and abrupt clay-modelling, of which we know little save that it was a sculptural parallel to the 'abrupt' style of calligraphy also practised in Zen monasteries (e.g. that of Sengai, d. 1812).

The tea-ceremony itself was, broadly speaking, a development from the ceremonial reception of visitors to the monastery. The pottery tea-bowls from which tea was drunk, the 'caddies' and flower vases used in reception rooms, came to be treated as direct vehicles of that spontaneity and mental illumination which was the aim of Zen life—especially the tea-bowls, which were often given 'personal'[83] names. For during prolonged meditative sipping, bowls were nursed in the cupped palms; and so they became a focus for tactile as well as visual contemplation. The language of directly modelled form could thus be used quite consciously and deliberately as a medium for communication between hand and hand among people sharing common interests and insights. It is true that many tearwares were in fact made initially on a wheel, while others were completely hand-modelled. But wheel-thrown pieces were frequently pinched, squeezed, or cut while still wet after throwing, so as to breach their symmetry and add fresh tactile and visual suggestions to their thrown shapes.

Tactile pottery came to be treated in Japan as a high art of profound dignity—which it never was in China, for all the beauty of the Chinese

wares—and major artists (e.g. Kenzan) as well as innumerable aesthetic amateurs adopted low-fired, coarse-bodied teaware as a primary medium of artistic expression. In fact this approach to pottery also involves by an act of self-conscious sophistication, the deliberate breaching of that almost universally accepted code of ceramic surface continuity described below (pp. 103ff.). Pots are given dimples, twists, kinks, and irregular finger striations which affront or negate the expected norms of finish. These irregularities probably depend largely for their effect upon the actual presence in the mind of the spectator of the norms which are to be negated; whereas the original Chinese Sung heavy wares reflected their own norms in a 87 positive way.

TACTILE TEXTURE The question of tactile texture involves many imponderables; but it is possible to discover a few general principles. Textures may be created by deliberate acts—e.g. cutting or rouletting—or be the result of the 7 nature of a material. The qualities of texture may appeal to sight as well as to our sense of touch if the texture scale is broad enough, especially when it is deliberately made. Tactile qualities can either be fortified by visual experience, or even inferred and experienced synaesthetically from sight alone. Texture, like shape, has its own symbolism, working on similar principles; and although the references of the symbolism are, on the whole, general and vague, there are surface treatments which can have fairly obvious and direct symbolic references; for example, bevelled criss-cross cutting may very forcefully suggest the skin of a pineapple.

Within any pot surface there are more or less hidden granulations or rugosities resulting from the working of chance. Individually these are not produced on purpose by the artist, though they may be intentionally contrived *en masse*. As well as these rhythms and 'infra-figurations' in texture, the hand may also be able to sense the density and physical hardness of the body structure, partly through a kind of resonance perceived through the skin, partly by its rate of heat absorption—whether it feels actually cold or warm. All these touch-experiences will have evocative qualities which work by appealing to buried memory-traces imprinted on the mind by past experience of analogous textures. And these latter will reinforce the effects of the other qualities a pot surface may have, such as its colour.

There seems to be a kind of scale of roughness which most people will recognize. At one end of it lies the very smooth surface on which

no granulation can be felt, and no unevennesses. Such a surface is tactually 'cold' and 'repellent'. It offers no stimulation to the touch, and seems dead. Plastics offer this sort of experience to the hand. A pot surface which approximates to this pole will convey a similar sensation; and if its colour be cold as well—a silvery white, say, or a glossy black—the pot will be given a kind of remoteness or emotional distance which may very well be incorporated into the potter's aesthetic intention, as it is, for example, in fine blanc-de-chine wares.

At the other end of the polarity lie very rough surfaces, full of irregular granulations and surface incidents of different sizes. If these are too emphatic, and so sharp-edged that they are actually painful against the skin, they can repel the touch more emphatically than any other surface. But normally such surfaces play little part in ceramic aesthetics; though occasional unglazed bases of a pot body opened with flint may show it; and a few younger potters convey aggression by means of such deliberately abrasive surfaces. But in practice the techniques of throwing under a hand which moves over the surface usually precludes such finishes; the potter's hand would be cut. It is, however, perfectly possible to produce a less extreme rough or rugous surface for aesthetic purposes, especially on hand-made pots, though also on thrown ones; in fact the finger spirals of throwing may even form an element in such a surface. But if, in addition, the surface is 'slick' enough from burnishing or glazing to allow the hand to slide easily over the roughnesses and experience them without impediment, or if the glaze itself has a texture of its own as Chinese aesthetics recognized that many fine glazes have, then the impression will be one of warmth and close interest. When these surface 'events' are purposely made interesting by the potter, with finger impressions, glaze pittings, globules, and a 'mobile' surface, as they were in many Japanese teawares, the aesthetic impression created by the surface seeming to move under the fingers can be very powerful. It invites the hand to intimate familiarity with the pot, *demanding* that it be picked up, and not merely looked at from a distance. Naturally, of course, the most extreme cases of this kind of surface development belong to pots made for people who used their hands quite consciously and deliberately to appreciate ceramics.

Within this scale there is, of course, a very wide variety of tactile possibilities among the surface finishes given by glazes. It is quite clear that many of the most sophisticated glaze techniques lie at the 'cold' end of the tactile spectrum. Practically all of the finest high-

Honan bowl, Sung dynasty (960–1279). Thick brownish black glaze with reddish petal design on buff body. *Durham University Oriental Museum*

fired, hard-paste porcelain of eighteenth- and nineteenth-century Europe—especially that made by casting or jiggering—has the air of 'don't touch' about it. It was, as we have seen, made primarily to be 134 looked at, and to create a visual impression of high style and good taste. As one comes down the social scale into the realm of hand-thrown and less high-fired glazes, one enters a region where the hand can still matter very much, especially where the life of the glaze enhances that of the pot surface, adding its own characteristic features without obscuring the body's. Most modern commercially manufactured tablewares, however, no matter how studiously they have been 'designed' with a view to visual *chic*, are through both form and glaze dead under the hand. It may well be that such slick pottery feels in actual fact physically colder because its rate of heat absorption from the skin of the hand is extremely high.

OTHER SENSE DIMENSIONS This distant impression can also seem very strong, at first sight, with some of the finest Yung-cheng and Chien-lung Chinese eighteenth-century porcelains. But we would be wrong to imagine that the cases are identical. There can be no doubt that a visual effect was actually one of the Ch'ing Chinese potter's chief aims—many of the surface designs are virtually pictures; and mechanical manufacture of some

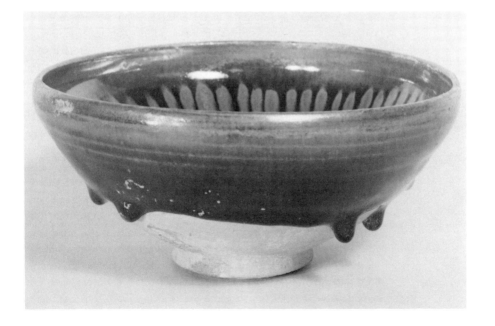

sort was used under the almost incredibly perfect glazes. But in China we must never forget that there are at least two other dimensions to fine porcelain which we in the West have never learned to perceive; in fact we can scarcely do so even when they are pointed out to us; for there is no recognized 'scale' in our minds to which we can refer our experience of them. But from many literary references we know that the Chinese perceived, judged, and relished these two other aspects of ceramic art.

First is the feel of the weight and body of the pot, with its glaze, in relation to its size. Here we know that vogues changed and what was sought for in one age may not have been sought in another. For example, the Sung connoisseur might like his pots to 'weigh'—and to feel—some like heavy jade (celadons, Chün) and others like lighter silver ware (Jing). Later the Ming might still prefer a pot to feel 'solid'. But by the eighteenth century there had begun that cult for utterly refined porcelains weighing very lightly for their size, which culminated in the famille rose, eggshell wares of the Yung-cheng and Chien-lung periods. Here the contrast between weight and size—achieved, of course, by turning and shaving—is extreme, and to the hand most pleasurable. Most of their enamels, though perfect in colour, are overglaze, and their thickness is apparent to the fingers; 58 whilst the pleasure felt in touching productions from human hands reaching almost an ultimate in dexterity is itself a valid mode of aesthetic experience. Medieval Persian pottery, again, may always feel to the hand as though the potter had created not so much a solid body as tangible surface, the inner skin closely related to the outer, the bulk being immaterial.

The second special dimension in Chinese porcelain is sound. Everyone knows that porcelain rings when touched. So, too, do jade and glass; and many people must have heard the tinkling chimes made even nowadays in Hong Kong. The Chinese *listen* to porcelain as intently as they feel it. Every piece has its own special notes, and a Chinese connoisseur would have been able to remember and classify the sounds of each piece of fine ware. Even today, during their prolonged parties, Chinese connoisseurs will enjoy the sound their rice-bowls give out when tapped with the chopsticks. It is not unreasonable to speculate that this interest in the sounds of pots was one of the incentives prompting the technical development in China of finer and finer vitrified glazed porcelains. This interest, however, has not travelled West with the techniques and types. Nowadays only

museum men and some dealers and collectors who handle pieces every day have developed even the most rudimentary sense of ceramic sound. It is impossible for the ordinary museum visitor to cultivate it at all; and many people may find it hard to believe in.

From the sheerly physical point of view ceramic sound is the consequence of the degree of fusing together which has taken place between the crystals composing body and glaze. This gives a ware the strength to stand up to use. But the shape of the pot also has a lot to do with it. And some Chinese pots were undoubtedly shaped partly with regard to their producing a fine, pure ring. These factors in the East help to counteract the tactual 'coldness' of too perfect a surface. In the West we are not so lucky, nor so personally cultivated, as to be able to listen to porcelain with understanding. But many people interested in pottery do have a developed sense of weight and size. Probably the majority favour a good solid, well-sintered feel; and some people are able to detect even a perfectly repaired piece from its feel. As far as glaze quality is concerned most pottery with which Westerners are likely to be familiar, even including Chinese pottery, has a fairly slick glaze. But there are quite a few sophisticated Western wares whose glazes do depart from the cold end of the tactile spectrum; and this is part of their charm.

Moving away from the 'cooler' end, first come many of the English eighteenth-century low-fired, soft-paste wares (e.g. Leeds pottery). 60 Here the glaze and body can convey an unusually soft and 'warm' impression. To this may be added a note of brittleness with the low-fired faiences, such as those of Rouen in the earlier eighteenth century. On these the glaze may have a very characteristic mobile 'orange peel' texture which gives a special impression of life under the hand. Further along the scale of 'warmth' are the slipwares of many different types, especially those of peasant origin, whose surfaces, though partly fused, nevertheless offer to the hand an interesting and stimulating tactile experience.

Wares which are not glazed, nor even slipped, but perhaps only burnished or slurry-washed, have quite another feel. Their body substance constitutes their surface. This circumstance may have overtones of 'unpretentiousness', the 'truth' of the pot not being covered over and given a veneer of 'proper finish' (though this unpretentiousness may even be itself pretentious, as in the sophisticated Wedgwood red and basaltes wares). Instead the pot body is made to declare itself through its own process of making. To the hand such a

body is almost always warm; though the extremely fine washing of clays used, for example, in Assyrian or the most sophisticated Roman terra sigillata, may even give to pottery with an exposed body some inclination towards cooler distance.

Now although the qualities just discussed are ones which appeal directly to the hand, there can be no doubt at all that the trained and experienced eye is able, to some extent, to grasp them, and refer them back through a synaesthetic faculty to past tactile experiences which were associated with comparable *visual* textures. This is a most important principle, because it helps to illuminate the ways in which our visual experience of ceramics can be built up. It is true that there is no substitute for tactile experience of pots. But it is also true that in our visual experience of pots there may yet be a powerful ingredient of tactile memory transferred across the boundaries of the senses. It is such compound visual experience that will be particularly affected by the other visual properties of the pot which combine intimately with, and qualify, our tactile memories; it can even affect our direct tactile experience by a kind of feedback.

In the first place there will be visual memory-traces of things other than pots. Many ceramic traditions, especially those with a highly evolved conscious aesthetic of pottery, such as Japanese teawares, will [83] deliberately involve, through visual similarities as well as touch-forms, [99] our tactile experience-traces of such other phenomena as mossy stones [60] or bits of tree-branch with loose bark. From the influence of Japanese example this is now a very common practice among modern artist-potters. And recently the additional evoked phenomena have often come to be the harsh or tactually 'cold' industrial objects character-istic of modern city life such as power insulators or gigantic concrete cooling towers. Metaphors, of course, as we shall see, must work primarily through the shapes of the pot, combined usually with that most powerful mode of emotive operation, colour.

This whole question of the intimate relationship that pottery shape and surface have to the hand has one other profoundly important aspect. By emphasizing the functional connection between hand and form it can provide a bridge to understanding a fundamental, but subtle and barely describable element in the expression of the visual qualities of pots. For these, in an allusive and metaphorical but quite definite way, refer to their experience-traces of moving hand gestures and their meanings. Many bowls, to take the most obvious example, are in effect three-dimensional projections of the cupped hands

making gestures symbolic of receiving and/or giving. The shapes of larger vessels, or of elaborated handles, may have an underlying kinetic suggestion of particular ceremonious hand gestures. The ana- 120 logical significance of those may well strike very deep roots into our experience of humanity's 'silent languages'. About this more will be *Fig.* said later. *32,* 125

VISUAL SHAPE The visual shapes of vessels embody what are perhaps the most important aspects of ceramics; and they are those which need to be most comprehensively illustrated. For the sake of explaining the characteristics of ceramic shapes, we shall have to resort to flat diagrams; but these do violence to the nature of pottery, which is essentially three-dimensional. For illustrative purposes we shall need to use, for example, vertical sections through pot bodies. The reason why such a section can be quite a faithful index of certain essential characteristics of a pot which has been thrown on the wheel is that thrown ware, as we have seen, is virtually a simple function of revolution of two unchanging lines, an outer and an inner contour. The really important point to be remembered, though, is that when one actually looks at most pots from the distance at which one normally uses them i.e. close to—one is always naturally aware of the object's *roundness* as well as its linear section. The two are, in good work, mutually and functionally interrelated. Even if one only looks at a pot without handling it, from about ten feet away, either the foot or lip, or both, which are in fact rounded in section, are bound to present themselves in some degree of plan-aspect.

Fig. 15

 At the same time, since most pots are experienced in use, have been turned this way and that, and seen from many different angles, they have needed to 'work' aesthetically as complete three-dimensional entities. Throughout most of human history they have been felt to inhabit the same world that we as men do, to sit beside us within the reach of our arms. And this total three-dimensional familiarity which pots demand is the prime justification for a most important criterion of form discussed later (pp. 103ff.). The truth is that, even when they have been regarded as visually remote 'treasure', during that recent and persisting Western cultural episode discussed above, good pots have never really been meant to retreat into that same 'symbolic distance' from the observer in which works of other arts have always belonged, represented by the picture-frame or isolating pedestal. In practice many of the finest pots of the world, those especially which

91

depend upon tactile rather than visual qualities, may look far less impressive in photographs than inferior works which have declamatory profiles.

Too extreme an accent on pure profile, implying that a pot belongs at eye level, outside the reach of hands, perhaps even beyond the reach of binocular parallax (some 13 feet) where objects lose their immediately perceived three-dimensional value, may introduce hardness and existential falsity into ceramic styles, along with the desired visual elegance. It may also make the work look impressive in an illustration. The finest eighteenth-century wares, both Eastern and Western, even if their profiles are developed, usually succeed in retaining their true three-dimensional presence in immediate personal space. This is less often so with many twentieth-century self-consciously 'artistic' pieces of potting, either hand-made or artist-designed and then machine-made. A point, therefore, that must always be remembered here is that the profile diagrams used in the discussion which follows are only abstractions of certain aspects of pots for the purpose of explanation. They are not in any sense intended to be either prescriptions or adequate representations of the full plastic presence of the suggestive concrete object which every pot must be. They may, though, aid ceramic thought.

MORPHOLOGY Pots as containers show among themselves a kind of typological kinship, a structure of relations based upon primary variation, which even the most sophisticated traditions share in. This structure of types is a constant factor in the aesthetic of ceramics. It is partly a natural consequence of that interrelationship between hand, material, and intended function which is the foundation of the transformation image reflected in the techniques described above. If one applies a version of the old biological maxim that 'ontogeny recapitulates phylogeny', one may find that some type-modifications represented here correspond, more or less, with the usually accepted stages through which individual pots are taken during their physical shaping by hand, or on the wheel. The more elaborate pots, those which are taken through a larger number of truly distinct stages in the making, are, of course, by no means necessarily the most sophisticated aesthetically.

This structure of relations may also have in some sense an evolutionary value, as different traditions have developed distinctive variations at different points in the typological chain, or in chrono-

Fig. 31, 124 (margin note)

logical and typological order. Some have ventured further from the primal root-forms than others. Some traditions have either confined themselves or reverted consciously to the primal, less elaborate shapes. Thus the posture of any given pot-form within this scheme in relation to the history of its tradition will play a considerable part in deciding its aesthetic effect. We may recognize that one pot is a splendidly form-invested version of a primal type; another a combination of two types taken in a specific direction; another a pretentiously complex variant uncertain of its roots, weak in inflection and lost in superficial imitation. One of the characteristics of all good pots, however, is that they are well defined both by their typological status and by the definiteness and clear characterization of their forms. As shaped entities they are specific and definite, not general and ambiguous.

Figure 16 gives a summary of such a typological structure of 94-5 relationship, which divides the general categories of shape as a preliminary to detailed discussion of the inflections which govern aesthetic expression. Its function is to suggest the kinds of kinship and variation which can be actualized in ceramic art; it does not claim to be complete or even truly comprehensive. It shows one fundamental aspect of transformation at work, as well as the logical lines which modifications, combinations, and variations have followed, and may yet follow. The diagram, which is itself bound to be abstract and general, cannot take proper account of all those various ways that have been suggested previously in which forms from other arts have influenced ceramics. Nor can it take account of variants which are not round in section, but may be, for example, square dishes or segmented trays. 120

The 'ur-pot', or primal form, is a lump of clay with a hole in it, pinched out into a rudimentary container. From this shape the first two directions of development are towards the 'jar' and the 'open basin'; by pulling up, or by opening out, while still preserving the container shape. This division corresponds with the normal ceramic distinction between hollow and flat wares. The jar type will fall into one of three further possible sub-divisions according to the potter's line of thought. The first line from the generic jar is perhaps the most important and fruitful of all. It has, perhaps, fewest functional possibilities, mainly because of size, along the upper row of rounded jars whose generic function is either quantity and/or long-term storage, maybe for later distribution. This type has sub-functions, which include preserving funerary remains and acting as water cisterns in hot countries. It is the smaller rounded jar from which a vast number

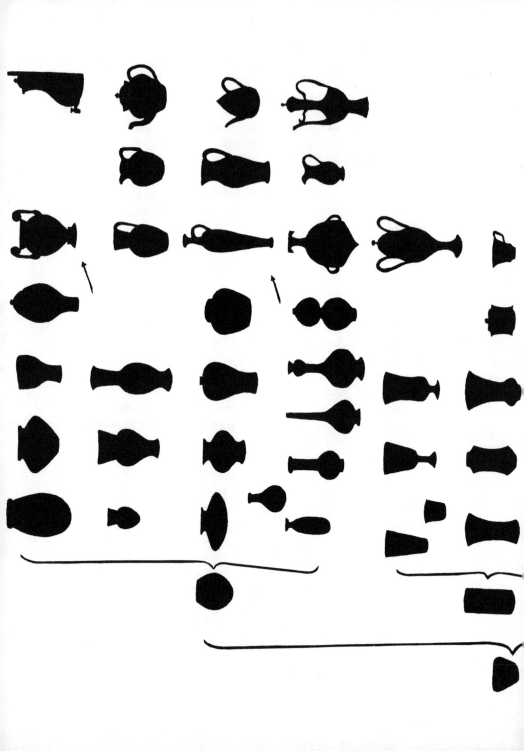

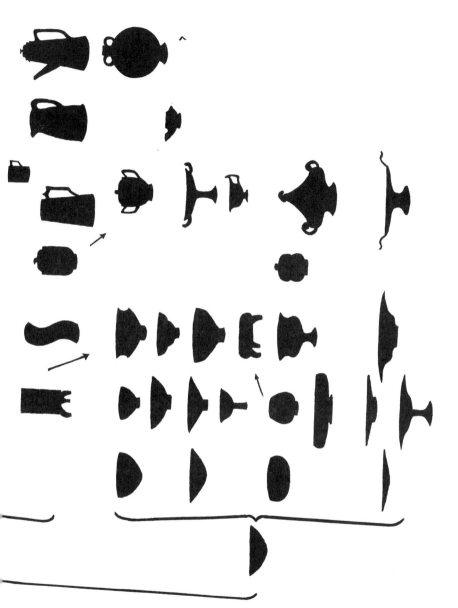

Fig. 16 Table of examples of morphological relationship reflecting patterns of thought (to be read vertically and horizontally)

of humanity's ceramic types are derived by combination and development of different special attributes such as necks, pedestals, and handles, which will be discussed in more detail on pp. 115ff. A multitude of vases, jugs, teapots, and ewers, whose expression may have been drastically modified by the addition of extra elements of form, may at first sight be difficult to recognize as the basically small rounded jars, that they are. The second line is the cylinder, which may seem somewhat arbitrarily separated from the jar, since so many modern jars are, in fact, thrown on the wheel from a preliminary cylinder. But the truth is that a preliminary cylinder is, practically speaking, an unnecessarily pedantic interpolation into the throwing procedure; earlier or primitive potters have always been quite prepared to throw their small jars direct from an opened clay lump. A cylinder is a special characteristic form with its own structural consequences. And it is often possible to recognize jars which have, in fact, been thrown by opening out the belly of an initial cylinder from a conformity of size and attitude between their foot and neck. Closing up the top of a jar of any type may produce further special vessels with shoulders, e.g. bottles or flower vases. The closing must, of course, be

Chinese wine-ewer, pale blue ch'ing p'ai glaze. 13th–14th cent. *Barlow Collection, University of Sussex*

Peruvian aryballos, Inca. Late post-Classical. Painted in white, red, brown, and black. This was meant for carrying as a water-jar, with a rope. *Kemper Collection*

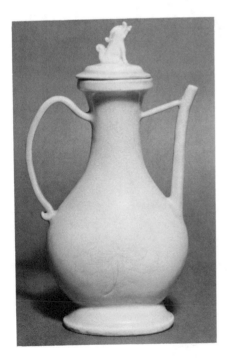

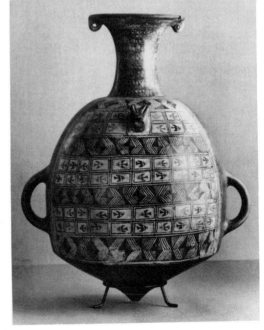

done in a way consistent with the overall design of the vessel; and it may be taken to almost any degree; so that the proportional relationships between the closure, the belly, and the foot produce their own special spectrum of formal suggestion, ranging from the wide conical closure at the shoulder of an Italian, Persian, or Spanish drug-jar to the tiny necked hole in the swelling shoulder of a Chinese mei-ping vase. The addition of a long neck, a special lip, a lid, handles, or a spout to either the small rounded or cylindrical jar can further radically modify the expression of any of these developed shapes.

The open basin, the third derivation, can be taken in two principal directions: first, towards that pattern of the open bowl or smaller cup enormously common among primitive peoples and in Eastern countries, which will contain food, maybe swimming in a liquid, without spilling, while the vessel is held in the hands. Such bowls continue in use to the present day; and, of course, closed with lids they have uses as serving dishes, tureens, etc., in Western countries. Handleless in the East or handled in Europe the small ones may become teacups. The second line followed by the open basin is towards either the flat plate and charger, or the open dish or tray. The plate, especially that with the flanged lip characteristic of modern Europe, probably belongs to cultures which eat off tables; for they really need to be kept steady in use. Trays or open dishes, on the other hand, are typical serving or offering vessels, e.g. for sweets, cakes, or pickles; many have raised rims. Whereas the open charger may carry solid food, such as joints of meat, the edges of some flat dishes may be slightly closed over so that they will contain wet food while it is lifted and carried. Pairs of open dishes may be luted to face each other and given a bottle-neck, thus becoming the 'pilgrim bottle'; hard-fired, inverted with added knobs, dishes may serve as lids; or adapted to each other in pairs may make ceramic 'toilet boxes'.

Of the various possible modifications and additions to this range of ceramic types the most important are themselves virtually types, although they do not usually exist on their own. The first, the pedestal, is made to give height, and hence dignity, to a variety of the other primary shapes, including jars, open basins, and cups, as in the Chinese stem-cup and the Classical Greek kylix. Many elaborate display-jars having them, perhaps with decorative lids and handles as well, own to no obvious function save perhaps as elements in furnishing garnitures (e.g. Italian Deruta and Dutch Delft faiences). Some candlesticks may seem like almost pure pedestals. But occasionally, in

archaeological contexts (ancient Middle East and India), pedestals, high and low, may turn up as separate objects to be used like the more primitive rings to support round-bottomed bowls which otherwise would not stand level. This may suggest that the pedestal has an original independence as a type which has become, for natural convenience, indelibly combined into all pots, and identified with the various forms of foot.

Long narrow necks, either separately made and luted on or thrown in one piece with the pot, are usually associated exclusively with water- or wine-drinking vessels. Only liquid, of course, will go in and out. They make drinking or pouring into a cup from a full jar of closed shape easy; Persian miniatures from the sixteenth century illustrate them in action. The spouts of tea, coffee, and wine pots are functionally related to the long neck, in this sense. It is also probable that the ritual flower vase is a natural descendant of the domestic water container or drink-serving vessel. Lids are an obvious necessity to keep out dust and insects from an open jar. But handles are in a different category. Obviously they are meant for lifting the basic jar; and simple strap-handles meant for just that are very common indeed. But they nearly always develop into a major expressive element in any pottery tradition. Their gestures, proportions, and decorative additions, such as volutes, play a major part in transforming in different ways the basic jars of many different traditions into expressive objects.

Multiple feet are not very common. They are usually added to primitive pots as an aid to cooking over a fire. A clay tripod at the base will keep a pot steady on the ground while twigs burn beneath it. There may well be vestiges of such functional feet retained in more sophisticated traditions. But multiple feet in these contexts are usually based upon imitations of other things—holy reliquaries or furniture, for example (e.g. the vogue for Pompeian feet in late eighteenth-century Europe); and they definitely have honorific overtones, as they keep the vessel from direct contact with 'defiled' surfaces of the everyday environment. Some special Chinese (and Japanese) overtones of such feet, assimilated as a merely honorific form into many Western ceramics, may spring from the Chinese reverence for their own past. For some early Han funerary wares buried with the dead, and long collected in China, represent model cylindrical granaries raised on triangular stub-feet from the ground— as Chinese granaries were (to allow air to circulate beneath so that the grain did not rot). Other ancient, much revered metal wares in China

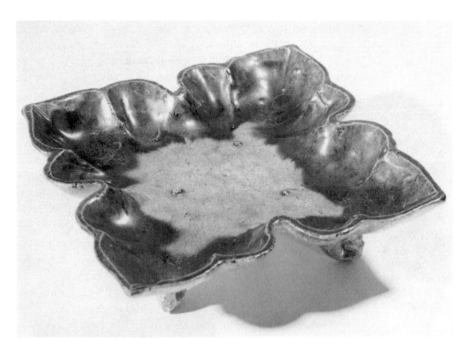

also had honorific feet, either solid stumps or with curved contour; but the triangular feet found on Ming water-jars, for example, and on Cantonese cylindrical jars may hark back primarily to the funerary granaries.

Among the many other modifications of basic shape used in ceramics the three most important are: foliation of the lip, halving, and cresting. The simplest form of lip foliation (done wet) is the jug lip, shaped usually with thumb and fingers. But occasionally (e.g. in T'ang China, seventeenth-century Japan, and eighteenth-century Europe) multiple pulled and pinched foliation was carried out to give superb flower-like elaborations at the rims of jars, vases, dishes, and plates. Vertically halved pots, luted to a flat back and given a bung or tap low down, were used especially as wall cisterns in hot lands. Nowadays cut pots are often used either to decorate other pots or to make wall plaques. Cresting, finally, which is usually cut or pinched out of wet clay, may be added to handles (e.g. Hispano-Moresque), i lips (e.g. Japanese Jomon wares), or the backs of cisterns (Italian faiences, Japanese Imari). It is, of course, intended to give a declamatory air, to display somewhat aggressively the 'virtue' of the pot and its owner. This expression may have at least some roots in those

biological signalling mechanisms which human beings both experience in themselves, enhancing them with feathers, enlarged eyes, hats, and so on (also used in many primitive masks), as well as recognizing them perhaps unconsciously in the animals and birds they observe around them.

BODY IMAGES From all this it will be obvious that container pots are normally felt to consist of a number of fundamental parts. The way that these parts are related to each other, the proportions they are given, their scale in relation to the human being and his hands, and the relation of one part to the others constitute a major element in ceramic expression. And it is no accident that we, as well as other peoples, have always used anthropomorphic terms to designate these different parts of the pot, which is seen to be, in some sense, a symbolic analogue of the human body. There is thus a powerful element of somatic suggestion in the proportions and relations between the parts of pots, which can only be felt, not really described. Only rarely do pots have heads (e.g. tenth-century Chinese and Persian 'chicken' ewers). But they all have 'lips'. And this term ('*labia*' in Latin) defining two orifices symbolically connected with those of pots, is most significant in view of the general female quality suggested below for container wares.

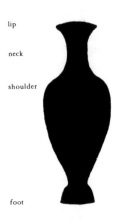

lip

neck

shoulder

foot

The main parts of the pot are usually described thus: 'belly' for the main bulk container; 'foot' for the supporting element, either a mere ring or a high pedestal, 'stem' if it is long and narrow; 'shoulder' for the point at which a shape turns over at the closure; 'neck' for a developed form giving on to the interior; 'lip' for the shape which encircles the rim. Flower vases may seem to lack a specifically developed lip, its place perhaps being meant to be filled by the blossom.

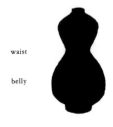

waist

belly

Fig. 17

Among all these different parts the varieties of possible expression are virtually infinite. It may be objected, however, that it should be possible to make pots which elude altogether the general categories of shape here discussed. Of course, it is not legitimate dogmatically to deny this. But it seems that human beings in exercising their analogizing faculty on the world around them inevitably project as analogue-form into ceramic objects a body image. The consequences of doing this with a food container which distinguishes itself as an 'individual' object from the tissue of reality, standing erect on a vertical axis very much as a human being does, are important. To begin with, it may be seen as female.

About the female element in the somatic reference of pots it is probably wisest to speculate modestly, since it is impossible to be too emphatic. Some people may prefer to ignore it. To those, however, who are accustomed to reading symbolic languages it will at once seem to be especially relevant; and if it is borne in mind during much of what follows, it may well help to bring out an otherwise hidden aesthetic dimension to the meanings of ceramics.

There can be little doubt that many traditions have felt a close metaphorical relationship between their pottery—especially certain particular shapes—and various functions of the feminine which that culture recognizes. Woman as nourisher has usually been her family's cook and food transformer. Both she and the family have thus tended to identify her vessels with herself. As well, more important, certain pottery shapes can have a specific bodily reference because they closely resemble the images of ideal shapes—sometimes images represented in the other arts—which a people entertain for parts of the feminine body, including especially the torso, the uterus with vagina, and the breast. In addition, the general shapes which fashion attributes to the female body as a whole, with its prescribed outlines, can sometimes be found reflected quite faithfully in the shapes of pots, e.g. mid-Victorian teapots. This kind of parallelism of shape may seem strange, perhaps, when it is applied in this direction, reading, as it were, from the pots to their feminine metaphorical attributes. Reading in the other direction, however, from the symbolization in human fantasy of different feminine attributes by pots the phenomenon is widely familiar in psychological and poetic literature.[1]

The fact that pots have overtones of 'the container', 'the receptive' (in China one of the names of the Yin), 'the generous', of the maternal and feminine in general, must play an important part in determining the attitude of the spectator to them. More, perhaps, than with any other art will the actual sexual and culturally endorsed erotic attitudes of the spectator condition his or her approach to a pot. Whereas a woman may identify, a man will appreciate; and according to his social milieu and conventional attitudes a spectator will follow the implications of this feminine projection, a woman being aware most vividly of the symbolism of what she both wishes and feels herself to be, a man of the suggestions of what it is he appreciates in women, ranging from the robust physical individual with a long ringed neck favoured by

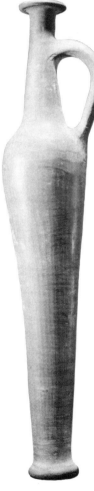

Lustrous red ware spindle bottle, from Egypt. *c.* 1500 B.C. of a Syrian type. *Durham University Oriental Museum*

[1] Cf. Esther M. Harding, *Psychic Energy, Its Source and Goal*, London, 1959, p. 127.

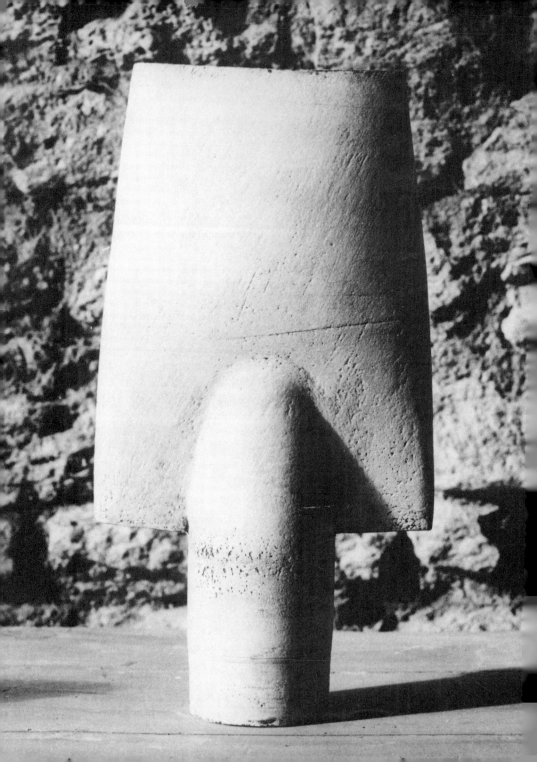

African communities to the delicately painted lightly bulging flower-girl of the courtly Chinese.

These illustrations are, of course, extreme. And when the matter is stated in these terms it loses its subtlety and its artistic validity. For, of course, the appreciation of pottery is not the same as the appreciation of women. If a work is to be artistic, its symbolic references have to be left open as suggestions; the circuit of meaning must not be closed into a direct identification. On the other hand this particular aspect of pottery opens up one of the avenues along which the significance and suggestiveness of ceramic form must be explored; as well as shape-metaphors, the metaphors conveyed by many of the common decora- 190 tive attributes such as foliated mouths, flowers, and ribbons, may be 32 seen in this light. Even the fact that in India, for example, a pot may be used inverted as 'container' for the spirit of a masculine deity can be seen as derived from the 'embodying' female function.

From this implicit femininity one may speculate in many directions. Possibilities which would seem far-fetched if they were stated explicitly are bound to spring to the reader's mind as he goes further in the book.

THE EXPRESSION One fundamental formal criterion seems to be the key to ceramic shape
ᴏꜰ CERAMIC SHAPE —invention. In this criterion can be seen most clearly embodied an essential prerequisite for all developed plastic thought.

One of the necessities of any wheel-thrown ceramic is the circle, given its sections by the rotation of the clay about the vertical axis of the wheel, which varies only in size. The axis of this circle is the invisible constant factor to which all a pot's inflections relate in one way or another; it may be high or low; the pot may depart wide from it, or hug it closely; the shape may swing wide here, close in there; the possibilities are endless. But whereas the axis is invisible, the circular section is extremely visible; it is, as it were, the concrete factor of shape with which the wheel-potter always begins. And the shapes he then evolves, whose inner and outer surfaces are each the 'function of revolution' of a contour, all have a morphological continuity with the circle. Compositionally actual pots are usually complex; that is, they are compounded of a number of distinct formal units. The nature of the single formal unit can be seen more easily than it can be defined. The experiment suggested below will help to clarify its character, Fig. 19, but it will, of course, need to be conducted on an actual pot whose 105 structure may well contain additional units, such as developed lips and

main
unit
of
form

g. 18

foot rings, which may impede it slightly. For the purpose of explanation it will be as well first to consider this individual unit of form.

It is no accident that the main bulk of far the greater number of pots is convex. The qualities of the purely convex ceramic formal unit are the most important, and they are the ones that can be most clearly demonstrated. (Other kinds of unit will be mentioned later.) But since they are purely plastic and have not previously been described in words, only transmitted by direct demonstration from potter to potter, the following description is bound to seem somewhat abstract. The point, however, is that it should help people who have not had the benefit of practical demonstration by a first-class potter to work out for themselves the basis of ceramic quality.

Each formal unit going to make up a whole pot can be interpreted as a pair of opposed contours, seen in elevation, which contain between them a cell of space. The convex unit, which is here taken as the principal type, seems always, in the major traditions, to have been given contours so shaped that the solid form they produce in clay, around the pot's axis of revolution, is continuously convex in all directions. At whatever angle a section is taken across it, its contours will be convex; this means that any line traced on its actual surface will move not in two dimensions only, but always in three. This is the factor that characterizes the formal invention of true three-dimensional arts, which all have an obligation to make themselves as three-dimensional as they can, as against the two-dimensional. 'Razor-edge' shoulders or break-backs, of course, may very well punctuate the unit-forms of actual pots, but they will be clearly integrated into the total convexity of the form. The basic shapes of the bulk of the most beautiful pots of the major traditions will be found to retain their total convexity even across such breaks. The confirmatory experiment is as *Fig. 19,* follows. A good pot is held in the hands and rotated away from the 105 eyes around an axis parallel with that across one's shoulders. The upper and lower exterior contours of the leading convex form will then be seen to pass continuously through different, totally convex cross-sections of the form-unit into the circle of the plan-section, without any break in continuity.

Obviously the most perfect example of this in practice would be a sphere. And to explain the special virtue of the good potter's thinking it may be necessary for a moment to appear dogmatic. Since the throwing-circle is a constant, endlessly repeated element in all thrown pots one must look elsewhere for the special factor which gives 'life' or

'expression' even to the single unit of a good pot (leaving out of account for the moment the qualities of the overall complex composition of elaborated pots). It seems to be this: that the potter seeks to make the vertical contours of each of his units depart as far and as subtly as possible from the arc of the circle which characterizes the horizontal section. (The images which inspire such plastic invention will be discussed later.) This means that the object becomes a complex three-dimensional entity, offering subtly changing curves as the angle at which its surface is seen varies.

Variety within unity seems to be virtually a universal criterion of quality in the arts. This also suggests why good pottery does not often use unit-forms whose contours are rigid straight lines, such as cylinders or cones. Certainly some generally cylindrical or conic forms do appear, but their vertical contours are very rarely anything like geometrically straight. True cylinders and cones lack the non-prescriptive variety that a live three-dimensional circular shape can be given by subtly inflected contours. This also seems to explain why vertical contours which approach arcs of circles—a common fault among amateurs, students, and modern potters—have no interest; they contain no development and offer no three-dimensional variety. It also helps to account for part of the charm of complex surfaces designed for purely practical reasons with complex curves, such as those of heavy electrical insulators. But the truth is that only the progressive curves which appear in the pots and diagrams illustrated in these pages, and not all curves by any means, can create true plastic forms.

These are the characteristics of the convex unit of form. But many pots have sections whose vertical contours are concave. Some trumpet vases may even be concave-contoured from top to bottom (e.g. Chinese, eighteenth-century wares imitating the form of the ancient bronze *ku*). The plastic unity of concave forms, however, does follow similar principles, in that it is a kind of topological inversion of the convex, and depends upon vertical contour-curves which are

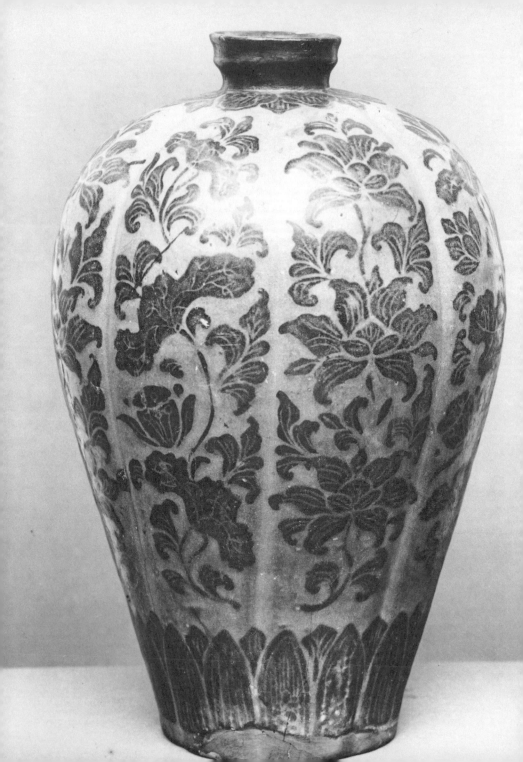

addorsed (back-to-back) versions of progressive curves which, facing each other would produce sound convexities. Usually, however, the concave form-units have been felt appropriate rather to such features as pedestals and necks than to the main container. They have thus been subordinate to the major convex units of form, and may be so largely conditioned by a need to articulate the more important convexities that they have little independence. Thoroughly thought out dominant concave-contoured forms, however, also seem to avoid in principle the straight line even in the sections of their diagonal directions. Although the 'total three-dimensionality' here described is limited in pottery by the constant circularity of the section, in sculpture—especially ceramic sculpture—the great practitioners have developed their own complex surfaces from units of form whose sections were not circular but variable, though still three-dimensional across all their sections, without flat or dead spots, and again with convexities vastly predominating.

This discussion has so far concentrated on the exteriors of pots. Interiors of both open jars and hollow ware offer the same criteria from a different aspect. The interior of a convex unit of form presents a concavity whose inflection in every direction is also totally three-dimensional. Splendid cases of topological inversion can appear, however, on the interiors of forms whose exterior vertical contours resemble concave variations on the trumpet-bell. A most interesting and important factor with some pots is a studied lack of congruence between exterior and interior forms. This, of course, is only possible with heavy-bodied wares whose walls are thick enough to accommodate these disparities. Usually the exterior is the dominant form with jars, and the interior with hollow wares. But in many good pots the two need not by any means be mere repetitions of each other.

It was mentioned above that not all curves can make good ceramic shapes. The qualities of the curve composing the opposed contours of a good convex form follow one very simple principle, which is not always—though it is sometimes—recognized by well known modern potters. It is that the curves are always related by width and inflection across the axis so as to close across any gaps into an intelligible single, completely convex form. In the case of generic jars this form will more or less complete itself across the top contours, from shoulder to shoulder. A lid may define a closure completely. In the case of open wares the forms (there may well be more than one) will complete themselves across the underside, leaving the upper side open to

Fig. 22

'receive' and 'offer'. In some of the finest Classical Greek jars, for example, the major convex units always complete themselves within the space occupied by the whole pot. All this means that the most important parts of the opposed curves, in one sense, are the progressively inward-turning upper and/or lower ends. The Classical Greeks and the medieval Koreans have handled the curve-ends with particular mastery. Modern potters are far too often unaware of their importance. To neglect them leads to flabby forms. Specially significant forms may result when opposed contours meet at angles at the Fig. 23, join, or suggest that they curve inward on themselves before they 110 meet. The different ways in which such forms may be cut or continued into other forms, is one of the chief resources of ceramic expression.

It was said above that the volume of a unit may be consummated within the volume occupied by a whole jar-type pot. When this is the case it is one of the factors creating a special unity within a pot. Some generic jars, however, create special effects with their main volumes Fig. 23, by cutting the formal unit off emphatically at either the bottom or the 110 top. In many jars the bottom is cut off into a flat base, which gives a special stable squatting effect to the pot. It is, however, a natural part of the expression of the open wares that they are formally incomplete at their open tops, inviting completion by what is placed in or on them. Fig. 24, A special characteristic of concave-contoured forms, of course, is that 111 they cannot produce this strong limiting and containing unity: and that is why they rarely give their primary shape to container jars. Those pots which consist essentially of one or two concave-profiled Fig. 24, forms have a clear suggestion of infinity and of refusal to limit the 111 reference of their contents. This may be one reason why such shapes are especially popular among younger potters today, and why a lid for such a form is in some sense an anomaly. But some classic types, such as the drug-jar (albarello), may have concave profiles, which are 109 emphatically closed at top and bottom by convex pseudo-conic neck and base.

Generally speaking, the metaphorical suggestiveness of ceramic shapes works in the first place through the unit-forms of which a pot is composed. When it evokes memory-traces, both visually and in the hand, for example of gourd, breast, or (with concave profiles) of a power-station cooling tower, it is usually the single units of form which convey this suggestion by the subtle inflection of their curves. The analogue of one formal experience to another (e.g. fruit to pot 132 belly) operates best one-to-one. This means that compound pots,

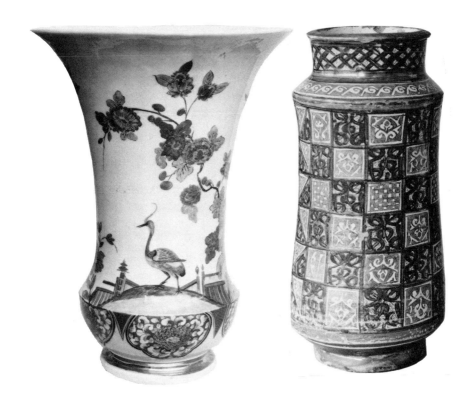

Meissen vase, made at August the Strong's factory in 1735. Painted in enamels in an imitation of the Japanese Kakiemon Arita style. *British Museum, London*

Drug-jar of Hispano-Moresque ware. Valencia, 15th cent. Blue glaze and lustre. *Victoria and Albert Museum, London: Crown Copyright*

made up of several units of form, are able to combine into one total subject several different formal analogies, each of which is carried by its own unit of form, and all of which it would be impossible for a single unit to convey without becoming hopelessly ambiguous. It is, however, true that many fine pots, especially from the Far East, seem to be able to convey single and direct formal analogies through their entire compound structure, e.g. many of the mei-ping type, whose 123 tiny neck and lip refer unequivocally to the stalk of the fruit which each pot itself resembles. With far the greater number of compound pots, however, the expression of the shape as a whole depends on other kinds of relationship between individual units. (These may also sometimes be conditioned by their subservience to the analogical forms used, for example, in familiar precious metal wares.)

The contours conditioning the shapes of units of ceramic form are not, of course, mere flat, diagrammatic and static lines. They are crystallized images of kinetic traces which were present in the mind of the potter, condensing feeling-charged traces from his memory passed

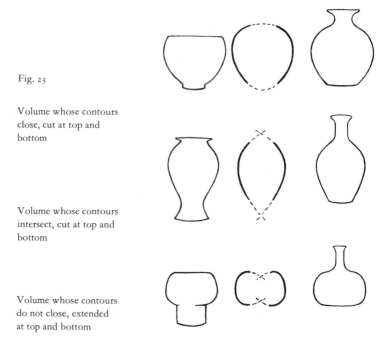

Fig. 23

Volume whose contours
close, cut at top and
bottom

Volume whose contours
intersect, cut at top and
bottom

Volume whose contours
do not close, extended
at top and bottom

down into his shaping hands. If we are to understand the true signifi-
cance of the formal units making up a pot, we must try to discover in
ourselves appropriate memory-traces of our own, chains of vivid
concrete experiences, to which, as we have seen, feelings may be the
only key (pp. 15ff.). And since it is primarily the contour of the
vertical section, in essence a kinetic trace, which gives a form its
specific character, we must taste its possible suggestions as fully as we
can. We may have to follow it with mind and hand up, down, over,
and under. One thing we may expect to find with many European pots
is that the potter created movement patterns which close in upon
themselves and make us feel each unit as a separate entity which needs
to be grasped before moving on to the next. Obviously, if we are to
get the best out of a pot or, if we are potters ourselves, to put the most
into it, we have to know how to read such movement patterns, or
how to construct them. We must learn to see not with a single motion-
less glance, but with a mobile, surveying attention which allows all
the other qualities of the pot's surface—colour, texture, and so on—to
attach themselves to the contour. The freely mobile or the closed-in
ceramic forms embody and bind together the analogues from our

experience, conveying them from mind to mind, from maker to spectator, creating those formal metaphors and suggestions referred to already several times, which are in essence ultimately kinetic. For *Fig.* lines as such *do* things in relation to their format; their meanings can ¹⁸³ be best expressed in verbs such as 'swoop', 'float', 'swerve', 'dip'. The contour *does* something similar in relation to the vertical axis of a pot. But paired contour lines, in limiting and qualifying each other, may combine to suggest actions quite unutterable in words; and the notional 'activity' a three-dimensional linear surface represents is totally indescribable, though we can indeed appreciate it.

Surfaces generated when complex linear profiles, enclosing more than one formal unit, are revolved about their axis have thus an overwhelmingly three-dimensional suggestiveness which can never be recorded as a straightforward linear combination in any diagram. There are, however, certain types of ceramic which lay so great a stress on profiles so complex that they cannot be grasped by the mind as a co-ordinated three-dimensional expression. Apparently simpler but in fact subtler profiles may produce functions of very vivid three-dimensional development. The weighting varies from type to type. All one can really say is that profile and third dimension may be intimately woven together to differing degrees. In some cases it will be the total three-dimensional form which evokes memories of formally analogous three-dimensional objects, whose contours were not the 'leading' characteristics in our experience of them when we encountered them in contexts charged with feeling. In others, especially those whose conventions and imagery are drawn from a current fund of graphic, two-dimensional design—pattern-books, for example—it will be primarily the forms of profiles which convey the meaning.

In some extreme cases (e.g. fourteenth-century Korea) both aspects ¹⁰⁶ may be developed to a high degree. This is one of the bases of the differences between traditions. Some of the memory-echoes given by forms may come from quite precise similarities of shape, which are easy to recognize for members of the same cultural tradition, and may add extra sense-dimensions to their experience of the pot. But for someone from an alien culture even quite precise similarities may be impossible to appreciate, if he has no first-hand knowledge of the things which these likenesses suggest. Pumpkins, melons, and mandarins do ¹³² not really belong to the world of modern man's direct sensuous experience. Some of the finest Korean twelfth- to fourteenth-century vases, which refer to organic forms, may provide clear clues to the

other terms of their metaphors by suggestive striations, by glaze painting, even by trimming and modelling. A wine-pot's basic shape, for example, may be impressed and cut to evoke a fruit gourd or a growing bamboo sprout, and demonstrate quite clearly that the [113] surface treatment is meant to arouse sense-memories which will enhance the taste-experiences it is conveying in its contents. One cup may show clear modelling of the petals that evoke a perfumed open flower, hints which in another cup from the same tradition may have been reduced to mere points on the lip or a faint fluting.

Such direct references to the world of nature in ceramic shapes give, of course, a special range of meaning, commonest in those traditions which flourish either among people actually in immediate contact with the natural world, or in civilizations like those Far Eastern ones which pursue aesthetic appreciation of the world of nature as a cultural phenomenon. The sense of growth, with its kinetic traces, which such pots convey, is live and direct (cf. vases with elongated necks, especially those with several, which vividly suggest natural shoots). [114] Their potters can inflect forms so as to evoke true echoes of the organic world in patrons who share with them some degree of common experience. And one finds, when Far Eastern forms with organic metaphors have been closely imitated in the West (e.g. Japanese Kakiemon Arita at Meissen), that the shapes have been diverted [109] towards an inorganic and architectonic inflection. But there are other kinds of reference to analogues, which the forms of other traditions may make, along a spectrum increasingly conventional and abstract even for the original patrons. The swan's neck suggested by an eighteenth-century teapot spout or the shepherdess's basket referred to by a cream ware basin form may have been real if conventional experiences to eighteenth-century citizens of the capital and to theatre-goers; for many of us today the 'content' of the references may be no more than second- or third-hand experience through fourth-rate illustrations.

Again it is characteristic of all rocaille forms that they refer not primarily to our experience of real forms—shells and waves—but to our experience of such forms as they are stereotyped in art. The roses to which a 1760 Sèvres rosewater ewer may refer are probably in the first place the roses that bloom in Boucher's pictures, not in the uncouth countryside of rural eighteenth-century France. Some of the finest ancient Egyptian jars refer in their strictly contoured shapes to [114] the common, almost hieroglyphic, stereotypes for natural forms

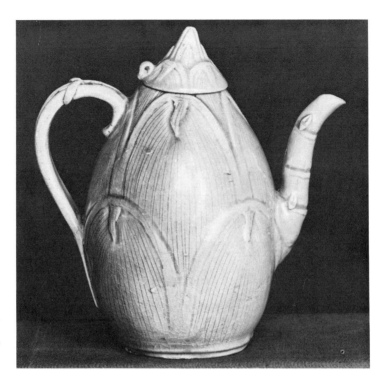

ne-pot, Korean. 11th–
.h cent. A.D. Celadon
ze. *Victoria and Albert*
seum, London: Crown
right

current in the contemporary stylized representational art, and stress
their association with those graphic emblems of value. At the furthest
end of the spectrum we may find that the forms to which Italian
seventeenth- to eighteenth-century faiences refer are forms not
recognizable in nature at all, but the forms, for example, of late
Roman urns and S-scroll shapes, whose remote origin in the natural
realm of the vine-tendril is lost in the mists of time. Such conventional
shapes developed by progressive abstraction during the Renaissance
and the Mannerist epoch into regulated and partitioned enclosures
which seem to have had a special value in that culture, perhaps symbol-
izing 'Classical rationality', just as architectural elements did.

 There may, of course, be inflections in any of these kinds of form
which can appeal to more vague and general experiences common to
most men. The way in which a pot belly swells may evoke imprecise 21
memories of the way liquid or fat fills a skin. A shape may suggest
organic pressure swelling it from inside as if it grew upward or 17
curved down, without any specific reference to an identifiable plant

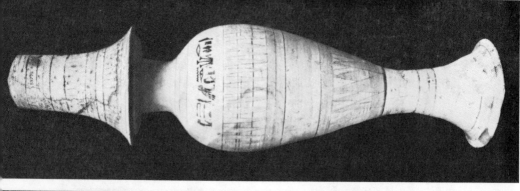

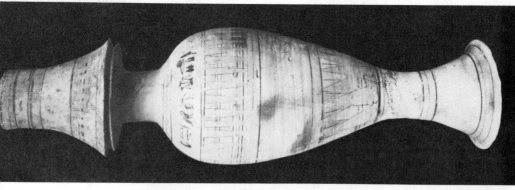

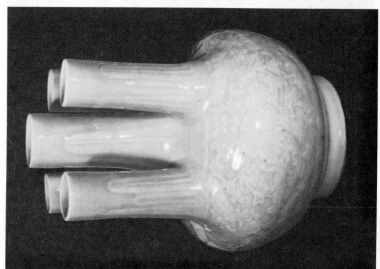

Large 18th-century
Chinese celadon vase,
pale greenish blue
glossy glaze. *Durham
University Oriental
Museum*

Vases with covers, from Egypt, *c.* 2nd millennium
B.C. Design executed
in blue and dark brown.
British Museum, London

or animal object. It may evoke sensations which reflect external forces, as if they had acted on it to give it, say, a compressed, cheese-like form. It may also suggest in a general way, as many Japanese nineteenth-century wares do, that the forms have been eroded by time, subject to the hazards of decay; and in suggesting this particular effect it may offer those deliberate breaches in the code of full three-dimensionality described above.

There are in fact very few pots, other than primitive ones, which are made up of a single form. The great majority are compounded from two or more units of form, usually corresponding with the physiologically named sections mentioned above—though this need not be so. In practice the lack of a varied multiplicity of forms in the wares of a pottery tradition can make them seem dull. One may indeed feel that many modern potters who attempt to compress their pots into single units which they make interesting by ornamental treatment of the surface, by plastic manipulation and/or glaze fantasy, do so because they are not fully aware of enough other possibilities. To articulate challenging, even disparate, units is one of the things that makes a good pot especially interesting. For it is in this that variation and invention have their freest play, and that proportion, architecturally mathematical and/or physiologically suggestive, can be fully developed.

The articulations found in ceramics depend for their effect in the first place upon the character of the formal units of which each pot is composed being defined as clearly as possible. Without the challenge of distinct units articulation becomes no more than casual jointing. It would, however, be wrong to assume, from the order in which it is necessary to discuss these matters here so as to make them intelligible, that this is the order of conception and making in ceramics. We must, of course, take for granted that the articulated whole, in so far as it represents the meaning of the whole pot, will come *first* in the potter's imagination just as the whole meaning of a sentence precedes the words found for it—which do, nevertheless, have an independent existence as a reservoir of their own possible contexts. The units of form articulated in a good compound pot are phrased so as *both* to contribute a maximum of individual formal meaning to the whole *and* to integrate themselves into that whole. Here again one will discover

Additive articulation by juxtaposition

Articulation by smooth continuity. Points of change from one volume to another, also from convexity to concavity, marked

Articulation by elision. Region of overlap shared by two volumes indicated

Fig. 25

differences of degree and variations of emphasis. There are pots composed of a single, vividly expressive unit of form. There are others in which one form—the belly say—is of overriding importance, and the neck and foot merely complete its expression. In contrast there are sophisticated pots so complex, so elaborately profiled with steps, waists, and bands, maybe overlaid with ornament, that no single individual form is allowed much expression. Needless to say, it is only rarely that pots of this last type have much aesthetic value.

The three principal modes of articulation—which may appear combined in a single compound pot—are: first, juxtaposition, by which the forms are simply added to each other and preserve each its distinct individual separateness, their junction places being clearly visible; second, smooth continuity, by which the contours of the form-units are carefully phrased and adapted to each other so that their junctions do not visibly punctuate the whole; and third, overlap and elision, by which the component units share common segments of contour. This last is particularly difficult to achieve; China's and Korea's are the two chief ceramic cultures which have succeeded in it. European imitations of their wares generally betray themselves by their inability to think in genuinely overlapping formal units. The reason why will become apparent later.

Pots which are articulated by the first method, juxtaposition of units (e.g. most Classical Greek wares), will naturally make a special Fig. 32, virtue of proportion among their horizontal divisions or even a 125 repeated metre analogous to the complex metric feet of poetry. This appears most obviously when the pots are seen in pure profile and suggests that the potters were indeed addressing themselves primarily to the 'architectural' eye, i.e. for display. Fine jars and bowls were indeed used for social display as will be seen. There is also a clearly visible community of contour between the outlines of pot forms used during the archaic black-figures epoch and the outlines of the parts of human bodies executed in the same style. In more elaborate, not to say fussy, Italianate derivations from Roman types, e.g. faience confections from Deruta or Delft, the vertical measure may be complicated Fig. 26, or enhanced by flanges, for example, and more commonly by banding 117 in the surface glaze painting, both of which may also incorporate 4 metrical rhythms by their widths relative to the vertical measures. One of the most obvious criteria determining the interest and expression of this vertical partitioning is pursuit of variation in its metre— perhaps itself embodying references to past experiences of measure,

116

musical and/or architectural. The standard potter's catchphrase 'make sure your pot doesn't divide in two at half its height' (e.g. body and neck) represents a rudimentary recognition of the need for vital proportion among a pot's horizontal components. A similar proportional variety and relationship seem to be necessary to make the horizontal widths of the component units effective, especially where they meet each other. As hinted, it may be possible to analyse the proportional scheme of a 'juxtaposed' pot according to some recognized 'beautiful' proportion or metrical scheme. Again, it may not, if the metre has its own direct overtones of memory. In his proportional systems the European tends to favour regularity and a unit-measure phrased and countable, as it were, within bar-lines; whereas the Far Easterner has usually favoured hidden, subtly extended, and widely varied rhythms.

. 26

Pots—or parts of pots—compounded by the second method, smooth continuity, will obviously not lay nearly so heavy a stress upon vertical metre—though it should certainly be present. Much Islamic pottery uses it very skilfully. The visual virtues of medieval European pottery also probably depend upon a hidden simple metre—which may even be consummated outside the borders of the pot by the natural conclusion of a 'cut off' unit of form. The hiddenness of the metre has led some writers on pottery to confuse the proportional systems of English medieval wares with those of Oriental—a grave mistake. Far the commonest use, however, for articulation by smooth continuity has been to give interest to the main bodies of pots, especially European, which are completed at neck and foot by sections juxtaposed by the first method. *Fig. 23, 110*

The last mode of articulation, overlap and elision, is far the subtlest. It means that there are no clear points of division discernible between the component formal units of the pot, and that quite large stretches of the surface may belong ambiguously to two units at once, each of which can nevertheless be clearly seen as an entity within the whole. Along with this kind of articulation may also go a fondness (e.g. in Korean celadons) for a very wide disparity of size between component units. In practice the particular highly developed ceramic types which use this method have been made in those Far Eastern cultures which have a special attitude towards space, and a special way of conceiving bodies through linear continuities. It is what gives them much of their universally recognized aesthetic value (see pp. 183ff.). Needless to say, the other methods of articulation were also used in Far Eastern ceramics.

g. 27

Fig. 28

Measure and proportion, of course, often play a part in the plan or overhead view of ceramics both in the angular division about the axis, and, for example, in the width of the flanged lip of a plate in relation to the radius of its hollow. It is most common in open wares meant to be seen from above, such as bowls and trays. Radiating metre may be plastic, that is modelled into the shape, or it may be painted on in the decoration. With the generic jars it is usually executed as vertical fluting or gadrooning, pressed in or out with the fingers. On dishes or bowls it may be done in a similar way, but also by foliation or scalloping at the lip. Some trays may even be modelled as a whole radial series of separate dishes either joined or separate. In all these techniques there will usually be found some structural relationship of proportion—not a mere angular division—between the plastic elements and the radius or diameter of the pot. A six-point lobed dish, for example, may show a distance between its points equal to the radius of the whole (Italian faience); or the width of gadroons over a belly at their widest point may correspond with the depth of the foot, at their narrowest with that of the lip. There is virtually an infinity of possibilities.

THE MODES OF SPACE

The sympathetic reader will recognize at once that the passage which follows concerning the modes of space which pots project about themselves can be realized under modern conditions only in imagination. The opportunities to intuit the spatial significances of old major ceramic works are now rare indeed. Only a very few specialist museums recognize that pots must be allowed to find their own natural scale and place within an environment which is itself on the scale the pots were conceived for. Crowded as they usually are into museum cases or on to shelves, 'shouting', as it were, against each other and cancelling each other out, the voices of their forms can scarcely ever be properly heard.

European ceramics, as well as Classical Greek, each in their own particular ways, have generally dealt with space by partitioning the bodies of their pots into characteristically distinct formal units, articulated by the first two methods, each of which contains and defines its own volume, what one may even call its 'substance'. Only by inference is the environment within which the pot belongs defined. Projections on these pots such as handles or cresting always seem to be extrusions from the content of space which the pot defines as within itself; they seem to suggest that the room we share with the pot should be

measured by the pot's own system of space-cells and proportion, by that same rational order of space-parcels which the pot defines. These relatively sophisticated wares belong into a specifically formulated environment.

The Oriental mode of space projected by the best Chinese, Korean, and Japanese pottery is special. Not accidentally do so many Oriental ceramics, figures no less than vessels, stand on bases which 30, seem like a 'gathering together' of the ground on which they rest. 67, 198 The fluidity and mutual interpretation of their forms, the often un-dulant linear refinement of the profiles which modulate their surfaces, indicate that the objects belong in an indeterminate, all-embracing, and fluid environment. They do not define it by including it but everywhere suggest it as a mobile medium of possibilities at the centre of which the pots emerge into reality as transformations of the hitherto undefined. Their lines and surfaces recognize continuity and change as valid forms for contemplation.

Between these two types of space-projection pottery can suggest a variety of modes. One interesting type, also based on contained volume, is represented by the Mochica and some Chimu pots of Peru. It seems to focus the pots on their own content, which is emphatically 194 stated without being at all clearly rationalized; for all such pots belong in a world of indeterminate measure—a world which many observers have felt to be imbued with tragedy, a feeling probably re-inforced by the solitariness and isolation expressed by the faces and figures (some even intimately coupled) that are modelled on to them. The same kind of undefined and mysterious space is projected by African ceramics, whose strongly marked rhythmic sequences of surface striation may seem to have an inner significance only, as if they 32 were crystallizing forms and measures absorbed *from* the untrans-formed environment, not projected outward upon it.

The fixed point of reference in all stipulated modes of space is, of course, the axis vertical to the ground which pots share with men. Owing to the pull of gravity on their contents all pots have a top and a bottom, save certain trick-pieces and a few modern experimental pots made expressly to explore disorientations of the sense of attitude, whose effect does actually depend by contrast and contradiction upon our 'natural' vertical expectations. Except with pots of rectangular or oval section, pot shapes have in themselves no particular orientation. They can be seen from virtually any angle around them. The addition of a jug-lip, or spout, with a handle changes this drastically. At

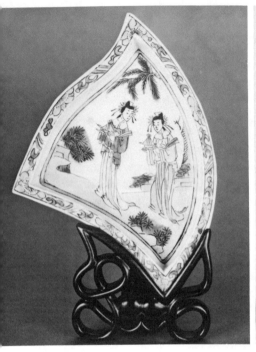

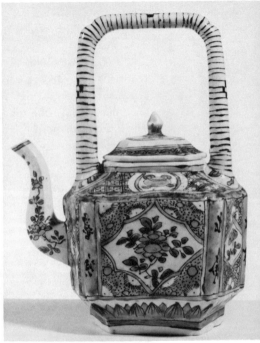

One of a set of Chinese dishes in famille verte colours—black, yellow, two greens, and aubergine. K'ang Hsi period (1664–1722)

Chinese famille verte wine-pot, painted in black, yellow, green, and aubergine. K'ang Hsi period (1664–1722)

once the pot acquires a totally new orientation in space. It becomes an object focused in the transverse plane of the spout and/or handle; its content is felt at once to have a definite issue in a tilt and a direction. Finely shaped spouts may even project and define the curve their liquid will take as it is poured. A jug, ewer, or teapot is thus bound to suggest a posture and a pattern of projected action for the spectator, who will, if he is normally right-handed, experience an inward urge to adopt an asymmetrical attitude, a little behind and to the left of its handle. The stirrup handles of many Peruvian pots suggest that they should be lifted vertically, from above, and hence that their user sits above them. Certain wine or beer-serving pots (e.g. German 'Grey-beards') may, by the frontal suggestiveness of the faces which are moulded on to their 'pouring' rims, offer themselves frontally to the 'honoured' and 'waited on' spectator, rather than offer their handles to his hand. This element of frontality becomes crucial in the development of ceramic sculpture. It also appears in, e.g. Peruvian Chimu pots, though with a different significance, as will be seen. *Fig. 32, 125* *194*

A pair of equal, strongly projecting handles ('jug-ears'!) has a Fig. 32, 125 related but special significance. The two suggest an invitation to the spectator to place himself squarely before the pot, as if he were taking a handle equally in each hand and lifting. Such a pot thus always has either one or a pair of principal faces; and the profiles of its handles can easily become such an important element in the expression of the whole that one may overlook the fact that the pot itself is usually round in section. Surface decoration can heighten this feeling. It is thus not surprising that this double-handled pattern, given reminiscences of the Classical urn, as cult-object, serve as the display shape *par excellence*, especially in those ceramic confections added to Rococo 134 interiors at chimney-piece and console. They suggest that they should be silhouetted, perhaps against a wall, and invite the admiration of the beholder from 'in front', thus creating a notional 'plane of reference' to which they belong.

SHAPE CRITERIA — As we have seen, kinetic lines determining what we may call the contours of the individual units of a pot are of the utmost importance. But in creating any aesthetic metaphor the paired contours of each form seem to need to depart as strongly as may be from the arc of the circle, in order to add a new dimension to the plastic value of the circular section of the pot. This means that each truly vivid ceramic contour is a curve whose inflection is progressive, developing, and altering as it goes, often deepening strongly at either top or bottom, or at both. Not only to articulate the *shapes* but also to integrate the *significances* of such vividly suggestive plastic forms is the principal aesthetic aim of the ceramic artist. Therefore the ultimate expression of an entire first-class compound pot can become a complex aesthetic experience, co-ordinating and combining into a single whole meanings and responses which may originate in particular ranges of experience that are not associated with each other in everyday life. Some pots may thus even produce a sense of dream or surreal-reality, an intuition of connections between our experiences of sensuous realities which our pigeon-holing, utilitarian attitude has never allowed us to recognize before. And, in being articulated, stock forms may demand modifications in each other, and so modify each other's meanings. Even if they do not demand physical modifications, they will provide each other with contexts that limit their individual fields of reference. In order to understand how articulation results in expres-

g. 29

Fig. 30

sion, we have to resort once more to that unreal abstraction, the two-dimensional profile.

When the contours of the forms which are functions of graduated and expressive lines are articulated there seem to be two considerations which determine the vitality of the articulation—and in this context vitality is virtually a synonym for variation. We take for granted here these well-conceived ratios of measure between the units which have already been discussed (pp. 116ff.). The first consideration is most clearly visible when articulation is by juxtaposition; the angles at which the inflected units of form in a pot meet each other will be varied, not repetitive. When handles are added exactly the same holds good, and the challenge to invention is increased. One of the special achievements of Classical Greek pottery of the sixth to fifth century B.C. is this kind of clear and certain variation. When articulation is by the second and third methods—by continuity and by overlap with elision—the same angular variety should be felt under the surface; but in addition the concave segments of contour which provide the continuity of the surface have the same kind of distinctly progressive curve as the major convex units of form. The curve has a different inflection, and again avoids subsiding into the arc of a circle (e.g. Korean thirteenth-century celadon waisted vases). *Fig. 27, 117* Thus it is very clear that the mobility and inventiveness of a pot's contour, at both the unit level and the level of articulation, are a matter of continuously changing and progressive inflection which yet gives the utmost expressive and plastic presence to its individual component units.

To achieve this powerfully belongs to the greatest traditions; but these considerations even seem to define the criterion which has been felt within each tradition—even if it is unspoken and undocumented —to be the touchstone of quality in its own wares. Variation of achievement among individuals must, however, be expected as a normal phenomenon in so far as ceramics is indeed an art. We have not yet got to the stage where we can identify correctly from their products the individual hands working at forming (as well as decorating) in many potteries. Perhaps we never shall, because of the accidents of history. But in principle we should be able to. For even in such simple and routine wares as eighteenth-century Nottingham stonewares individual potters were naturally able to endow their productions with that variety and life which we recognize as a criterion of achievement in other arts.

The great danger to all potters in articulating their forms, the indecisive, evenly undulating contour, whose curves, both convex and concave, are virtual arcs, is a trap particularly alluring to those Europeans who are under a strong impression from the Far East, and who believe that in this way they are creating that linear articulation by overlap which is the East's special forte. Linear articulation can only be done properly by artists whose formal language is the truly *Fig. 27,* mobile line and who understand 'in their bones' how lines must be *117* led and inflected to give real vigour to their expression. It would be invidious to mention names of victims of this trap; but even the most distinguished of modern artist-potters have been by no means immune.

The second consideration mentioned above is that the essence of linear expression, applied to the total contours of pots, is a matter of what can only be called phrasing (by analogy with musical phrasing). As has been mentioned, whilst each such contour must, of course, express clearly each individual unit of form of which it is compounded (giving it the maximum individual variation *away* from the arc of the circle), it must at the same time, whatever type of articulation is followed, phrase the units together into a single coherent contour. The 'contour-phrase' will sum up and enclose all the various elements of shape and proportion, such as relative size and weight among the units, and the linear expression of each, into a single kinetic image. The latter, in terms of the whole pattern of movement it suggests—which in thrown ceramics is virtually always upwards, for obvious technical reasons—speaks a language of pure gesture. One may feel it virtually in one's own hands as if they were tracing between them a momentum of feeling.

It is, perhaps, necessary to interpose here once again a new warning, for a new reason, that paired and opposed two-dimensional contours, despite their obvious importance for decorative pieces meant for distant display, can only be, with respect to the ceramics of the world, a medium of explanation and an instrument of criticism. Although it is perfectly true that the world's most subtle ceramics have been made in those countries—China, Korea, and Japan—in which mobile lines have been the fundamental medium of artistic expression in all the arts, such lines have always been felt there to be truly mobile and three-dimensionally protean, never confined to the diagrammatic plotting of contours. Even in the two-dimensional art of painting the lines proliferate, without claiming dogmatically to enclose fixed units of reality. In the three dimensions of figurative sculpture likewise they

develop into surfaces which explore and adumbrate a surrounding unlimited space, and never merely point to standardized unvarying cells of volume which they enclose.

Thus the flat, continuous line has never been thought of, in major traditions, as the original medium of ceramic invention. It ought never to have been allowed to become the main vehicle of design, as it has now become in the West, not only for mass-produced ceramics but for the supposedly three-dimensional design of silverware, implements, and furnishings of all kinds. The effect has been to destroy the multi-sensuous man, and dissociate him from real, many-dimensional experience of his environment. The process has, of course, been continuing hand in hand with the increasing dominance in our culture of the graphic media, including television. In practice the unit-volumes of a good pot will show among themselves a relationship of volumetric proportion, of actual and implied weight, which will be created by the potter in terms of his own intuitions of multi-sensuous order, to describe which the words have not been coined, nor the symbols devised to plot.

These possibilities will usually reveal themselves to the spectator in a series of feelings concerning the disposition of the weight of the pot while it is being used in relation both to the proportions of its parts and to their formal suggestions. Here, if anywhere, one must rely on one's own insights. One may progress to almost any stage of intuition from basic speculations which may sound simple-minded when put into words such as these: that the heavy belly of a pot is stable on a broad base, less stable as the base becomes narrower; that it is more stable if it sits low, less if it sits high. But since dignity and social worth are normally expressed by 'elevating' what is to be highly valued, the 'natural' shape practical for a stable container, say of liquid, a broad-based low-bellied one, is exactly that which a consciously 'high' life-style considers beneath it. The 'natural' shape may be all right for the bourgeois domestic pot or jug; but far the greatest number of truly sophisticated ceremonial vessels hold their bellies high and attenuate their bases as much as possible, maybe helped by a spread foot, and often given any pedestal they may have a stepped or tiered look which also has honorific overtones (e.g. Classical Greek krateroi, and other festal mixing bowls). The mid eighteenth-century sophistication of the European aristocracy, however, with its cult of Arcady and idyllic imagery, demanded many pots which reverted in their posture to the original 'natural' distribution of weight (1760

Fig. 31

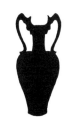

inese T'ang Amphora,
cent.

reek Attic mixing bowl,
500 B.C.

ruvian Chimu beaker

g. 32
tic red-figure vase,
480 B.C., with volutes
ded to handles

Sèvres or Worcester jugs), but much decorated with rocaille or ribbons, and only for fun. (No one was really supposed to be going to knock them over; high style and pedestals soon reasserted themselves.) In practice, of course, high-style porcelain, European especially, may owe far more to the surrounding documented and changing fashions in design which dominated all the sumptuary arts at once than to any immediate purely ceramic expressiveness.

A wide-mouthed jar will let a hand in to take a handful out. A posset-pot with a broad-coned trumpet lip will give a generous draught when held by both its ears. A bottle with one of the types of plug lip will give an easy swig from a capacious body. Where eastern Islam may like its bottles, narghiles, and ewers to be onion-squat, with the conventionally elegant tapering neck that was held in the delicate hand, western Islam prefers its pot bellies carried tulip-high on feet that taper to flat bases and need care in handling. Peasant virtue may stress commonsense bulk and balance in pottery and a direct address to the hand, with ornaments basic and *ad hoc*, produced without adding perceptibly to the expense. (Even the great Chinese Sung peasant wares—e.g. Yüeh and Honan black—conform with this. In reality, of course, it costs no more to make an aesthetically expressive shape from the same clays and glazes than a dismal one.) A landed peasantry will pay for a broadly emphatic pottery used on the wooden or basketwork dresser, with bold rhythms and textures that can be clearly seen, whilst a bourgeoisie may well demand multi-plicity of form and some finesse of articulation. The court demands the grandest and most complex of all possible forms. And finally, perhaps, an ascetic, aesthetic élite may look once again for a rustic style that is simple only to the undiscerning eye.

*Fig.
31*

Vases by their shape may declare the way they hold their flowers. The relative widths of foot, belly, and neck will give a sound feeling of how bulky the blossoms, peacock feathers, or coral stems would have been which a vase was meant to contain. A capacious lip may invite a generously toppling—even vulgar—weight of bloom, and need a spreading stable foot, especially if the belly is high. A vase with high shoulders and a narrow foot could never hold, for example, heavy peony-heads but only stems of lily or iris. We will attribute to it therefore a 'delicacy of form' which really depends upon a character-ization of its putative contents as much as upon its own shape. A handle added—or a pair of handles—towering over the lip and neck crystallizes demonstrative 'lifting' gestures—as in Classical Greek or

belly and shoulder

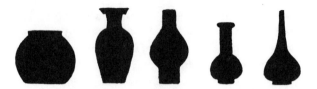

jar lips

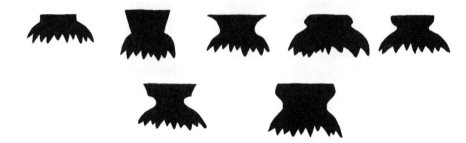

bottle or vase lips

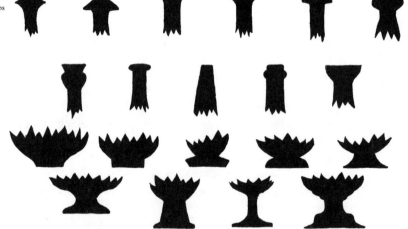

feet

lids

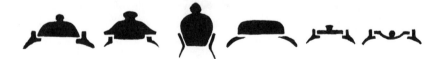

T'ang Chinese amphorae. The handles of the last may even be worked as dragons biting at the female lip. And how numerous are the handles or spouts which terminate in flourishes evoking ceremonious gestures, 80 ranging in severity from the Sialk libation ewer to the more secular 120 Classical Greek volute to the preciosity of the Chelsea teacup! It is no Fig. accident that Italian Renaissance and Mannerist faiences favour rather 125 loose, bulbous, and strongly recurving stereotyped forms for jars, with and without handles, and for platters either central bosses which make them resemble shields or a double concentric concavity which, as it were, reduplicates the gesture of the basic form. In fact there is scope for a vast amount of detailed analysis of the codes of manners and gesture which play a role in the silent languages and schemes of psychic order which each tradition of ceramics incorporates from its own culture.

One must, in fact, question the *quality* of every act which every kinetic form and synthesis embodied in a pot suggests, feeling it both with one's hands and with one's inmost kinetic senses.

COLOUR: GENERAL The symbolism of colour is an enormous field, and of course it is impossible to do more here than indicate a few aspects which have a special bearing on the meaning of pottery through the colour-qualities of body and glaze, which must be treated as vital elements in ceramic form. One must also remember that what is dealt with here is not literary documentation, but immediate response.

In interpreting the meaning of any colour one has to be careful to discover what special attitudes and responses to any given colour prevailed in the society which made or used any particular pot. This may first of all also have something to do with climate. For the quality of the light in which a ceramic is normally bathed will both enhance and condition the reaction of its users to its colour. The 'killed' or impure colours of natural oxides, if they are used as a group on the ceramics of hot countries with clear skies and a high sun, can work far more vividly on the emotions than they can in a less luminous climate. A duller environment, especially one in which seasonal weather and changing atmosphere is appreciated, as in China and Japan, may promote either a desire harmoniously to conform ceramics with surrounding nature, or a desire to brighten them with brilliant colours. Both these desires will have different feeling-implications. And we must try, in our imaginations, to 'correct for' and take into account these factors (very difficult in museum surroundings).

Fig. 33
Examples of varied
expression in the different
elements of pots

127

The ochre yellow used extensively on Italian earthenwares would, to the Chinese, have overtones of earth and sadness. And so it appears in Chinese ceramics which have those associations, for example in T'ang funerary wares. Conversely, the Chinese later Ch'ing dynasty adopted a brilliant crocus yellow virtually as part of the Imperial insignia as a background for robes and palace hangings, deep blue being reserved for certain official grades. These associations must have imparted some overtones to Chinese appreciation of, for example, Ch'ing antimony—iron yellows and cobalt—manganese blues in ceramics. One must be ready to find a strong connection in regulated societies between sumptuary rules and ceramic colour-schemes. (Cf. the Sung and Ming encyclopaedias. Much work remains to be done on the memoranda proposed by the Board of Rites and consequent Imperial edicts with respect to the symbolisms of colour, which to the Chinese were of serious ceremonial importance.)

One has also to remember that the potter's clay and glaze materials are not, when he uses them, always the same colour as they will be when they are fired. So the ceramic decorator is always aiming at an imagined, prescriptive effect; and very often he is prepared to admit into his intention the result of accident, of the hazards of the firing process. Except in the most highly industrialized processes the potter's colour intentions may thus, to some extent, be general rather than specific. For he may be working with naturally available substances which can only give him a restricted range of possible tones, and with kilns whose atmospheres cannot be controlled with absolute precision. Thus only rarely has he been free, as a painter is, to produce complex colouristic effects of his own free choice. And only since ceramic chemistry took substantial steps during the eighteenth century at the hands of the chemists employed in the great court potteries have certain colours or inflections become possible at all in glazes. Instead, as has been mentioned, the potter and his patrons have been content to accept conventions of colour, and to take their often narrow limitations as given aesthetic constants. An excellent example of the immense artistic possibilities of such an attitude is the centuries-long tradition of Greek vase painting in red-black-white-purple. There are, of course, many other standardized colour-groupings which have been found to go together, and work both technically and aesthetically. Once discovered, such colour-groups have often travelled by imitation from one ceramic tradition to another. Classical examples of this process are the Meissen

copies of the Japanese Kakiemon schemes and Worcester copies of Imari.

The aesthetically successful colour-groups are those familiar in ceramic history: T'ang funerary yellow-green-dull blue; the familles verte and noire, with yellow-green-black-aubergine-orange-red, all with a 'natural' inflection; the Italian majolica ochres-blue-dull green. But there are many others. One can easily see how true such groupings are, and how they provide valid joint symbolic overtones, by looking at examples of ceramics made in one true colour-system which have been 'clobbered' (i.e. fired somewhere else with extra patches of overglaze enamel belonging to another tradition). Clobbering, however brilliant, can destroy completely the mutual balance of glaze colours. It was done for commercial reasons to Chinese export wares in Japan during the late eighteenth and nineteenth centuries; and it seems also to have been done to many older wares in Europe as an amateur occupation during the same period. The reasons why such clobbering destroys a colour-group will appear in what follows. It is not solely due to the clumsiness with which clobberers have so often worked.

The two most fundamental groups of colours found in pottery are those natural iron colours of clay, fired either oxidizing or reducing—red ochre shading off to beige, and black running off to grey. The techniques which produce them have been discussed earlier, in the technical section (pp. 52ff.), but their symbolic implications are many. Generally speaking the tonal polarization towards light (or whitish) in all versions of these tints has an obvious function of relieving the colour from the full weight of its significance, seeming to move it in the direction of clarity and ease. For, of course, lighter clays reflect more light than dark. And the nearer to pure white a clay or glaze approaches, and the more lustrous it is, the close does its significance approach that of the precious metals whose radiance is associated so often in symbolism and metaphor with the transcendent or spirit world.

In practice, however, ceramic body, slip, and glaze colours must share in the generally recognized significances of colours; although, of course, the colouristic significances will have dimensions of their own added to by their pottery contexts and by what they are used to do. Clearly a glaze which reinforces a plastic formal analogy—as, say, a manganese aubergine glaze applied to a pot shaped like a type of gourd whose colour as a natural object is aubergine—will have an entirely different effect from one which adds a totally different dimen-

sion of meaning—as, say, a pure white body and glaze do to a teapot suggesting in shape a cluster of bamboo canes. A 'correct' colour may thus also reinforce the metaphor conveyed in a painted design, as when the very common Chinese peony, with its undulant and pleated petals that have feminine sexual overtones, is painted in a pink natural both to flower and to the second element in the metaphor. Further, a Korean gourd-shaped pot may have a colour which whilst not that of an actual gourd, is nevertheless consistent with the organic world. There can be little doubt that this kind of subtle consistency accounts for the pre-eminence of medieval Far Eastern complex-glazed ceramics.

On the other hand a colour may add itself to a ware as a purely symbolic dimension as when, for example, a Chinese Immortal is painted in an unnatural but highly significant blue; or when a Ming lidded water-pot shaped like a mandarin fruit is painted with a blue and white landscape. A Meissen figurine, conversely, may be glazed in an imitation celadon. Thus colours can by their very 'realism' or 'unrealism' amplify or change the significance of either a whole pot or its individual component parts. In ceramics before the eighteenth century, in China and Europe, when matching of colour to represented actuality was virtually impossible, colour always retained a powerful independent symbolic significance. But in this kind of metaphorical transference there seem to be no necessary limits to invention, so long as the basic elements of the metaphor are clearly identified in feeling. Where intention leads, technique may follow. And in interpreting the works of past traditions one can remember that this is one of the points where profound metaphorical symbolisms may be hidden, waiting for the spectator's intuition to reach out towards them.

We must, however, remember that our own eyes and colouristic appreciation are highly sophisticated. We live in a civilization which has filled our everyday life with experiences of the hectic colours (with completely excluded colour-opposites) given by modern dye-chemistry, which are used for commercial printing-inks and textile tinting. So the sober reds of the iron oxides or copper, for example, may seem to our senses rather dim and unstimulating. We may find it quite hard to discover in ourselves the right kind of responses to certain pigments which to other people have been highly stimulating. The whole range of 'killed' reds, yellows, and greys natural to clay must thus fail to give us anything resembling the feeling they gave an original, more 'primitive' public.

There is, however, a related consideration we have always to bear in mind. 'Killed' or 'neutralized' earth colours have a double value according to who appreciates them. Whereas it is true that genuinely primitive peoples, who know haematite as their only red pigment (blood darkens rapidly) and who have only a few other earth colours available, may experience quite vivid responses to it, and find it exciting in a way we never can, people who are familiar with bright colours in dyes and even ceramics, on the other hand, may well appreciate the subdued earth colours precisely because they *are* subdued. There have been phases in taste in Europe, as well as in China and especially in Japan, when over-bright colours were considered barbarous or common if not indecent, and when sobriety and subtlety have been valued in ceramic colour as major elements in expression by contrast with the gaudiness of more vulgar arts. This was the case with Japanese teawares, and with, for example, the grey-glazed true Kuan of Sung and imitation Kuan of Ch'ing China. It was certainly one of the elements in the appreciation extended among the more emotionally restrained sections of society in eighteenth-century England to the earth red and chocolate brown biscuit Yi-hsing tea-pots imported from China, and to Wedgwood's own versions of unglazed haematite red ware (e.g. Rosso Antico). His matt black basaltes and olive ware must also have aimed at a similar type of response. Many people today feel a similar fondness, if not for identical reasons, for the sober subtlety of 'killed' glaze colours. They may feel that they are somehow more 'natural' than brilliant glaze pigments, and especially suitable for hand-modelled or unsophisticated pottery. In a sense, to them, a 'natural' terracotta-coloured pot cast in a mould, may be an anomaly. The factors involved are not the same, however, as those involved in our appreciation of complex colours. This is another issue discussed later on (pp. 142 ff.).

One other thing to be borne in mind is that earlier ages and more primitive peoples do not differentiate between named colours in the same way as we do; they do not name, and hence probably do not perceive colours as meaning what they do to us. This is a subject around which dispute has long raged. The evidence is largely literary, and is not by any means consistent with surviving art, so that there is always room for speculation. But it does seem that there is a group of basic historical assumptions about the appreciation of colour upon which there is a measure of agreement, and which can be of help here.

Most 'early' peoples, including our European forefathers, did not

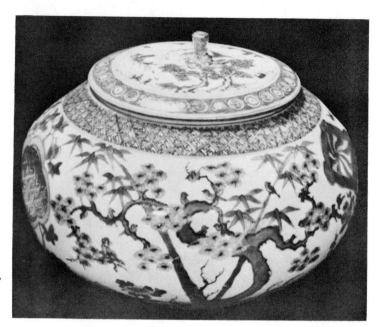

Blue and white water-pot, shaped as a mandarin fruit. Chinese. Ming dynasty. Diam. 8$\frac{13}{16}$ in.

differentiate colours according to the prismatic scale we now know to correspond to the wavelengths of light. In fact we ourselves are limited both in our perceptions and our structural thinking to the sequence of seven colours we have chosen to isolate as corresponding to the customary colour names we apply traditionally to the rainbow; we have chosen not to treat as primary the colours actually visible at what *we* call the intermediate wavelengths. For the spectrum is a continuum, not a ready divided band. And what divides the band for our own consciousness has conditioned not only our own perceptions and emotional responses but even the pigments we have developed for artistic use, with their own characteristic spectrum exclusion-bands. We live in a world whose colouring is far more variegated than we recognize.

Instead of our current prismatic grouping, however, many other peoples have distinguished and responded to colour according not to spectrum frequencies but to what we would call colour-qualities, such as saturation and relative brilliance. Their colour categories correspond more to the distinctions implied in our names 'olive', 'brown', and 'pink', rather than to 'red', 'yellow', and 'blue' as spectrum frequencies. Thus for the Chinese what we would distin-

guish as clear blue and green, given in ceramics by copper oxides, seem to be versions of the same 'colour', neither of which is seen as the same colour as the dark cobalt oxide blue used on blue and white porcelain, and which has its own special features. These facts should play a part in our own interpretations of the Chinese Sung complex-tinted wares which we would call, respectively, greenish, bluish, or greyish, but which the Chinese seem to have felt to be modifications within one 'colour'. Again, it may well be that what to us appears as extremely conventional colouring in Classical Greek wares—black and earth red, with touches of manganese purple and white—seemed to a Greek mind, if not exactly naturalistic, at least unquestionably congruent with their vision of a heroic world. This very important issue will be taken up later.

COLOUR AND GLOSS There remains to be discussed the question of glaze-quality in relation to colour. Any colours appearing matt in a clay-body seem to impress themselves on the sight and consciousness as less intense than when they appear in a glossy glaze. But there does seem to be another question involved here, one of degree. Glazes with the intense gloss given by a high temperature glaze technology, such as some of the hard, vitrified monochromes made in eighteenth-century China and at Sèvres after 1765, as well as evoking the archetypal overtones of gems as light crystallized by fire into the veins of the earth, do seem definitely to place a barrier between the viewer and the pot. The sheen, especially one so intense as that of late eighteenth-century Sèvres, isolates the significance of its colour into the same kind of anti-intimate aristocratic distance to which the shape-silhouettes also remove the pots. It is as though we are informed that the brilliant surface colours, and their significance, are to be enjoyed in the imagination only, that they are not meant to 'come forward' into an immediate involvement with the beholder's life, perhaps that the content of their symbolism is to be contemplated virtually as out of *this* world—an effect enhanced in all European aristocratic wares by the jewelled grandeur of their designs. The glossiest monochromes of Imperial wares from eighteenth-century China may give a comparable sense of 'distance'; but the hardness and gloss of the glaze is rarely so obtrusive, especially in the case of overglaze enamels. The complex Chinese glazes such as the peach-bloom or flambé, however, vitreous they may actually be, never have that gem-like brilliance which was

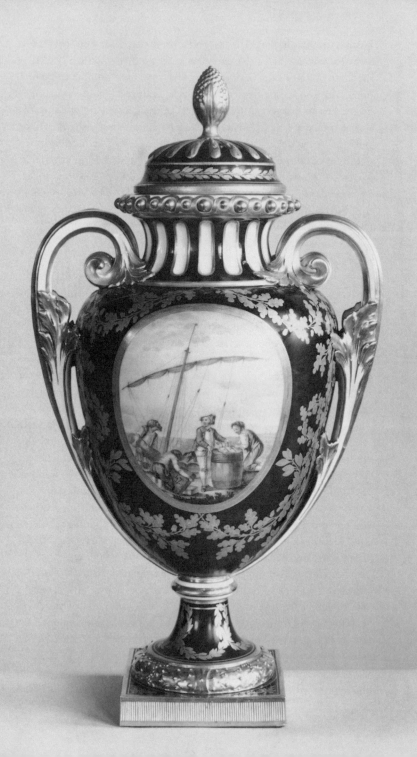

the European ideal; they may have minute crackle and bubbling, and their colours may be complex and ambiguous in a special way.

It is in the middle range of gloss that the variations of expression of which glaze and colour jointly are capable become most interesting. Glaze depth undoubtedly intensifies the emotive value of a colour. A fine Imari orange enamel has a far more emphatic quality than the same iron orange when it appears in the biscuit body of a Yi-hsing ware. A really deep glaze, however thick and unctuous as in Sung Lung-ch'üan and Chün, seems so to speak, to draw the attention within its own translucent thickness. Its depth gives us a sense of the internal mutual reflections of its glaze particles with their different colours; the eye is not forced to accept the outer surface as a coloured sheen. A similar effect, though less pronounced, may be felt with underglaze or fully fused-in overglaze blue enamels, even when the ground is relatively high glost.

It is the special charm of many of the eighteenth-century European soft-paste glazes that they emphasize their colours neither too much nor too little. Since, in effect, colour symbolizes feeling, most people have felt happier with that degree of glaze intensity which matches their cultural attitudes. If, as has been suggested, matt conveys reserve, the feeling offered by colours may thus intensify along a scale of gloss emphasis; at a certain point, related to technology and expense, it may then come to express an ambitious and even unacceptably inhuman desire to overwhelm with grandeur.

INDIVIDUAL COLOURS By way of preface to the following extremely speculative section, it might be as well to propose that, if any reader feels that the interpretations of individual colour meanings are inappropriate or go too far, he should try reversing or substituting them one for another. He will then find that they really do work only along the lines here suggested.

BLACK Black surfaces absorb light. The analogues in experience are the black of night, of fainting, and of 'death' when sight fails. Germination takes place in the darkness of the hidden source. As a ceramic colour black is thus identified with the substantial 'form' of utter shadow, and its significance must be based upon its 'negative' quality. It may, for example, represent in painted designs the solid substance of bodies which displace and contrast with the generally luminous pot ground (early Middle Eastern and Greek black-figure wares), an 'unvalued' setting of undefined space (Greek red-figure

wares), or a purely conventional drawing substance which is so commonly current in a graphic culture that it becomes virtually 'invisible' as a colour-value. This last function, admittedly, is common only on some later eighteenth- to nineteenth-century Chinese and European wares, and it can seem somewhat out of place in combination with high glaze. Black as a body-colour may seem to give a satisfactory density of reality to a ware. But how one feels about black may also have something to do with the climate one lives in. In torrid India it may symbolize a grateful shadow, and it can even have erotic or lively overtones among peoples whose hair is black (e.g. Peru). One of the world's most beautiful pure black wares was the Northern Black Polished ware (a true archaeologist's name!) made in the Ganges valley during the mid to late first millennium B.C.

In the conscious aesthetics of China and Japan black enjoyed a special role as a symbol for the neutral, undefined quality of physical presence which gave 'reality' to phenomena, the 'root' of all colours. It was used as such in black-ink monochrome painting; but in ceramics black-glazed Chinese T'ang and Fukien as well as Japanese Raku wares enjoyed a special reputation in the East. This may have

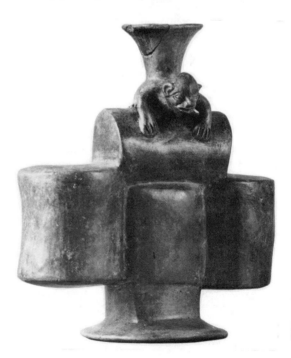

Hand-modelled jar from
Peru. Polished black ware

been partly due to their gloss, whose abrupt highlights give to an intrinsically negative 'substance' a luminous and undeniable presence working a counterpoise to the ceramic shape's 'function'. In eighteenth-century famille noire ceramics the large expanses of black ground, which may be very thick and translucent, are usually overlaid with the same transparent light green as is used in the decoration. This gives them a special resonance, the basis of which will be apparent in due course. But it seems to have served to symbolize in the Chinese mind a kind of fertile darkness, a black felt to be not negative but in a sense creative.

In European ceramics black must retain something of its older, generally funereal, symbolism associated with night and blacked-out worldly sensation. It may well be that in some Neolithic and Bronze Age funerary wares (Hungary, Kansu, China, c. 2000 B.C.) the blackness of the painted whorls has something to do with post-mortem (maybe also ante-vitam) symbolism and beliefs. But most Europeans of the later Christian era will have accepted it as tinged with its function as part of the livery of death and priestcraft. The 'formality' of black ceramic liveries may in some sense symbolize the suppressing of the more vital and perhaps disruptive feelings (cf. Wedgwood's black basaltes ware).

Most black ceramic pigments are based on iron. But the manganese oxides in primitive technologies also give a dark colour which shades off to purple and so has a warmth about it which the iron blacks may lack. This manganese colour certainly shared in the general symbolism of black. But it had a different inflection, towards an active rather than a passive darkness, due to the red, positive colour component. An interesting technical point is that it has been shown that the Chinese learned about 1650 to persuade essentially manganese ores to fire to that clear blue which was so much admired all over the world, and had hitherto been made only with cobalt. The affinity between two dark symbolisms, which will be discussed later, would thus have been reinforced by material and technological considerations.

WHITE Pure white as a colour for ceramic bodies was for centuries scarcely attainable. Now it is universal. There is, however, a long history of white surface pigments. The natural significance of white is, of course, as a polar opposite to black. It reflects the most light of any ceramic pigment and at the same time unlike clear glass does not transmit images of its surroundings. In relatively unsophisticated colour-

cultures (e.g. the Classical Greek and Roman) it may render simply the brightness of pale objects, such as the skin of females. But it may actually symbolize abstract light in those cultures in which this is an important element (e.g. Islam). It seems to belong where all the colours of actuality vanish in brightness. It also symbolizes 'purity', since it shows at once any contamination which may fall upon it; and this has always been associated in the public mind with high caste, social status, and spiritual advancement. In many symbolic decorative systems white also plays, along with black, an important role as the light pole in the metaphysical dialectic of positive and negative forces, of light and darkness, of Yang and Yin. This dialectic may be given different interpretations according to differing traditions.

White may work, when it is seen as 'livid' rather than luminous, as a symbol for that absence of colour experienced in the figures of the dead who have lost the vivid attributes of life; it thus may be seen as a 'ghost' colour when it is applied to the face, say, in rituals or recognized as characteristic of bleached bones and wood. It may thus have implications not so much of death as of supernatural, post-mortem spirituality, implications it sometimes shares with silver in literary and philosophical speculation. The precise qualities of its whiteness—greenish, say, or creamy—will give it special overtones either of coldness or the kind of warmth and value associated with ivory (e.g. certain fine Chinese Te-Hua figures)—always, however, associated with remoteness from the everyday world. A fine plate may be said to shine like a full moon; and this lunar association can also invoke its own special aura of meaning. For the light-symbolism of white is not the same as that of gold, with its overtones of solar warmth and red brilliance infusing life into the everyday world. A pure white translucent kaolin body has thus usually been felt to be symbolic of the brightness of the remotely ideal and pure. And one may add to this in the East–West trade context (thirteenth to nineteenth centuries), the fact that the finest hard-paste white porcelain was always expensive to make until quite recently, even in China. It enjoyed that prestige as a treasure which may have owed a good deal to fashion, both in the Muslim and in the Western worlds, but which passed on a special status and value even to its relatively less 'successful' soft-paste or tin-glazed imitations. Thus white ceramic wares have added to their symbolism the cachet of sheer expense and social elevation. As a light ground for the darker blue underglaze or fused-in overglaze enamel it is clearly an element in a light–dark dialectic. As a ground for

the more vivid overglaze colours, all of which are nevertheless darker than it is itself, it still serves as the 'basis' or light-reflecting medium for the translucency of the enamels laid over it.

Blue, especially the dark blue produced by cobalt oxide, is far and away the commonest, and incidentally the oldest, non-clay glaze colour in the history of ceramics. It was used in the earliest phases of glass and frit manufacture in Egypt (*c.* mid second millennium B.C.). But despite its antiquity it only became a standard element in developing ceramic technology after the fourteeenth century A.D. Potters in the eastern Islamic world and in T'ang China had indeed used blue glazes previously. But in Ming China, in Renaissance Italy and fifteenth-century Iran the use of blue ceramic glaze became so widespread that whole ceramic styles were based upon it. It was used as an overall glaze in Iran; to paint decorative motifs in Iran, China, and later in Europe, Holland especially; to illustrate scenes, either painted or later transfer-printed, all over the civilized world. In fifteenth- and sixteenth-century Italian majolica it was used as the basic drawing colour and ground tone for scenes elaborately developed in iron orange and yellow, with copper green set against it. That blue should occupy such an overwhelmingly important position in the history of ceramics—and in painting—needs some explanation.[1]

Obviously a primary element in the symbolism of blue is its natural and inevitable association in human experience with the open sky; and different qualities of blue will associate themselves primarily with differences in the sky. From this element many special symbolic inflections may be derived which can be traced through the history of the arts. Among them are: distance and celestial impersonality; airy power and transcendence; setting and counterfoil to the focal solar gold. All these taken together can add up to a symbolism most suitable to attribute an unearthly super-reality to the surface ornaments which play a vital part in the transformation imagery embodied in ceramics, carrying the imagination far away from the earthy origin of the raw pot materials. At the same time there can be little doubt that, as both Goethe and Rood observed,[2] blue has a character which can best be called 'active shadow', or 'positive darkness'. So it can take on some of the role of black, but with a vital difference. For whilst it can make

[1] See K. Badt, *The Art of Cézanne*, London, 1965, Ch. 1.
[2] Goethe, *Theory of Colours* (*Farbenlehre*), C. L. Eastlake (Mass., Connecticut, 1970) and H. Barrett Carpenter, *Colour*, London, 1915.

its images impersonally present, it can also make them celestially paradisal. The overwhelming blues one experiences in the dark interior of Galla Placidia's mosaic-lined tomb at Ravenna, in the skies of Titian, and in the pale elegance of the Pompadour's salon décors can all, with varying degrees of seriousness, power, and value, impress the mind with an intuition of the unearthly. The lotuses, chrysanthemums, mythical animals, and legendary figures painted on Ming Chinese blue and white wares thus become symbols with a special value, not copies of meaningless reality. The blue trees and landscapes of mythical 'Cathay' convinced Europe not only of their imaginative reality but of their value as ideal patterns. Something similar is also true of the ideal landscapes, Italianate as well as Eastern, transfer-printed in blue on tens of thousands of English soft-paste wares during the eighteenth and nineteenth centuries. Blue thus became the natural vehicle for all those images of the mythical 'dream time' in which ideal landscapes of the mind are crystallized. The blue ground colour upon which Italian Renaissance majolica was painted may have served, perhaps, as a direct symbol for space as the medium for a reality at once present and ideal, long before Cézanne.

There is, however, another aspect to the colouristic appreciation of blue upon white in ceramics, and though it is not peculiar to blue, but common to all single-colour decoration on white, it is far the most significant in relation to blue. Seen on a plain white ground no colour appears to the human eye on its own, and so the effect of any colour never depends on itself in isolation. In fact the ultimate effect upon our minds of single colours depends far more than most people realize on the complementaries they evoke rather than on their own unaided power. Any coloured image looked at long enough will, for familiar physiological reasons, propagate in the eye an after-image of its complementary on the colour circle which will be 'seen' on an adjacent white. In the case of deep blue the after-image is pale orange-gold. (The after-images generated by other design-colours will be mentioned in due course.) Such after-images may be very difficult to perceive consciously; but they work most strongly when the basic design-colour is not complicated by the addition of spots of other colours. This is why Dutch and English faience Delft wares which add little patches of dull red, green, and yellow to their blue can produce an uncomfortably deadened colour-sensation. It also accounts for the success (some feel) or blatant vulgarity (as others feel) of the typical eighteenth-century Japanese Imari porcelain glaze colours

based on blue, allied to a clear iron orange which is a version of the blue's own after-image diverted towards the 'hottest' colour sector. In practice one may find that the after-image of one outstanding, predominating colour may well tinge any adjacent colours in a glaze either by enhancing them, if they lie near that of the after-image, or by dulling them if they conflict with it. Thus a predominant blue can seriously dampen the effect of a less than strident green, whereas quite a dull overall red can much enhance it. This phenomenon is, of course, one of the most powerful reasons why one should see pots not *en masse* but individually, or at least with their colouristic companions. It is also one of the reasons why so many parti-coloured wares, such as some Turkish Isnik, can seem drabber than their many colours might lead one to expect.

The complementary after-image effect, of course, depends upon the colour of the ground itself. Only if it is a pure white will the complementary have its full effect. If, as is so often the case, the ground has a faint blue or green tone, the after-image colour for a blue and white ware can be virtually killed, and the whole piece can take on a kind of single valency, lacking the symbolic resonance of its complementary. This lack of resonance can become quite disturbing if the blues both of the design, and the ground, tend towards the purplish, and especially if there is—as often in early nineteenth-century English wares—so much ultramarine blue used in the design that the ground tone is swamped. In relation to their entire surroundings, not simply to their own porcelain body, blue glazes can, as it were, give peace to the distracted eye by 'neutralizing' the symbolism of their assertive opposites where they appear. It seems virtually certain that the Chinese calculated deliberately the colour qualities of their white grounds so as either to cancel or to assert the complementary after-images of their coloured designs.

Blue glazes can vary much in their tonal qualities; and their emotive and symbolic effects will vary accordingly. The earliest Chinese cobalt glazes have a blackish tinge with irregular dark lumps, which give them a significance closer to negative darkness than other blues. The Ch'ing blues, on the other hand, may often be of precisely the right brilliance to promote a clear, pale orange after-image on a pure white ground. The deep hard glossy purple-blue characteristic of the late eighteenth-century Sèvres hard paste gives an after-image colour tending towards cold yellow and has overtones of rigidity and dominance. Combined, as it so often is, with pinks and purplish tones

its complementary colours tend to be cold yellow-greens. Whitened and paled, fine cobalt blues seem, everyone agrees, airy and frivolous; their after-images are scarcely present but are closer to the yellow-red. The dull blue on much early Delft ware can fail of a powerful effect by its own 'killed' or neutralized quality combined with a blue flush in the ground. The violent purplish blues on much nineteenth-century English commercial ceramics can become so emphatic and assertive, partly because of their red content, that they cancel out the multiple symbolic valencies of blue as a colour, and thus can appear banal.

BLUE-GREEN AND GREEN: COMPLEX COLOURS The complex of pale blues and greens based upon the copper compounds, plus the duller greens of chromium and iron, are probably best treated as a unity. Their range extends all the way from the dark greens, deliberately reminiscent of old patinated (valued) bronze, lead-glazed on Han jars to the cerulean green-blues of thirteenth- to fourteenth-century Persian Sultanabad. Green, unless it is bright and yellowish or strident, is always felt to be a neutral, unassertive colour, not stimulating, even banal, a characteristic also of old summer foliage. Some people (Goethe among them) regard it as a restful and satisfying union of the characteristics of blue and yellow. In Islam it is the central colour, symbolic of the spiritual. A turquoise blue or green may suggest a watery coolness which makes it especially grateful to peoples, like those of eastern Islam, who live in a burnt and desiccated land. They, certainly, are the cultures who have used it most on their pottery—interestingly enough as an overall colour, not as a design-painting medium. Such colours occur naturally in the old glass made in these regions. The Persians have used them very extensively as a leading colour in the ceramic tiles with which they clad the surfaces of parts of their mosques. In its brightest, purest form this turquoise colour is allied with a complementary image of the most fiery golden orange. Of course when it is used as an overall colour, not as a design-colour, it cannot project this complementary image upon itself, but it may itself seem to stand out as the exact contrary to the 'hottest' colour in the scale; this is why it may seem gratefully 'cool' in a torrid climate, as the strong and precise symbolic opposite of the tone of its surroundings.

Among the subdued complex greens the iron-glazed Chinese Yüeh wares and celadons (ninth to sixteenth centuries)—through which the complementary reddish ground often glows—occupy a special place. In China itself they were recognized as appropriate to wares of

Imperial quality during the Sung dynasty, and much exported to the Middle East, and to the West. But it is not likely that Western patrons ever realized how profoundly moving the Chinese found these soft bluish greens. The deeply ingrained Chinese belief in modesty and self-restraint in social manners, in Confucian gentleness (theoretical at least) in personal conduct, their love for haze-breathing landscape and the subtle colours and textures of jade, all combined to make them obtain from these glazes a complex and elusive intuition best summarized, perhaps, in a description of Yüeh ware as suggesting 'the colour of distant mountains'. They belong, moreover, to an unequivocally organic non-ideal conception of nature.

A range of further complex and restrained glaze colours shared in China this same kind of appreciation—all of them used as overall colours on the ware. They were felt to create surfaces which were in harmony with nature, ambiguous in quality, avoiding the banality of crude definition. Their colours, produced by refined firing techniques and glaze compounds, look more like natural than artificial productions; the thick, viscous glaze-body in which they are reflected seems itself to be stone rather than ceramic. This must represent an extreme version of the transformation image, with the artistic value of 'the

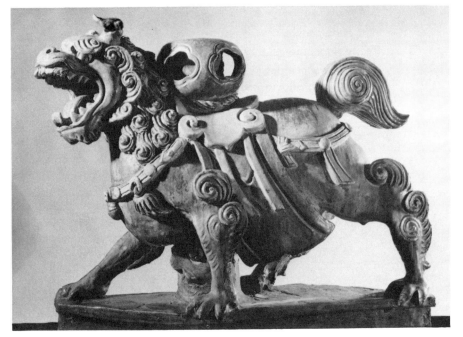

natural' playing a role at the peak, as it were, of the transformation process, as epitome of value. The other Sung wares which follow this aesthetic are the pale bluish lavender Chün wares, technical kin of the celadons of North China; the rare and precious Ju, made only for a very short period early in the twelfth century for Imperial use, whose crackled glaze shades from lavender into green; the bluish Lung-ch'üan celadon whose thick unctuous glaze was laid over a solid body; and the highly refined greyish Kuan, in types of which the body may be far thinner than the glaze. Occasionally one finds similar glazes, whose effect was always earlier felt to depend upon their being used as overall colours, used in the nineteenth century to paint designs on to pots, either biscuit-glazed or otherwise. The effect is strange, and may even seem perverse. But when a group of such similar glazes is used, maybe roughly applied together, on Japanese teawares or flower-arrangement vases which are themselves meant to evoke the world of organic objects, the effects can be most refined.

Clear copper and chromium green glazes have an obvious associa-tion with vegetation. They are used, of course, in ornamental painting simply to tint leaves. In the late eighteenth and the nineteenth centuries a type of pottery tableware (imitated in the twentieth century, but the best known original versions are Davenport and Wedgwood) was moulded with foliage forms and glazed with a glossy but beauti-fully restrained green glaze. The fanciful intention here—a conceit (see p. 188)—was obviously to suggest that the users were eating their food in poetic rusticity from leaves, not plates. By its after-image it can also enhance the redness of a polished wood table-top. Something of this same significance is probably attached by clear green glazes to any ware they adorn. In the Far East this vegetable symbolism of green would be reinforced by the universally recognized association of the green dragon (a common motif in Ming and later ornament) with spring and sprouting vegetation. The more clear and limpid the green the stronger this association probably was, enhanced by its frequent association with bright yellow. And at the point where a green may suggest specific sensuous associations with vegetable foods, e.g. apples, or flowers, it is possible for one's response to an overall glaze colour to become almost physical. One can, however, encounter greens, such as that on the hard-paste eighteenth-century Sèvres wares, whose significance passes out of the realm of the organic altogether. Their relatively restricted spectrum bands make them seem hard and gem-like, transmuting the ambiguously organic (reflecting in

many spectrum bands) into the strict perfection of a mineral order (narrower in spectral range)—an effect emphasized for many of the Sèvres colours by the imitations of raised cabochon jewels along the borders painted on the wares.

Green as a colour for executing designs alone is not very common. It seems not to have the necessary independent substantiality. As ground and design element on Chinese famille verte, or as over-glaze and design element on famille noire, it can play a leading role in a composition. It does, of course, appear as a vehicle for the green dragon on white Ch'ing porcelains, which are often, interestingly enough, given a greenish white ground which cancels any red complementary colour-image. But it seems that it has always been felt to be a colour of resolution, where light and dark balance or cancel each other, not primarily as a colour able to generate a vivid after-image in the red domain.

YELLOWS Yellows, in the pigments we know, are all bright, and most colour theories have accepted yellow as an immediate surrogate for the in-tensest light of the sun, a symbolism it shares with gold. Delacroix (quoted with approval by both Signac and Kandinsky) wrote that 'Yellow, orange and red represent the idea of joy and richness.' Van Gogh regarded it as the colour of light and love. Generally speaking, the paler and greener it is, the lighter, cooler, and less emphatic its effect; the redder it is, the warmer and more energetic. Some yellows —melon yellows—may represent a 'ripening' of green. Antimoniate of lead, the painter's Naples yellow used for warm highlights in flesh, is also used to give clear daffodil yellows in European faience glazes, and perhaps in Chinese Ming enamels. But its tint will not survive high enamel temperatures. Combined with calm blue and lettuce green, as it often was in European faiences, its significance was, as it were, cancelled. For here green represents that point of repose where yellow and blue meet. Good clear yellows, however, for high-temperature glazes may have been evolved in Ming China and purified under the Ch'ing. They were based on yellow iron oxide; and varia-tions of firing gave different tones. In eighteenth-century Europe beautiful high-temperature yellows were fluxed with silver and uranium.

Since the emotive qualities of a yellow glaze may vary according both to its density and to how closely it advances towards either green or red, its complementary images must be taken into account. Used as

a foil to a manganese and copper green, as it so often was in later Ming times, it had the effect of enhancing the purple of the aubergine in which the green by its own complementary image also enhanced the red value, both together making it seem more vivid than it would be alone. Used with the gold-based lilacs and pinks of the eighteenth century on the dresses, say, of shepherds and shepherdesses, it could give them sharpness. But used as a ground (as at Sèvres or Vienna) to predominantly pinkish lilac figure paintings, with gold added, it could sometimes overwhelm and chill them. Their own colours only served to bring out the yellow. At Meissen in the 1730s, when it was used as a ground to a group of primary colours spaced evenly around the colour-circle, together with blue and lilac, a green added to the combination prevented the inversion of its significance, giving a cool rather than extravagant effect. Clear yellows used alone with clear green, as in the Ming (redder) or Ch'ing (paler) 'egg and spinach' green dragon designs, contribute to a most vivid impression analogous to joy and early summer. One extraordinary complex yellow-orange opalescent glaze, so vivid and stimulating as to be scarcely tolerable, was developed in Ruskin ware made at Smethwick in the early decades of this century. Nothing like it had been seen before. Its bowls have the symbolic intensity of suns, the shades blending from pale yellow to orange, and make their surroundings seem shaded and greenish.

A most important factor in the effect of ceramic yellows is how easily they are spoiled, and how much their symbolism suffers from colouristic degradation. A sulphurous green tinge in a 'killed' yellow can produce one of the most distressing colours in the whole gamut. It has been mentioned that an earth yellow was to the Chinese the colour of mourning and the grave. In most Mediterranean faiences the available yellow has been a relatively impure oxide of iron, with a strong earth red tinge. This, used, for example, in majolica on the blue ground with other iron oxides, gives an effect vividly recalling that of the Italian landscape itself in its sun and drought, which everyone must have felt and recognized as truth. But similar yellows used without their true companion tints in the imitation majolica made in Britain, France, and Germany during the nineteenth century, may have all too often an unintentionally depressing effect.

REDS Reds, purples, lilacs, and aubergines form a distinctive series of colours, varying much in density and effect. In fact a true primary red

resembling the colour of fresh arterial blood does not exist in ceramics. An intense yellow-red which can seem almost to bore into the eyes is produced by iron oxides. It is much used in Japanese Imari wares, when it is laid over a white glaze, less vividly in Worcester and Spode. Certain seventeenth-century Imari was famed for its deep mulberry red glaze, the secret of firing which has been lost, even in Japan. A fine iron red was used as overglaze enamel in Ming China.

Red, as a colour-group, symbolizes fiery powerful feeling which can be toned and directed into different expressions either by the inflection of the colour itself towards the yellow or blue poles, or more especially by its association with other colours which can enhance with their complementary power one or other of its aspects. The thirteenth-century Persian mystic poet Jalal ud-din Rumi calls red 'the best of colours which reaches us from the sun'. The feeling-element of red added, for example, to the intrinsic dark, negative quality of blue, which is natural to manganese purple, gives a special tone of dark power to any designs in which it plays a part, as in Kansu burial pots or the bodies of Greek heroes. But perhaps the most self-contained, centrally situated and exalting red is that ruby-magenta called by Goethe 'purpur', and realized in eighteenth-century ceramics by means of colloidal gold-chloride, which will be discussed later.

Far the commonest ceramic reds are the natural iron oxide ochres, the purest of which, such as the haematite ores can give a considerable intensity of hot colour even to relatively primitive pottery. They are, however, always slightly 'killed' towards brown. The hot earth oranges of the Classical Greek red and black wares, the surprising scarlet tones of some Imperial Roman or Indian Doab wares or even the Ming red enamels—which must all, incidentally have been fired to pretty exact temperatures—whilst they may indeed have been very stimulating to their original owners, may seem now to us to lie well within the region of reserve. Haematite ores were sometimes used (e.g. in Iron Age Europe) to sprinkle on the dead, it has been suggested, an emblem of the vital blood of which they stood in some kind of need. It is thus more than probable that red, even in unglazed pottery, added for many pre-industrial peoples, according to their degree of sophistication, a natural excitement to the significance of any ceramic object.

Most iron oxide clays, however, readily burn brown. This seems usually to convey an impression not so much of neutralized feeling as of feeling ploughed back into the soil of everyday reality. The turned

earth is usually a variegated brown, dark in the north, dry and bleached in the south. Any glaze colour, or even a salt gloss, added to any of these would give inevitably a 'lift'. For the duns of peasant pottery illustrated in Dutch seventeenth-century paintings, or standing on beaten earth floors in Chardin's pictures, proclaim the nearness of the ceramic to the dusty earth.

Chinese potters learned during Ming times to make a fine red from underglaze copper, which would be reduction-fired as an underglaze flash—often golden-carp shaped—on a white body. By the seventeenth century Korean potters were making superb copper red designs with great freedom and *élan* under a transparent glaze whose greenish blue tint intensifies the red of the drawing with great subtlety. Copper ores, ground to various sizes and integrated into glaze-frit and fired in an alternating reducing and oxidizing atmosphere, were used under the Chinese Ch'ing dynasty to produce that whole range of blood red, flambé, plum purple, and peach-bloom glazes (developed from the Chün techniques of Sung and Ming times) which met the Chinese taste for complex colour in the reddish range. Either darkened or compounded and reduced towards purple they avoid the declamatory

Dish painted in lustre on white slip, from Rayy, Persia. 12th cent.

Goblet of pale buff terracotta, painted in earth red. From Susa, Iraq, fourth millennium B.C. *Louvre*

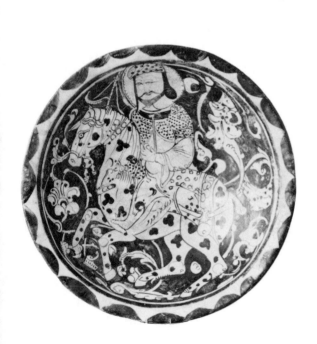

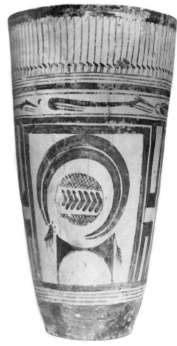

expression of violent emotion which a raw red would convey; although the more vividly purple examples can indeed suggest a most uncomfortable quality of violently unsettled 'underground' feeling, the vehemence of red intensifying the darkness of the blue. For the violence of purple to be truly tolerable as a ceramic colour, it seems usually to have been 'killed' towards a manganese aubergine (common on Chinese famille verte) or, as Goethe correctly observed, lightened towards lilac.

The range of red and lilac glazes developed both in Europe and in China on the basis of colloidal gold-chloride represents a most extraordinary episode in ceramic history. For they gave, quite literally, a new dimension to ceramics—and, indeed, to the colour sense of the whole world. The only pigments previously available even to painting to give comparable tints had been fugitive organic lakes and cochineal. The Chinese famille rose enamel (begun *c.* 1730) and the Rose Pompadour of Sèvres (after *c.* 1756)—both significant floral names—symbolize a kind of ultimate in luxury. What they are based on is that

namelled tile from ersia. Kubachi ware. 600 A.D. Black, lue, ochre, yellow, nd red. Durham University Oriental Museum.

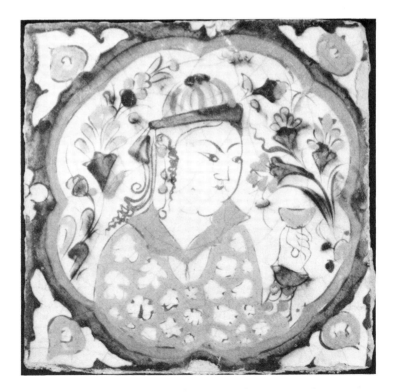

self-contained ruby-magenta colour, which is the essential gold-chloride tone, and which Goethe recognized as the focal or source-colour of the spectrum, containing no tendency either to blue or to yellow and giving a feeling-tone virtually of self-absorbed ecstasy. At early eighteenth-century Meissen and at Vincennes, for example, this colour was used, in all its depth, to illustrate an iconography of idyll. But lightened to pink it takes on what can only be called a note of complacent sensuality, full of intimate, cosmetic—perhaps even physiological—echoes which many people have thought of as specifically feminine. The decorative iconography it is associated with is certainly based upon concerns which have been identified culturally both in China and Europe with high-caste feminine interests; whilst the peony, the gold-pink flower *par excellence*, was in China the standard metaphor for the female sexual organs. Lightened towards lilac the same pigment suggests, for reasons which cannot be explained but only felt, overtones of delicately heated, perhaps erotic, aspiration. When various grades of gold-pinks and purples are used to execute complete Arcadian or heroic scenes, as they were, for example, at Vienna *c.* 1810, with a naturalistic bent, in panels set maybe in turquoise or blue-green ground, the effect can be extremely emphatic—appealing to some, repulsive to others.

LUSTRE Metallic overglaze lustre pottery was probably invented in pre-Muslim Egypt, and thence dispersed through the Islamic world into Arab Spain (Hispano-Moresque wares). It was, however, only used extensively in European ceramics during the eighteenth and nineteenth centuries, although gilding with leaf was, of course, more often used. The expressive qualities of any lustre depend upon its luminosity, upon the colour-inflection of the metals themselves which are alloys of yellow-gold and reddish copper, or of pale silvery platinum (silver itself is unsatisfactory and tarnishes) and finally upon the colours over which or against which it is laid. The popularity of lustres in the Islamic world is sufficiently explained by the general Islamic fondness in art for shimmering surfaces which reflect God's essential light and play down the plasticity of the body they adorn. But in Europe the interest was certainly based upon the symbolic association between precious metals, aristocracy, and wealth. Nineteenth-century lustres (Sunderland, for example) laid on to a reddish purple glaze, clearly use their opulent metals to perform that most important Victorian function—eye-catching. For one of the characteristics of all

Victorian furnishing, as of Victorian collecting, was to fill a room with objects which offered in all directions a mass of 'incidents' for the eye to pick on and enumerate without absorbing. This probably reflected a particular way of gaining a sense of self-identity through sheer possession, without regard for artistic meaning, and may indeed mark out the first phase in that loss of the sense of life-purpose in ceramics, as well as the other arts, which this book is concerned to redress.

SURFACE DESIGN:
GENERAL

When one considers the possible types of graphic design used on the surfaces of ceramics, and their meanings, one has always to take into account the colours in which they are executed, and allow one's appreciation of a design to be modified by the emotional tonality suggested by its colour system. The last may have been subject to fashion and taste, not only in Western Europe. How this is so, and what it means in each individual case, are matters for specialized art history.

A most important aspect of all ceramic surface design is the way in which it may (or may not) pick up and relate to the plastic qualities of the pot to which it is applied.[1] In the most thoroughly successful ceramics the surface ornaments may be related to the form of their pot not only through proportion and rhythm—important though these are—but through actual formal echoes. For example, the conical shape of a Susa beaker may supply a basic motif for variations in its 148 graphic decoration. On a Minoan Cretan jar the form of an octopus painted on it may imitate both the form of the jar and its attributes, such as its double lugs; a row of tall flowers may systematically echo the curves of a contour, while their calyces repeat the pot's own base shape. One can thus find in many hand-painted wares a very subtle and powerfully suggestive transformation of the plastic shape into surface 163 ornament through thematic developments. They may be quite deeply hidden. And in many cases the relationship may seem to be the direct consequence of surface-decorator and shaping-potter using the same basic repertory of design-motifs. This by itself, though, is not enough; in first-class ceramics there will be a genuine proportional and thematic *rapport*, which shows itself in the placing and filling out of the design, between the two aspects, whether they are executed by the same or by different hands.

[1] See the discussion of thematic relations in the author's *Drawing*, pp. 219ff.

The brushwork of practising decorators, who work all day and every day, naturally tends to become conventionalized. A repertory of 149 stroke-forms made by holding the brush in different specified ways, and of assemblies of groups of these varied strokes, becomes natural habit. Such standardized repertories may be wide or narrow, and the motifs they represent may be more or less realistic; they may be common rather than individual property, folk rather than individual art. Work in which this element is strong, showing all the marks of routine production, in which the decorator has repeated the same designs hundreds of times over, can produce extremely fine and powerful decoration. This happens, as is well known, when artists and public share a strong sense of corporate identity in a society which satisfies their existential demands. Even elaborate pictorial motifs can be rendered as repeated brush-formulae, the strength and confidence of which may be a major component of their expression. Many potters nowadays have tried to formulate fresh designs of their own which can be rehearsed and repeated in the same way. And it has become a matter of pride for potters to attempt to create surface patterns which combine the strength of conventional brushing and design with the nuances of a personal calligraphy.

There are ceramic decorators who have succeeded in being highly individual artists. The painters of ancient Greek vases have been identified by their styles, if not always by their names. Sixteenth-century Florentine majolica painters are known by name and style. 178 Early eighteenth-century Meissen decorators and later French ii porcelain painters earned high personal reputations, as did, for example, the Japanese Korin, decorating his brother Kenzan's tea- 153 ware. But in the works of all these artists there is always a solid, underlying basis of carefully studied routine which enabled them to repeat, with variations no doubt, the essence of their designs many times over.

Ceramic painting, even at the most highly individual level, when it conveys unique, freshly developed images (eighteenth-century 184 Chinese Imperial wares), is always a matter of studied, immediate brushwork. This is because every touch of ceramic slip or glaze must tell. No touch can ever be lost. The physical substance, shape, and colour of each single brushstroke claim recognition as vital ingredients in the transformation image. They remain rooted in the physical substance of the pot material. There can be no mistaking the fact that pictorial ceramic painting which loses sight of the physical

reality of its pigments, and attempts to imitate the blending methods of the pure painter, becomes an anomaly and destroys the underlying transformation material. This is a pit into which many of the late nineteenth-century gentlemen-craftsmen fell.

Life in brushwork is a matter of variety combined with clear formulation of stroke-shapes. Both are normal attributes of good drawing. It is therefore natural that those ceramic traditions whose visual arts were based on calligraphic disciplines have produced the finest surface ornament. The obvious examples are the Far Eastern and Islamic traditions. Anyone who has handled and compared the brushwork on, say, Chinese blue and white wares with their European imitations will recognize the distinction between the Oriental and the Western hands. The first is capable of brushing sustained and varied strokes; its linear skill relates directly to linear three-dimensional invention in ceramic forms. The Western hand tends to repeat short, scarcely varied touches, which are combined in transverse rhythms, related generically to the transverse vertical rhythms of additive and

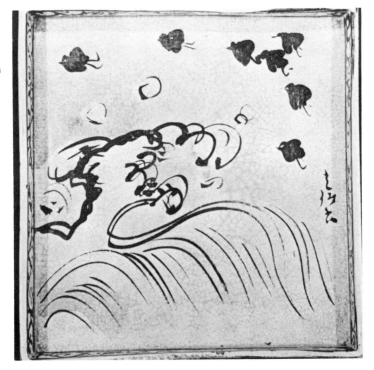

Japanese teaware dish by Kenzan, painted with a design of plover over waves by Korin. Early 18th cent. Dark brown on whitish buff, crackled. Width 8⅝ in. *Cleveland Museum, Ohio, Purchase from the J. H. Wade Fund*

continuous articulation in the body. In the same way as the strokes themselves in good decoration are varied yet definite, so too are the pattern groups they make; internal spacing, rhythms, and variation are all important.[1]

Cutting across all the categories of design described in what follows there may be found a kind of dialectic at work between on the one hand conceptual reduction and on the other a more comprehensive pictorial realization in terms similar to and based on those used in the major pictorial arts produced in the same culture. This second pole of the dialectic, although it has its roots in the graphic arts rather than in ceramics pure and simple, is limited by glaze technology, convention, and accepted ceramic norms. These make it either more or less easy for ceramic decorators to take their imagery close to what pure graphic artists are also doing. One can find, for example, that the illustrative panels painted on late eighteenth-century 'high aristo-cratic' porcelain amount to tightly finished miniature pictures, appreciated and admired for themselves. They were virtually the sole *raison d'être* of the ceramic or enamel snuff boxes which were so

[1] These questions are properly aspects of graphic art and have been extensively discussed in *Drawing*.

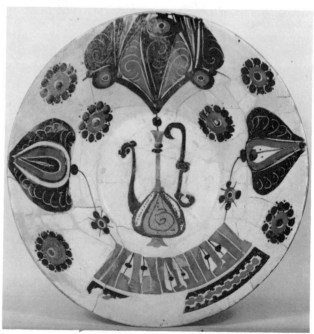

Persian bowl, from Nishapur. 9th–10th cent. A.D. Painted in red and dark ochre over cream slip. *British Museum, London*

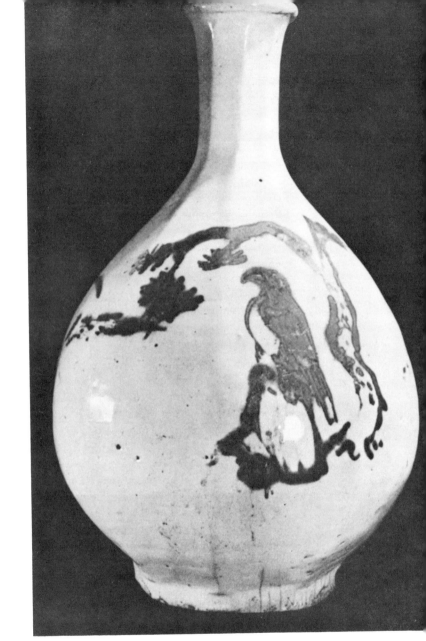

Korean eight-
faceted bottle-vase
with underglaze
red design of a
hawk on a pine
branch, greenish
white body-glaze.
Late 17th cent.

eagerly collected by the quality. The colours may have special inflections, usually towards those gold-chloride pinks and purples which were available in ceramic enamels as against the oil paints of the time. But in principle the works are miniature paintings, to be looked into for virtues similar to those of pictorial art, with the added dimensions of ceramics. Even more striking are the transfer-printed landscapes which appear on countless pieces of late eighteenth- and early nineteenth-century English blue and white ceramics. They may indeed be versions, modified somewhat by ceramic necessity and by colour symbolism, of the representational prints then current and immensely popular. The originals of some designs are, indeed, from well known printed books (e.g. Meissen). Early American Tucker wares take pictorial realism to a naïve extreme. One may also find, for example on Korean or Japanese seventeenth-century wares, designs which use to the full the same aesthetics of abbreviation and hazard as are accepted for painting; such a ceramic design may be virtually a contemporary picture, carried out in, say, red underglaze copper on 155 the rough surface of a bottle-vase instead of in black ink on a toothed paper.

The first pole of the dialectic, conceptual reduction, may reflect, broadly, any one of four situations. First, of course, conventional graphic reduction into generalized shapes may be the sole genuine mode of visual expression in the culture which produced the pottery. The same kind of images may appear on related arts, all constituting the current language of visual form, as in the case of early Mesopotamian Susa or Peruvian Nazca design. The second type of reductively conceptualized imagery may form part of a special stylized symbolic language in a culture which also knows quite other kinds of visual presentation. All heraldic symbolism, for example, comes into this category. And one may well find quite a range of greater or lesser degrees of realization used in the painting of such designs even within the same ceramic tradition. The bear, bird, or leaf in a blazon, for example, may be either very stereotyped or realistically executed within the given outlines of its standard form. The third type is when a ceramic style makes a cult out of reducing well known broader themes and motifs to a special kind of abbreviated symbol language in which are created not stereotypes but inspired comprehensive calligraphic images. Some twelfth- to fourteenth-century Persian designs are of this type. But the Far East especially cultivated the particular expression given by a calligraphy which made a virtue of the unique-

ness and individuality of its every stroke. All artists trained in the Chinese cursive script in China, Korea, and Japan knew how instantaneous, unrepeatable impulses of the hand, combined with the effects of splash and surface hazard, can add to a purely graphic meaning additional expressive overtones. These may evoke memory-traces of movements and realities that have no immediately obvious connection with the reference of an emblem, but which nevertheless enhance its total significance. Fine cursive calligraphy was also used on Chinese pottery. But the most sophisticated examples of calligraphic expression are typical of late medieval Korean and Japanese teawares, which set out to represent at once the uniqueness of each moment and the immemorial antiquity of the processes of change. Conscious aesthetic archaizing can produce some excellent examples of this type of reduction as when, for example, sophisticated second-century A.D. Alexandrian ceramic decorators imitated archaic styles, or eighteenth-century Chinese potters used patterns derived from ancient Chinese tomb bronzes of the second millennium B.C.

The fourth and final type of conceptual reduction is when a stereotype represents an attempt by a decorator who has only a restricted repertory of graphic symbols at his command either to reproduce or to refer back as a value-indicator to a more elaborate and richer graphic imagery—an imagery with which he is acquainted but over which he has no command. A rustic Staffordshire or Delft decorator's version of an eighteenth-century Nanking blue and white landscape would be an instance. But so, usually, would the Nanking original. For it would itself have been a reduction of a more exalted Imperial designer's landscape drawing. This fourth kind of transmutation can produce some extremely impressive imagery when peasant potters convert into their own terminology of boldly brushed stereotypes a more complex, perhaps even an effete, aristocratic decorative tradition. A stylistic terminology originating in this way can revert, and become a pure example of the *first* situation if the decorators lose contact, for any number of possible reasons including political isolation or cultural decay, with the more complex style they are imitating, and cease to make any pretence at 'aping their betters'. Much fine Balkan decorated pottery, for example, fulfils this condition, as does much 'Gaudy Dutch' Pennsylvania American pottery.

The graphic dialectic can be found in all sorts of different historical contexts, cutting across and conditioning the various categories of ornament described below. One can also find two different types of

conceptual reduction 'laid over' each other; as when, for example, a nineteenth-century Japanese potter of restricted formal endowment practises in his own limited terms a reduction of a design originally invented under the *third* grouping, or when a nineteenth-century Staffordshire decorator uses an emblematic border to frame a pictorial design.

The kinds of design used on ceramics can best be discussed in relation to the way they add a content of meaning to the transformation image—not this time at the level of the unconscious intent. All too often the decoration of pottery is written off as mere meaningless ornament by academic authorities, who may perhaps for professional reasons be reluctant to commit themselves to any comment which goes further than classifying the purely external characteristics of the wares. Here it is taken as axiomatic that all ornament has a meaning in relation to the transformation image of the pot, even if any explicit recognition there may once have been of that meaning earlier in the tradition's history has been apparently forgotten. (The poet, however, is always sensitive to the etymologies of the words he uses.) One can only hope that future academic writers will be encouraged to investigate the symbolisms of the individual traditions of ceramic ornament; these must, after all, have remained in use even when they became 'conventional' because, to some extent at least, the conventions continued to have some kind of subjective value, even if only at the level of 'mere talk'. It is, perhaps, not accidental that such an existential downward curve should accompany the proliferation of surface ornament. Where decoration can truly match the expression of the pot body (as in Italian fifteenth-century or Hispano-Moresque faience) one can capture a genuine opulence of feeling. But where the reality and presence of the pot body are subordinated to the status of mere vehicles for surface decoration, one may well find that the transformation image has lost its roots, and that decoration and body are not truly complementary.

GRAPHIC EMBLEMS A first category of decorative designs can be called graphic emblems with a generic significance which relates them to charms or amulets. The essence of the graphic emblem is its flat character. It adheres, as it were, to the outer surface of the pot, implying no visible space which is not the pot's own surface. It does not demand that we make an imaginative act which breaches the integrity of the plastic body. This

also means that graphic emblems can combine into single images, forms whose meanings could never be brought together in more 162 'realistic' representations. Animal and vegetable may be combined not only by being added together, but more subtly, by being set off against each other as positive and negative aspects of the same silhouetted forms.

Emblems as amulets are, of course, easily misunderstood by a certain type of modern Western mind, which is accustomed to dismiss such symbols as mere superstitious rubbish, produced by a misunderstanding of natural causality. To far the greatest part of the human race, however, such emblems have been extremely important; they still are, even among our European contemporaries. This is not simply because people believe them to have a physical effect on the environment, but because they can reinforce and develop a person's sense of his own being and value, maybe in the face of disease, danger, and the unknown. And we can easily misunderstand the meanings of emblematic symbols if we imagine that they must have simple, single-valued translations into words that correspond with meanings we ourselves give those words. They don't. It may, of course happen that the graphic elements which compose designs may be so general—triangles, zigzags, and so on—that without documentary evidence we cannot know either what they were meant to signify, or what recognizable reality they were supposed to indicate. One thing, though, does seem certain: that strongly stylized patterns are felt to have an especially potent magical value, the more so if they contain rhythmic alternations and counterchanges which are the visual parallel to incantation-rhythms. It is true that artistic patterns, unlike the symbols in developed graphic scripts, do always retain some visual conceptual resemblance to what they signify. This is the genuine distinction between the conventions of script and those of visual communication. Context and usage would have provided the key to specific meanings of elements in the generalized design-languages of cultures remote from us. Some we can perhaps understand partly at least, because we use similar images ourselves. Primitive peoples often used triangles for hills; so do we on our road-signs. They may have used parallel zigzags for water, as we do on our maps. Other peoples may have used triangles for clouds. But we can only grasp something of the feeling implied by certain groups of triangles and zigzags, for example, if we actually know that they refer to imagined towering mountains and vast waters which the dead are believed to cross as they journey to

their 'other world'. If we want to approach the complexes of meaning to which amuletic emblems refer, we have to accept that such meaning, like a pot's other meaning, can only appear to us as a constellation of mutually reinforcing and overlapping indications, none of which alone 'contains' the whole meaning. An additional difficulty, of course, is that because we have so very little direct information to go on in understanding the art of the most remote cultures, we may be compelled to remain in the dark about large stretches of significance. If we are prepared to grope and interpret the clues offered by comparable usages in other cultures for which we do have some information, we may go further—at some risk, it is true. But our stated aim in this series of books is to 'appreciate' the arts, including those of exotic peoples; and appreciation is a matter of feeling and sympathy, not merely of amassing a file of accurate detail. This last, of course, may be forever impossible for the meanings of the arts of most dead or alien cultures. We must again, for our own benefit, be prepared to acknowledge and trust our own responses, hoping to discover resonances in ourselves which the works themselves evoke. To the extent that certain forms and images are archetypal, and that human experience has common structural features, we can expect some success.

One of the commonest factors in the emblems on the primitive pottery which time has preserved for us is their association with ideas relating to water and food; this is conveyed in their shorthand reference to living creatures, including men, which have a direct relationship with the burning question of whether one eats or starves. On innumerable ceramics from the early phases of many cultures we will 148 find formalized symbols for the animals the people used to eat, especially goats, cattle, and moufflon, often supplemented with 162 symbols referring to foliage and trees. Rectangles symbolizing enclosures or pens, as well as the mountain-triangles and wavy water-lines, may also appear. References to fishing (Mohenjo-daro, third millennium B.C.) and hunting with bow or spear (Susa, third millennium B.C.) are quite common. Sometimes animal and vegetable may even be joined into a single image, as at Nal in Baluchistan (third millennium B.C.) whose pots showed cattle adorned with leaves.

Quite possibly there may have been legends circulating, now lost, which identified human or animal figures on many early wares with mythical characters; and many vessels must have been given a ritual significance by such ornament. But even if we know nothing of these, the emblems indicate clearly enough what their users felt the con-

tainers to be functionally related to. By the added dimension of graphic symbolic thought the pots were extended into a realm of meaning which had a high content of feeling for the users. If we are to appreciate such art, we must beware of doing what academic categorizers must do, and 'earth out' our feeling responses in a conceptual jargon which refers with pseudo-scientific detachment to 'hunting and food gathering', 'food animals', and so on. This only removes us from aesthetic contact with the pots. Instead we have to make the effort imaginatively to put ourselves in the place of the users, seeing the symbols as having not the content *we* might see in them— references to certain classified food-items to be butchered and served —but as elements in a vivid life of sensation and emotion, which could be positive and affectionate, not merely negative and utilitarian. 'Primitive' people, for all their sacrificial rituals, are quite ready to compare their lovers' hair with their goats'.

Many such direct references to the fabric of active life can be deciphered in the elaborate languages of symbolism which have been incorporated into ceramics. For example, on Susan pottery we can find references to irrigation ditches, hunting from boats, and even perhaps to the alternation of day and night by means of 'rolling' winged rectangles partitioned into light and dark. A herd of goats may be rendered as a flat glyph with a head at each end and many legs; and this symbolism may be extended on a bowl, for example, by partitioning the interior into four 'cardinal' directions with a goat-herd on each one, thus suggesting, perhaps, goats 'in all directions', as a schematic image of wealth.

Such symbolism can constitute at once a complex mixture of wish, claim, and assertion. The people whose feelings it was aimed at originally, and who could afford the more expensively decorated pots, were usually kings, chieftains, the rich generally, or status groups. An aristocracy always lays claim to status; and kings may even assert their command over the whole world of nature through an elaborate fabric of symbolism. The superb pictures on the palace storage jars of Minoan Crete, illustrating flowering plants and many sea and land animals such as octopus and dolphin, must have been not merely 'delightful' additions (though certainly inhabitants of 'the palace' would find them so), but must have carried implications of dominance over and possession of all the desirable foods, beauties, and domains ('the dolphined sea') which were held to be natural tributaries to people proud of their vitality and dominance. They may, too, have

referred to the means whereby they were acquired, as for example by ship or war. The poor man's pots may wear their own images of his more modest stake in life. And what the life which is nourished by food and the feminine is felt to consist of, *that* is what lies behind the symbols.

There is, however, one important special use of graphic emblems: as ornaments on funerary ceramics, especially jars which were intended either to contain the remains (bones or ashes) of the dead, or 194 vessels meant to be buried with them. And the graphic emblems used for this purpose seem quite often to have been adopted and transferred to adorn the wares meant for the living, at least ceremonially. One may guess that it was perhaps partly for reasons having something to do with the display of social prestige customary at funerals in many 'early' societies, that such other-worldly symbolism was adapted to secular uses. (Of course, it was not confined to ceramics, but was used on other grave furnishings.) Some became, perhaps by literary association, part of the conventional symbolic apparatus of established religion; in Islam, for example, the tree of life, the mosque-lamp, and the mihrab-niche, which indicates the sacred direction of Mecca, were used in ornamental emblems. Ornament of this kind

Pueblo Indian (Zuni) clay jar, hand-modelled and painted in red on white with animals and emblems. The animals show the 'life-line' and the heart in the 'X-ray' style. *British Museum, London*

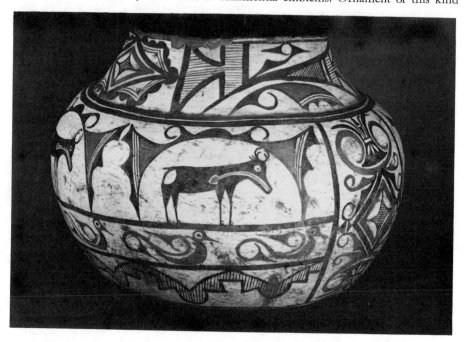

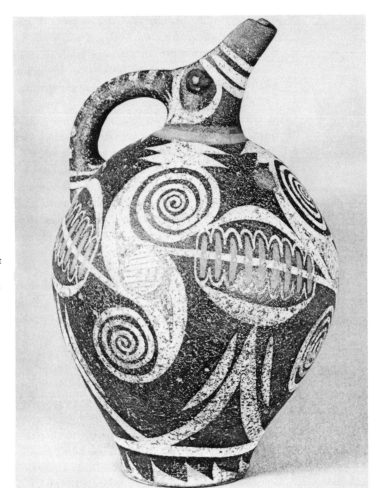

Cretan jug from Phaistos,
probably ceremonial.
1900–1700 B.C. Abstract
vegetation designs in
white and red on blackish
ground. H. 10¼ in.
Heraklion Museum, Crete

would have been most appreciated on their ceramics by those who
lived a consciously religious or ritualistic life.

The commonest mortuary employments of emblems are those
which refer to the life-to-come or to the essentials of life-in-this-
world which the dead wish to take with them, either by means of
sacrifice or by artefacts acting as surrogates. Some funerary wares may
actually set out to represent in summary form the world of his normal
life which the dead man may wish not only to remember, but actually
to realize in the spiritual world. Hunting and animals are naturally

common motifs. But one mortuary symbol of special importance is widespread across Asia, the Middle East, Europe, and into Africa. It is the curvilinear whorl or meander, sometimes squared off into the 'Greek key' or labyrinth pattern. It has been shown pretty conclu- 16 sively[1] that this design expresses a tenuously formulated intuition of the shape and continuity of successive creation and destiny in time. In its early European forms (e.g. on tombs in Megalithic Ireland and Brittany) it relates to the maternal function of the earth as both womb and grave, cyclically giving and receiving. In more easterly regions the concept may become articulate as a mythology of continual return or reincarnation. Sometimes it has been associated with patterns of dance and ritual which still exercise a fascination in our secular age. Symbols based on the whorled or S-scroll meander may be adapted to illustrate the concept of a post-mortem journey, either across water or over mountains, which may take on rationalized, literary garb as a visit to the underworld. But, generically, such whorl-decoration seems to indicate that what it adorns is in some sense supernatural. 163

There have, of course, been peoples who have lived totally absorbed in a ritual existence, and who have seen their own lives as an unbroken continuum with the being and acts of the deities who populate their mythology. These people may show in their ritual ceramic ornament no traces of what seems by comparison the secularized concern with goods and possessions in the 'wealth' emblems discussed above. The most thoroughgoing examples of emblem-languages related to this ritualism are those used on Central and South American pottery. Its stylized jaguar masks, feathered snakes, skulls, and status symbols indicating 'heads taken' are deeply 193 rooted in an ideological system which recognizes no distinctions between what we would distinguish as the material and the transcendent worlds. And the important fact with even these cases, as with all the other cases of genuine emblematic decoration, is that: THE EMBLEMS REFER TO REAL EXPERIENCE; that is to say, they have a genuine meaning in relation to life. In addition they may well have had quite a wide circulation in their own culture, being used to adorn many other objects than ceramics. They may therefore have had a well-understood formal meaning which would have carried its own special patterns of response with it. When confronted by emblems we

[1] G. R. Levy, *The Gate of Horn*, London, 1963; W. F. Jackson Knight, *The Cumaean Gates*, Oxford, 1936; S. Giedion, *The Eternal Present*, New York, 1962; R. B. Onians, *The Origins of European Thought*, Cambridge, 1954.

must always, therefore, make an effort to fathom the reality, and hence the degree of genuine feeling, which lies behind each formal symbol. This will depend, naturally, on the cultural situation of the people who use such symbols; and this is why we study iconography. But all the emblems must have been meant, in some way or another, to add value and spiritual effectiveness, through their evocative overtones, to the ware in the eyes of its user. Even if we describe them as mere packaging devices to make the pot or its contents more 'attractive' to the buyer, we must realize that the word 'attractive' conceals a plethora of those cultural and psychological factors of which modern advertising research has made us aware.

We must always therefore allow for the likelihood that to other people than us their emblems, however 'conventional' they may seem to our secular and abstract imaginations, may have a far greater content of direct significance than we may be willing at first to believe. Living as we now do insulated from the practical necessities and experiences which were once part of people's everyday lives, we may find it all too easy to write off other people's ornament as having been to them 'purely conventional' in the same vulgar way as it is to us. Everyone must judge for himself how valid these overtones from direct experience may be. But surely the beautiful stylized hares and birds on Persian ceramics, for example, which look to us 'merely decorative', may be so artistically vivid at least partly because they record vestiges of the Middle Eastern hunter's direct feeling and memory of the *movement*, not just the static appearance, of hunted animals. At another level the dragons which gyrate on thousands of pieces of Chinese porcelain must be recognized as emblems for vital cultural realities, constantly present to Chinese minds, even though the dragon is not a 'real' animal. As an emblem it summarizes, nevertheless, a wide complex of real experiences embodying power, such as thunder, flood, and Imperial justice (the emperor was supposed to be the earthly embodiment of the remote celestial dragon wheeling round the Pole); dragons live underground, and the 'dragon arousing' expresses the urgency of springtime. Again, the peacock which appears so often on Muslim wares as emblem both of dynastic and metaphysical glory, means more to people in whose experience the sight of a male peacock spreading his tail is a reality than to people who have never seen such a sight. The imaginary Chinese Phoenix, which did have a visible basis in the gorgeous Chinese pheasant, was used to symbolize all kinds of brilliance,

seasonal, dynastic, and sexual, each aspect reinforcing the others with its own associated feeling-traces.

Other Chinese examples of the complex and allusive symbolic language of the Far East are the peaches so common on Chinese 63 eighteenth-century ceramics, which not only recall experiences of the fruit itself but convey references to Taoist sexual rituals and imply vigorous old age. The various 'precious things' such as the scroll, 40 ancient bronze, silk, and cash were used perhaps more conventionally, but still with concrete references, to hint at both the wish for (on a gift) and the claim to (on a possession) cultural wealth. Other Chinese emblems which may be based on stock phrases, such as the leaping fish that symbolizes success in examinations, or the mandarin duck and drake which mate for life and so refer to married happiness, take on a far more vivid dimension of meaning if we can awaken in our minds appropriate memory-traces. This is so even with others which are derived from puns, like the bats that allude to happiness.

Heraldic emblems of noble families, European and Japanese, say, may have little content at all for us today. But to their original patrons, whose whole sense of security, status, and self-value was rooted in the family, they may have meant a great deal. Families have often treasured legends describing the 'original', maybe mythical, occasions on which their emblems were adopted, and which linked them to a super-natural or heroic identity. Even the emblems for military prowess, conventional classical trophies consisting of captured weapons, helmets, spears, and Roman eagles, so often used on late eighteenth-century European porcelain, must have had a genuine content of aristocratic self-congratulation ; for it was customary (indeed still is) in many aristocratic houses to maintain collections of weaponry con-nected with the family's military past, arranged in trophy patterns on the walls. Hunting trophies composed of horns, guns, dead deer, and hares must also have had at least some content of vivid experience to aristocratic people who spent quite a lot of their time out killing animals, many of them dangerous. And such hunts may perhaps have retained psychological overtones of the far older royal ceremonial hunts whereby a ruler was supposed to demonstrate his dominion over the animal world.

One final type of purely graphic symbol used on ceramics is writing itself. It may be added both for what it says, and for its own calli-graphic beauty. On Persian (Raqqa, Rayy) wares the script may em-body reminders of religious or heroic duty and virtue. On Chinese and

Japanese pottery it may add the aesthetic savour of poetry to the contemplation induced by food and wine. A wine-jar, for example, may bear characters reading 'purity, clarity and abundance', which is a rebus referring at the same time to the virtues of the jar's contents and to human virtues. On the Englishman Thomas Toft's earthy and 77 vivid dresser slipwares script may declare (a point, one supposes, for domestic pride) the name of the potter. On many a Staffordshire piece were recorded these popular patriotic slogans which were current during the rising phases of British imperialism. They added to dresser wares, no doubt, a satisfying declaration of conformist identity.

FLORAL DECORATION One special category of symbolic ornament plays so large a part in the whole history of ceramics, Eastern and Western, that it needs a special 32 discussion. It is the stylized flower ornament, in the shape of garland, 71, meander, or posy. Flowers have exercised a powerful fascination over the minds of men as symbols loaded with feeling; and in the form of garlands they have been used to decorate sacred objects and images, shrines, the necks or heads of sacred victims, or of feasting men.

Individual flowers and their names have each their own culturally conditioned symbolism within particular traditions. Unless we look into the matter we may find it hard to believe the wealth of lore and symbolic belief about flowers and plants which other peoples, whom we may consider primitive, retained in their minds. Even our own ancestors responded actively and precisely to vegetable symbols. In Europe and Islam the rose (the old-fashioned single kind, of course) has been the queen of flowers, focus of the closed-in garden of the mystics. It has been used time and again, partly for the sake of its mandala-like radiating petals, to symbolize both the central and feminine mystery of the universe and the wisdom which reveals it. The fertility and springtime goddesses of the ancient world were conceived as having bodies, or at least dress, composed of flowers; and countless post-Renaissance images of Flora (a kind of compendium of Ceres and Persephone) show her in a dress elaborately sprigged with blossom.

Many other plants, some flowering, some not, have a special significance in European tradition. The laurel, for example, identified as transformed Daphne, beloved of Apollo the Sun-god, was used to crown the victor. (Ovid's *Metamorphoses* is a treasurehouse of traditional and now barely recognized transformation-metaphors.) The vine, Dionysus's own plant, whose fermented blood was in Greece ¡

the instrument of ecstasy, and in the Christian world the means to eternal life, was perhaps the most frequently represented of all, supplying decorative art with an infinitude of forms, including those once vital but now forgotten book-printer's tailpieces. Fig, ivy, honeysuckle, dianthus also had their roles. In Islam an imagery based on many of the canonical flowers cultivated in the garden, that grateful oasis of peace and early analogue of Paradise where the fountains of life play and the rivers run, was used as a basis for more or less elaborate and abstracted fantasies in literature and in every kind of art. In the Far East the winter-flowering plum, narcissus, peony, and chrysanthemum were the most important symbolic flowers associated with special meanings. The plum represented sexual pleasure; associated with ice, as in the 'prunus and cracked ice' design on ginger jars, for example, it referred to such pleasure in old age. Narcissus was a constant simile for young feminine beauty. The vivid pink peony is a most elaborate metaphor combining into one thought both summer and the feminine external genitalia, prized as one of a woman's beauties; on eighteenth-century famille rose enamels the flower was often shown as welcoming the solar, masculine 'red bird'. The chrysanthemum became, perhaps, a more generalized symbol for late summer splendour, the pleasures of maturity and the elderly contemplation of longevity, nourished by chrysanthemum wine, so deeply cherished by China's scholar-officials.

Perhaps the most important single flower, so far as pottery decoration is concerned, is the lotus. It had a long history as a symbol in Egypt, Greece, and the late Classical world. It appears as a border of petals on many Classical Greek wares, in a design which, probably *via* the Middle East, reached China. There it was combined with an originally Indian Buddhist symbolism for glaze designs. The lotus blossom, in fact, is a whitish pink. But during and after Ming times it was most often painted in China as blue, on blue and white porcelain. This adds a dark, celestial dimension to the literal significance of the flower, which always refers to a crossing over between the physical and metaphysical worlds. The real lotus grows straight up from its rhizome, which spreads in a lake-bed, out of the water on its stem. Its leaves spring separately. In blossoming, therefore, it crosses the surface from under the water into the air. Seen from 'our side', the physical world expands towards us like an opening lotus from an unseen region. Buddhas and Bodhisattvas emerge into our world from opening lotuses; saved beings are born in a reverse direction out of

our world into the Buddhist Paradise in lotus blooms. Innumerable Ming bowls and jars bear rings of opening lotus petals around their lower parts—their feet particularly—which vividly suggest a special transcendent value for the pot itself, and bear out one of the suggestions offered below.

These flowers and plants were employed in real garlands before they were used as ornamental motifs in decoration alone. The very idea of the garland, however, is a symbolic notion of great antiquity. Weaving and knotting strands together is a fundamental and profoundly symbolic human creative activity, connected in the figurative thought underlying many languages with the processes of creation and destiny. Woven garlands were, we know, customarily draped upon sacred trees, on the doorposts of temples or those many rustic sacred objects and images at springs, by roads or in the fields scattered over the ancient world. They seem to have transmitted something of their magical and honorific power to the carved or painted garlands, festoons, swags, and leaves which first of all became commonplace on architecture, and then on those many ceramics which drew inspiration for their ornament from architectural forms. One further elaboration of the garland very commonly found, when it may be of laurel or acanthus-type leaves (perhaps referring back to an original symbolic palm), is made up into a circular wreath. This, of course, is outwardly honorific, as when it encircles a scene on a dish, and refers back to the garlands bound in Classical times on the heads or necks of honoured men, victors, or poets. Here they symbolize conferring a happy fate, endowing them with a fertile destiny.

In both East and West, where documentary evidence exists, it suggests that garland-forms, or related symbolic flowering and fruiting trees with their long undulant stems, have yet another dimension of buried but active meaning[1] which may join itself to the symbolisms of shape and colour in all ceramics. This is the implication that the object they adorn is full of some kind of 'sap of life', felt to be an analogue of that generalized creative energy which different mythical traditions particularize and interpret each in its own way. On the evidence of parallel phenomena, well authenticated in India and the South Pacific, we may grasp how vegetable strands and garlands on a jar may symbolize the channels and nodes through which creative vitality flows into the nourishment which the jar itself contains. Thus

[1] F. D. K. Bosch, *The Golden Germ*, London, 1960.

to add fictive vegetation to any object may attribute to it some morsel of that ultimate but undefined value which we can only designate by our degraded and almost meaningless term 'sanctity'. Such garlands or trees when their symbolic impact is enhanced by the form and significance of the meander, described above, can attribute to ceramics they decorate, or the walls the ceramic tiles decorate (e.g. Islamic mosques) a powerful but quite undescribable significance. We can only appreciate them if we are prepared to make the necessary imaginative projection. There is good reason to believe that even in the eighteenth century ceramic decorators had some sense of the deep-laid numinous value of their ornamental forms, which they shared with the decorative engravers.

A functional relation, most likely, of the garland is the sprig or ribboned posy. In the Islamic world the ornamental sprig of dianthus, for example, was used as an equally distributed diaper pattern on textiles from about 1550 onwards. It may have originated there from the sectioned design given by ceramic tiles, each with a single floral spray, applied to a wall and from the patterns of carpets which represent, at bottom, the Paradise-garden, whose floral symbols are laid out in formal beds. We may recognize Muslim sprigging in certain Chinese ceramic designs. In Europe, however, it had become customary by the sixteenth century for aristocrats to carry a posy of aromatic herbs as protection both from disease and from the offensive odours in their lives. These became almost a mark of caste. Furthermore, the whole poetic tradition based upon late Classical idyll (Theocritus, Virgil, Islamic love poetry, and the Troubadours) and the broadly Neo-Platonic Renaissance cult of love imaged the beloved woman as a 'shepherdess', who spent much of her time in gathering flowers and making posies. The beribboned aristocratic 'shepherdess' became, by the eighteenth century, a stock figure of high-caste mythology. And it was natural that her porcelains, those instruments with which in her salon she fulfilled her feminine social nature, should bear the stock emblems of the once poetic, but now domestic, status she claimed for herself. Sprigged posies with equal spacings may indeed promote an undemandingly feminine rhythm.

RHYTHM IN DECORATION A further aspect of all ornaments is their value as rhythmical element, punctuating and structuring the external or internal space of the pot in terms of metre or rhythm, often in bands. The rhythm may be irregular or regular. When, for example, there are seven main blooms in

a meander circuit, or sixteen, the aesthetic effect will vary accordingly. Usually we will find the metre most satisfactory if the rhythmic elements are emphatic enough for their modular unit to be easily picked out. If, however, they are executed small and evenly, they may (as on much eighteenth-century French porcelain) produce the visual equivalent of the musical grace or trill. A pattern of this sort, truly related to the proportions and scale of the piece, is what is so often lacking on wares which are not hand-painted but decorated with transfers. For printed designs were often conceived quite out of any relation to the proportions of the final pot, and were in practice cut up and applied with careless joins or overlaps.

A similar type of metre, related to architectural proportion, naturally belongs to those bands, panels, partitions, or arcades so common on Classical wares and on eighteenth-century European porcelains. These are, on the most effective pots, disposed so that 4 their separations and breadths, or their diameters on the section, bear some relationship to the proportions of the pot itself; and especially on Classical wares, these may be based upon regular pro- 175 portions which the eye can readily take in. These proportions may be conceived upon a single unit of width, to which larger and smaller elements bear one of the simple numerical proportions $1:2$ or $1:3$. On a surprising number of wares this unit-measure will be found to be the *difference* between two major form-units of the pot, or between its height and width. On Peruvian Nazca pots one may find horizontal and vertical partitions which follow a continuous progression of size from one measure to another, following the scale of the plastic spread of the pot surface. And, of course, vertical divisions can only be experienced correctly in *turning* the ware; for the pot's curvature away from the eye destroys the metric value for a purely static attention. It is possible that more sophisticated systems may theoretically be based upon those fertile proportional norms (expressed as $1:\sqrt{2}$, $1:\sqrt{3}$, and $1:\frac{1}{2}(1+5)$) so widely adopted in architecture which, since they can only be assessed, not measured, by the eye, cannot be precisely incorporated into so complex and tactile an object as a pot.

On many wares, of differing cultural standards, one may encounter what can best be called texture-metres added to the faces of a pot. Ground patterns, such as trelliswork, cross-hatching, or even the 40 striped fill-in brushwork on peasant wares, may convey measures 77 related to the true proportion of the pot, which may have very powerful rhythmic effects. Again it is only by hand-painting that such

texture-metres can be executed in direct response to the proportions of each piece; though well-conceived transfer prints may indeed have some success. Such designs, by means of their glaze colours and density, also give a specific quality to the surface, especially by giving it presence without weight. Executed as an element in broad designs they may seem to give the textured parts a life within the surface of the pot, whose own presence they may dissolve (e.g. in Persian, Chinese Ming, and Balkan peasant wares). Carried out, for example in rocaille basketwork patterns, they may also suggest a transparency which floats just above the actual surface of the ceramic. The elements out of which such texture-metres are composed may themselves be symbolic, with a reference beyond pottery, as when they refer to textile design, basketry, or brocade patterns. They may also consist sometimes of a multitude of 'degraded' symbols, which have been reduced to a repetitive mass.

One ingredient in decoration which is sometimes not properly appreciated is the way in which even the most schematic designs can imply quite vivid movement in or of the pot surface. Directions of movement can be suggested, mainly by attributing to represented living creatures movement, which can be woven into impressive counterpoint. For example, a chequer board of flying birds 96 may be horizontally opposed around a Peruvian jar; or animal forms may 'rotate' around the centres of early Mesopotamian bowls. Such movement need not be produced by lines or shapes which are themselves imbued with movement—though in cultures with high calligraphic traditions it may be. In contrast the implied movements of figures within more fully realistic styles do not have this effect. For their character as 'pictures' isolates them into their own space, and prevents their kinetic content being seen as intrinsic to the pot surface.

PICTORIAL DESIGNS — All the methods of decoration discussed in what follows demand that we read into the pot some kind of space which is not limited to its own surface. They call for imaginative visual projection on our part of the subject-matter of the surface design out of the order of visual reality which the pot itself occupies into another. In all of them we will find that it is the vertical axis of the pot which supplies the fixed point of reference for the world of figurative imagery. The imagery has its own inner logic, in which painted pots may exist, but not the pot on which it is painted. The images refer to objects as existent in a coherent world of their own, and by this means they develop a spatial

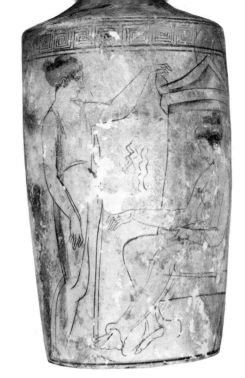

Greek lekythos painting,
black on white slip,
illustrating a woman
making an offering at the
tomb of another woman.
420–400 B.C. *British
Museum, London*

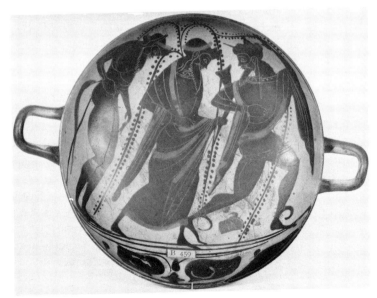

Interior of a Greek cup,
illustrating Dionysus,
Hermes, and a Satyr.
500 B.C. Black figure on
red ground. *British
Museum, London*

depth within their own terms of meaning which works as a powerful element in the total transformation image which the pot itself becomes. At the same time we will usually find that, however highly developed their techniques for representing bodies may be, the greatest pottery traditions by various devices always jealously preserve a strong sense of the material fabric and visual coherence of the basic pot-as-object. No ceramic decorator, of course, ever employs any motif for the sake of mere pictorial completeness. The pictorial imagery is employed for its positive symbolic value. It is usually confined, on pots large enough to require it, within bands or panels in a ground. There is, however, a group of very interesting and often beautiful modes of decoration, used on pots whose physical fired-clay presence is nevertheless obvious, which seems virtually to ask us not so much mentally to dissolve each pot as an entity as to envisage its surface as transparent in some special way. Various characteristic modes of space will be brought out by concentrating on specific styles, which each exemplifies its type in the highest degree. There are, of course, many intermediate possibilities, but this spectrum of types can serve as a general key to what we may look for.

FRIEZE DEPTH The first level of change from the emblem to the spatial image is probably best represented in the black-figure ceramic painting of archaic Greece (derived from the emblematic geometric) which was 173 replaced by red-figure styles about 530–20 B.C.; it may also appear in Egyptian (tenth century A.D.) and Persian (Rayy c. 1200 A.D.) dark-figure imagery on bowls, which seems to have a special kind of notional, maybe even traditional or conceptual, relationship with its Greek predecessors for all the stylistic differences. In practice Islam's interest in stylized flat line prevented its ceramic design from developing in the direction it did on Greek wares. We know that Islamic peoples had positive theoretical and religious grounds for retaining the integrity of their surfaces, and resisting suggestions of bodily presence; and those grounds became progressively more firmly established in artistic practice through the earliest Islamic centuries.

The basic notion of black-figure design was that within the circuit of the design-space objects were 'objectified' by the density of their darkness by the positively applied black pigment, which suggests the spatial density of bodies. These bodies—human beings, gods, animals, ships, and so on—are set in relationships which correspond with remembered visually-perceived assemblages of bodies: but

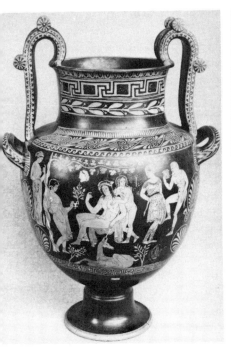

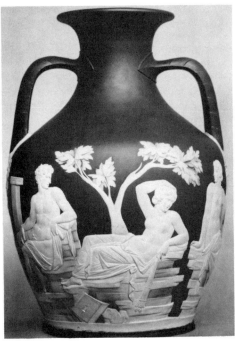

bodies which are selected as individual symbols, isolated by the focus of interest, value, and feeling into a single shallow space-band, quite distinct from any visual continuum which everyday reality might present by being rendered in their most 'typical' profile extension. The lines which characterize them are laid out along the surface, and refer only to volumes parallel with it. Limbs are all extended in a two-dimensional profiling. And the ground against which the bodies are set appears as a warm luminosity—the red oxidized clay—which thus takes on an indeterminate and 'negative' value as a sort of floating indefinite continuum contrasted with the bodies of the dark figures. This corresponds closely with contemporary techniques of large-scale sculpture.

The bodies imaged are, however, related directly to the shape of any black format which may frame them, and stand on its base-line. In the disc of a bowl-floor they are frequently adapted, curved, or postured, so as to treat the whole curved 'lower' edge of their design as their base-line. In the bands or panels around the exteriors of jars the bodies are arranged on their flat base-line, perhaps curved in the third dimension over a shoulder-surface, so as to 'radiate' around the axis

of the pot. This effect is not incorporated into their space-image. So in a sense the figures are still kept very tightly related, almost as emblems are, to their actual pot surface. One would not say the artists were aiming at 'relief'; for major parts of the pot body may also be black. They were aiming at a presence which they felt to correspond with physical identity in both realms—that of the pot body and that of the design. The black and red represent an ontological polarity of presence and emptiness. In red-figure painting this polarity is reversed, red becoming presence, black emptiness. Again echoes of this procedure are found on Egyptian Fatimid, eleventh-century, and Persian Kashan, thirteenth-century, wares, modified by Muslim linearism almost two millennia later. For a while in red-figure wares the conceptual basis of black-figure thought was retained.

The subject-matter to which these styles were devoted is interesting and important in the history of ceramics. The main themes are grouped here under five general headings. First: heroic mythology of the kind we meet in Greek drama, including legends conceived as belonging to the recent past, many of them having, no doubt, a 'family' significance as they do in the celebration *Odes* of Pindar. These are the legends in relation to which the Greeks 'located' their existential identities. In this they were imitated, perhaps with less seriousness and more fantasy, by Muslim Persians. Early medieval 148 Persian pottery often bears images of legendary heroes. Second: scenes of Dionysian exaltation and frenzy, the participants being goat-hoofed satyrs and maenad-women brandishing thyrsoi, as well as Dionysus himself. These scenes probably illustrate a profoundly significant 'type' with which the Greeks felt their own religious being to be bound up, a counterpoise in impersonal ecstasy to the ordered cosmos of duty and social identity. Third: the feast. For the Greeks, as for the Etruscans, the feast or wine-party had the obvious secular fascination; but it also had meanings which related it to the Dionysian frenzy of wine. In other cultures it was also related to the after-life of heroes. Many militant populations from India to Iceland have imagined this after-life on the pattern of a soldier's heaven, consisting literally of wine, women, and song. This category of subject-matter was adopted in Italy under the very secular Romans as overwhelmingly the most popular, often represented with its normal erotic incidents in relief on concave mould-thrown and impressed red or stimulating scarlet wares. The fourth category illustrates scenes of religious ritual, either sacrificial before images, or, on lekythoi (libation 173

bottles) especially, funerary commemorations of the dead person, who is shown sitting to receive his offerings. The fifth, and least significant, comprises scenes of everyday life.

The change from black to red figures, however, made possible a special development of the sense of space in relation to pots. For in order to paint in the black ground around his bodies, i.e. the red figures, the artist had first to draw the *outlines* of the whole bodies. Whereas the black-figure painter composed his bodies out of areas with prescriptive shapes almost in the manner of sophisticated tangrams[1] modifying and enlivening them with overlaid lines, the red-figure artist developed a purely linear fluency which had to *suggest* the volumes it contained, and was also able to refer to many visually observed details of bodies and the real world. He also was able quite easily to dispense with the black ground altogether, and (e.g. on funerary libation lekythoi and on late Hellenistic vases) to draw freely in outline and in areas of colour-tone pictures of bodies in action which seem to inhabit a reality independent of the pot's surface conformation. Athletes, women with children or umbrellas, floating assemblies of gods, were painted on the surface virtually as if it were flat, treating it for all its unequivocal physical clay presence as if it were a more or less indifferent support for the bodies. They, however, never claimed to occupy more than the single constricted space-band within which archaic relief had confined itself.

Likewise also the relief scenes on moulded Megarian bowls and on Roman wares remain, for all their overlaps, within a single group and for all that as *reliefs* they project moderately from the pot's surface, do not breach this fundamental conception of depth. The pot's surface thus may be made to seem as if it were not flat but of a transparent depth of thickness adequate to contain bodies that occupy it, bodies whose movements for all their volume are usually most carefully controlled so as to imply no vectors which would pass beyond the limits of this band of depth. By this means the iconography is kept within an imaginative realm which remains firmly attached to the pot body. An even firmer frieze-like depth-identity is preserved in, for example, fine Central American, especially Maya, ritual painted wares. Here the sections of which the figures are composed are made up of strongly outlined segments whose contours recall the contours used analogously in sculpture. The third dimension is given and accepted

1 Tangrams is a Chinese game, in which a set of cut-out shapes of standard pattern are manipulated to create images and quite elaborate designs.

as a foursquare depth, the defining contour being deliberately taken to its maximum extension on the very frontal plane.

The self-conscious attempts to revert to the frieze depth made by Wedgwood in the 1780s in his Jasper wares based upon the glass 175 reliefs of the Roman Portland vase, and imitated, for example, at Sèvres, seem not to have been able to achieve the same sort of genuine 65 connection between surface imagery and the nature of the pot. Too much pictorial history and too many devices for emphasizing pictorial depth had ingrained themselves into the European eye. Stiffening the outlines and eliminating too many body overlaps was not enough to abolish the whole weight of eighteenth-century spatial fantasy. This is not, of course, to say that such wares are not beautiful; but they must be recognized for what they are, a special classicizing and archaizing version of the European painterly style, which eliminated only the background of 'reality', not its methods of bodily definition.

PERSPECTIVE PICTORIALISM The next mode of treating space in pot decoration with clearly marked identity is that used on many sixteenth-century Renaissance majolica, Tuscan especially, which also had an odd three-dimensional inheritance in Bernard Palissy's French Mannerist faiences. This has a

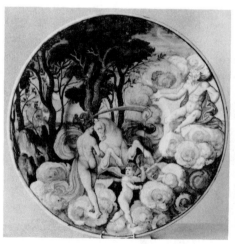

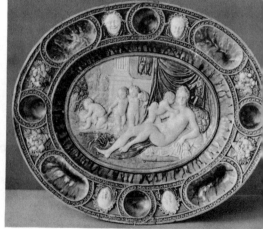

double aspect. In the first place the wares frequently, but by no means always, bear panels or bands of emblematic ornament which reinforce the presence of the glazed surface of the pot body. In open wares a shield-like boss at the centre may again emphasize the fired-clay presence. The technical forebears of this conception belong to the world of Islam, with overtones drawn from the late Byzantine and Sicilian-Norman decorative repertory. Into this ceramic idiom, based upon surface emblems and rhythms, was emphatically thrust the Quattrocento perspective-image—the second and from our point of view the more important aspect of majolica space-definition. A natural consequence was that such wares often present a single principal 'face' to the observer. A majolica plate of about 1510 in the Victoria and Albert Museum shows a majolica painter at work drawing the basis of his design in blue pigment, over which would have been laid iron yellows and red, purple, and green. The picture panels on majolica may occupy a whole face, say, of a dish; or they may be 178 framed in cartouches reminiscent of the frames given to both pictures and sculpture in Renaissance churches. The designs themselves have more in common with the schemata of contemporary engravers—on whose works, indeed, some designs are certainly based—than with the free inventions of major painters and sculptors. But the essential characteristic of these majolica pictures is that, using emphatic and relatively intractable ceramic glaze substances in strongly conventional colours, they set out to imitate typical three-dimensional techniques of Renaissance relief-sculpture and painting which were based upon that monocular peephole-perspective which subordinates figures to a horizon line and a unified vanishing point. This creates the visual illusion of a continuous 'space-box' which, however much it may be banded into depths, begins at the foreground and ends at a deep horizon, unless it is cut off by a 'backdrop' as it often is in majolica.

This drastic conflict between conceptual space and emphatic glaze surfaces with their constant colour system can produce a most extraordinary and disturbing effect. The ascendancy of these alternative elements, of course, fluctuates in different wares and individual pieces. Emphatic brushwork can make even a strong perspective design tend towards the emblematic. But there can be no doubt that a major effort of these majolica painters was bent on converting the surfaces of pottery into analogues of conventional painting supports (panel or canvas) which were supposed virtually to abolish themselves in

lian majolica dish, inted in tin glaze by ancesco Durantino th a design represent- g Saturn appearing as a rse to Philyra, *c.* 1540– 45. Colours: blue, hite, yellow, red, and own. *Victoria and lbert Museum, London: own copyright*

sh by Bernard Palissy. ance. Second half of th cent. Glazed in blue, een, yellow, cream, and ll red. *Victoria and lbert Museum, London: own copyright*

favour of the depth-boxes painted onto them. Thereafter to create such pictorial depth-boxes on the faces of ceramic wares became one of the chief aims of glaze-decorators all over Europe, their three dimensions combined in a dialectic with the two dimensions of the emblematic design based upon garlands, architectural derivatives of garlands, and rhythmic texturing.

The iconography of these pictorial designs must have played an important part in directing the painters into that particular mode. In the first place it awarded to an imaginary environment, symbolic of the 'ordered' world, an existential value equal to that of the figures populating it. In fact an overwhelming emphasis is laid upon those heroic classical legends which incorporate the idea of personal *virtu* (virtue); briefly a kind of compendium of personal courage, stoicism, charisma, and vigour. This is the mythology upon which Renaissance men came to frame their sense of personal and social identity. The legends had to be artistically executed in what was then regarded as the rational and authoritative perspective manner appropriate to the true Roman style. Allied to the pictorial images were pictorialized emblems of triumph, military victory, and Neo-Platonic enlightenment. When, therefore, these wares were used at table in a grand house, family, guests, and servants alike would be confronted with visible manifestations of the indwelling domestic *virtu*. The second major category of subject-matter might cast this impression in a different mould. For, of course, a great deal of Roman Catholic religious imagery was also painted on majolica wares—but, be it noted, in the same 'virtuous' Romanizing style as the classical imagery. It should be added that in Spain large religious majolica ware pictures were painted on tiles, principally for monasteries.

Several important traditions stemmed from the adaptation to ceramics of the Roman and perspective imagery evolved in Renaissance Italy, reinforced by mechanical optical machines. Perhaps the most important consequence was that the mode of conceiving reality within a space-box fronted by the pot surface entered deeply into the eye of European art. It was reinforced by the prolific circulation of Italianate engravings which became a spate during the sixteenth century. One result was that when the ceramic decorators of major northern tin-glaze centres, such as Delft, Rouen, and London, attempted to imitate the landscape on Ming blue and white ceramics, they 'saw' the Chinese originals in their deeply ingrained European terms, and were never really able, for all their summary execution, to

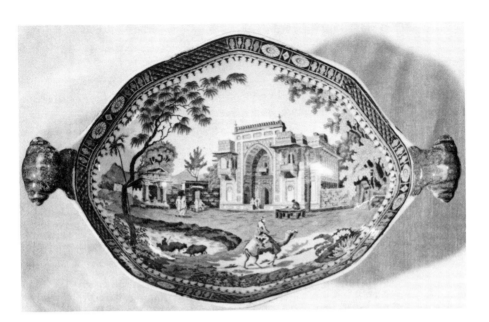

tureen, English, by
Rogers of Staffordshire.
Early 19th cent. Printed
in blue with a transfer
landscape

cast off the underlying box-perspective structure of space, and think as the Chinese did. Indeed one of the things Western patrons seem to have found so charming about Far Eastern wares was the sense of freedom and trans-reality their painting conveyed—precisely because it was based upon a conception of its own (ceramic) pictorial space, which had never submitted to the perspective-box. It will be discussed later on (pp. 183ff.).

The Frenchman Bernard Palissy, working for the French court during the later sixteenth century, used lead glazes on his earthenware, not tin; he was, though, a French Mannerist, subject to the same kind of association between perspective space and, if not Roman 'virtue', at least Italianate fashion. His elaborate designs, and those of his followers, were carried out in relief and usually based on Italian engravings or verbal descriptions. Some of them create, by means of 178 their low relief, a pictorial depth within their panelling which seems to contrast with and complement the plastic protuberance of the surrounding ornamental features. But others, the famous dishes, much imitated in the nineteenth century, which contain virtually three-dimensional snakes, fish, and moss, amount almost to three-dimensional transformations of tableware into the fashionably startling and 'out of this world' grotto-objects. Though it should be

noted that original sixteenth-century work in the Palissy vein, unlike its imitations, could still actually be used to serve a meal in the admired 'grotesque' environment.

The ultimate development which three-dimensional pictorialism reached in the eighteenth century was much aided by the expansion of glaze technology, which gave to the ceramic decorator, as we have seen, a range of colours that enabled him to approach the works of pure painters in perspective 'realism'. The breaches through the pot surface into the third dimension were allowed and compensated for by the decorative frames or ground ornament by which they were usually surrounded (almost suggesting proscenium arches) and most of the themes were anyway subjects belonging to the world of literary dream and fantasy rather than reality. They thus invite the spectator into a world which does not set itself up as in any sense a counterpart to or correlative of any sort of everyday spatial reality. Cherubs on clouds, for example, were no longer the subjects of intense 'realization' as they had been at the hands, say, of Veronese or Titian, who saw in them depths of Neo-Platonic significance. When designs couched in the current graphic language were executed, as they so often were (e.g. at Meissen), in colours that had a strong and independent symbolic value, such as blue or purple-magenta, the conceptual normality of the designs was effectively counterpoised. Brushwork, of course, can always reduce a realistic image in the direction of the surface emblem. One does, however, find certain eighteenth- and nineteenth-century wares which create a kind of ambiguity or continuity of spatial sense, whereby it is possible to read the large flowers in the border as continuations of the vegetation contained in a thoroughly perspectived scene in the centre of a dish. Such a disorientation of the senses is specific to ceramics.

Many eighteenth-century transfer designs representing, say classical or exotic landscape in their original printed versions, perhaps in a topographical volume, were originally meant at least partly to constitute an addition to conceptual and factual knowledge. But when they were used as ceramic ornament, printed in blue, it must have been for their symbolic significance. They added, no doubt, suggestions of 'knowledge of the world', high-toned feeling, and response to the 'picturesque' as elements in domestic self-recognition. In practice, however, a high degree of perspective realism in ceramic design depends largely upon two factors which may easily be forgotten. The first is the symbolic value of box-perspective itself. It had, from the

late Quattrocento through to the early twentieth century, a special status as a symbol of scientifically 'accurate' visual truth reinforced by the drawing machines which were used to attain it. To this kind of vision changing emotional values would be attached both according to period and to subject-matter. By the eighteenth century, however, when virtually the same graphic style was being used to illustrate scientific volumes on conchology or general zoology as was used to represent erotic episodes from the *Metamorphoses*, its symbolic value must have become identified with the 'reason' of the intellectually 'curious' as the eighteenth century saw it, not as the Neo-Platonic Cinquecento did. The second factor is that eighteenth-century society, for all that it understood well enough certain grades of emblem, needed an elaborate apparatus of visual rationalization to persuade it to respond to a complex symbolic idea, as well as demanding of art that it ruminate sensuously upon the pleasurable physical details of either a 'real' object or a fancied one. The eighteenth-century response to graphic symbols was not immediate, direct, and unambiguous, as a 'primitive's' would be. It needed its values to be spelled out in all their alluring attributes.

FAR EASTERN PICTORIAL SPACE The Far Eastern—specifically Chinese—sense of pictorial space is certainly the most important for the whole history of ceramics. It is based upon assumptions and intuitions, even a metaphysic, which were foreign to the entire Western humanist tradition. This sense of space is apparent whenever the subject-matter of the ceramic decoration ceases to be emblematic and becomes representational in the pictorial sense. It is, in fact, an extreme form of that pole of spatial thought described by the French art-historian Henri Focillon as 'l'espace milieu', space as an unbroken environment without defined limits. The Far Eastern ceramic painter has always treated the pot surface as if it were crystallized out of the continuum of space, pre-existing as a kind of provisional segment of endless space in which objects may appear quite naturally. The artist thus has no obligation to define a perspective-box, or to make his objects fit into the frame provided according to any formula save their own presence. The picture does not have to describe a complete visual field to be consistent. For even when there is only one feature on it, say a single figure, the picture space is already, as it were, complete and satisfactory in the pot surface; what the artist does is to materialize with his cursive brush those aspects of the phenomenon he considers worth rendering. He

can quite happily allow parts of an object to 'vanish' beyond the edge of the format as if it continued in space beyond it. For the pot's own space is continuous with the space around it, into which it extends and which it makes perceptible. 132

This contrasts strongly with the Western space convention, which insists that only the bodies represented are there, and that the picture surface itself is, in an important sense, like an open window, 'through' which, not *at* which, one looks. Its presence is accepted as a plane intervening between ourselves and bodies, although the latter

Polychrome enamelled, white porcelain bowl, Chinese. Yung-cheng reign mark. 18th cent. Colours: blue, greens, pink, yellow, and black. Diam 16·1 cm. *Palace Museum, Taiwan*

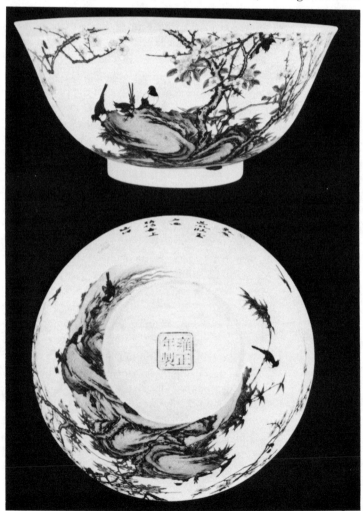

may certainly be co-ordinated strongly with it. Thus Europeans looking 'through' their ceramic surfaces have felt that, for the scene surveyed to be convincing, it must be bodily complete. That fading away at the edges in the manner of a vignette, used on some eighteenth-century porcelains, in fact gives the European viewer an impression of losing focus or of fading reality where the rendering vanishes. In a Chinese picture on the other hand we are quite prepared to accept large gaps of empty space or the vanishing of rock-massifs, without reading them as an interruption in the continuity of space.

That this can happen has a good deal to do with the way in which the Chinese brush 'realizes' bodies. For it guides our eye along highly varied and changing linear tracks over the surface, each of which offers what one can call a satisfying kinetic 'ride' to the attention. Attention can then pass from one to another in the same way as our natural perception is guided by interest on a pathway over the visual field.[1] Space to the Chinese is not composed of defined enclosures. It is a real but fluid medium of space and time in which the attention encounters phenomena. And since phenomena are to the Chinese truly 'appearances' rather than solid bodies whose space-content indicates an absolute substance, the Chinese artist is not obliged to define complete bodies in order to convince us of the reality of the space his phenomena occupy. The sense of sight can accept whole flowers, parts of the trunk of a pine, segments of bamboo, a few humps of rock and ground, all appearing in an arrangement which demands no explanation as a complete system of interconnected volumes. Relationships of 'before' and 'behind' expressed by over-laps, of far distance by 'height' in relation to the lower edge of the format (the near being low) are needed. And so, to a certain extent, are what one can call 'normal' visual proportions of objects distant and close, determined against a scale of optical measure. But that is enough. Since in ceramic painting the eye may be supposed to travel from painted object to painted object, adjusting its focus as it goes, there need be no great difference in touch and handling for notionally distant as opposed to less distant objects, such as there may be in the atmospheric, independent landscape painting of high Chinese art.

This treatment of pictorial motifs on ceramics is quite consistent with the Chinese conception of the nature of ceramic form described below (p. 187)—indeed it complements it precisely. European

[1] Cf. *Drawing*, pp. 15ff.

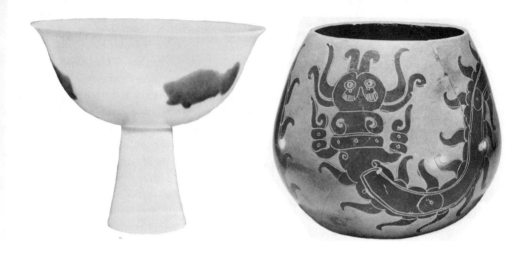

pictorial techniques are not consistent with their ceramic forms in the same way; they introduce into the surface of a concrete object a symbolism of a different order. All European attempts to imitate and adapt Chinese formulae have suffered from their drastic and visible change of conception. The brushwork, however swift, easily falls into a very few stereotypes, which Chinese does not; while pictorial designs, also becoming less fluent, tend to approximate more to surface emblems than to spatial images, becoming decorative rather than pictorial. They thus lose their underlying seriousness of intent. But the relationship of the Chinese spatial conception to truth also underwent changes and degradations inside China itself. Some pots (e.g. flat sided baluster vases) were made expressly to support their painted decoration. The greatest ceramic decorators of the eighteenth century (who painted the Imperial wares made under Yung-cheng) used their white porcelain bodies—rice-bowls and small vases—with virtually the same freedom as painters, treating them as a painting ground of most interesting and challenging format, even developing them as space-images in a manner described below, without this resulting in the degrading of the existential basis of the ceramic object. Less able artists, however, especially those working on the commoner wares for export, tended both to reduce their pictorial images to schemata and to try and adapt their designs to Western box-perspective, sometimes by copying Western prints, again without losing contact with the reality of their ceramic object. This process produced many odd and fascinating spatial images.

Chinese Ming stem-cup,
white porcelain with
underglaze red flash
shaped like a fish. H. 4⅝ in.
Hsüan-te period (1426–
)

Pottery jar, from Otates,
Vera Cruz. Painted with
centipedes in dark red on
buff. White outlines
incised. H. 6⅛ in. *Museo
Nacional de Antropología,
Mexico City*

It is also interesting to transfer one's appreciation of this Chinese pictorial conception of space away from the obviously pictorial subject-matter to which it is strictly relevant towards designs which should belong quite firmly in the category of emblems. As it has been suggested that the Chinese conception of pictorial space was indeed consistent with their conception of ceramic form, one can therefore readily understand how some of the finest Ming designs on bowls, jars, and plates can take on a new dimension of imaginative conviction from the spatial mobility of the surfaces they adorn. This is particularly evident in the case of fluent designs, such as dragons among clouds, lotuses in water, or the copper red underglaze flashes on 186 stem-cups which resemble glimpses of golden carp under water. If one accepts the pot surface itself as a crystallization out of a fluid space, the ornaments too can seem to acquire a meaning in reality which does not confine them to the space crystallized in the pot itself, but suggests that they have a phenomenal presence both within and independent of the ceramic surface.

POT SURFACE AND
ACTUAL SPACE

This insight leads directly to one more important way of handling the surface designs of a pot, which is found on, for example, Ming and Ch'ing Chinese ceramics, on Cretan jars of the mid and late second millennium B.C., and on certain Central American pieces. This involves using the three-dimensional movement of the surface of the pot to impart an *actual* third dimension to objects painted on the surface. On a Chinese jar it may be a dragon in blue; on the recurved face of a Cretan vessel an octopus among seaweed; on a cup from Vera 186 Cruz a centipede coiling around the exterior. Whilst this is in China a natural extension of the Chinese conception of space, it represents a special and most significant departure in other cultures. For it brings intimately together the imaginative reality of the painted figure and the actual reality of the world which the pot inhabits as object. There are many extremely subtle expressive possibilities in this procedure. Some were taken up by Art Nouveau potters at the end of the nineteenth century, when swirling three-dimensional shapes were incorporated into ceramic wares. But this was usually accompanied by so strong a reduction in the physical and tactile identity of the pot-as-object that the effect is less interesting than it might have been. Gauguin's ceramics succeed here where more 'sophisticated', professionally-potted works failed. Such an ambivalence in space can produce a strong dislocation of the sense of scale. For we are no longer looking

at an illustration within an object which makes us accept imaginatively the scale established within the illustration's own terms of reference; our attention is not focused down within a scale suggested perhaps by painted architectural columns as well as by the actual size of the objects so as to dissociate their 'space' from ours by symbolic distance. Instead we are ourselves virtually transported and located into a world whose scale is determined by the images on the pot. We do not —and this is important—adapt the scale of the images to the scale of our surrounding real world, but the other way round. Why will soon be apparent.

One interesting incidental point about figural decoration on ceramics is that human figures which actually seem to be looking 'out of' the pot and addressing themselves to the spectator, are very rare. Occasional Muslim Egyptian or Persian Minai and Kashan lustre figures of the early Muslim Middle Ages do so from their 'bodiless' surfaces, perhaps in distant imitation of Byzantine and Coptic images. So do occasional European figures copied from portraits. But it seems to have been almost always necessary to avoid any sense of direct human address, so as to preserve, no doubt, the existential identity of the pot body from too gross an encroachment by the illusionist impact of its pictures. For the pot as a whole object to address itself to the beholder with an organic presence represents a radical further step in the transformation process.

METAPHOR AND CONCEIT Ceramics has contributed one of the most important streams of method to the complex phenomenon we know generically as sculpture. Like the graphic arts, the three-dimensional arts know two major modes, or polarities, of fictional or notional space. One, the mode of space as unlimited environment, has already been described as characteristic in its most extreme form of Chinese (and other Far Eastern) arts. It will be discussed later in its modifications or degrees in so far as they affect ceramics. The other polar mode is 'space as content' or 'space as enclosure', and is perhaps the mode which is typified most clearly in much ceramic sculpture. What we may call 'potter's space' shows it, perhaps, in its purest form.

One preliminary distinction is necessary: that between the true plastic metaphor and the 'conceit'. Both occur in ceramics. Metaphors of various types and grades have already been described, especially in connection with plastic shapes. And, of course, it is metaphorical suggestions that colours and designs can contribute to the formal

meanings of pots. The essence of the metaphor is that the suggestions conveyed by the pot's inflections and forms are communicated as allusions, while the pot retains its existential identity, visibly and tactually, as what in fact it is. Thus a Korean wine-jar may be trimmed, 113 pinched, striated, and lidded to suggest a fat bamboo sprout; but it remains nevertheless unequivocally a pot. Its colour may be that of 'distant mountains', but only by analogy: its glaze remains glaze. The conceit, on the other hand, sets out to imitate a single natural object to the extent that the pot's identity and its many-dimensional symbolism may be shed in favour of one dominant analogue. A T'ang-dynasty cup shaped as a halved shell may be glazed in the conventional ceramic colours used on other pots. An eighteenth-century Chinese porcelain fish-tank may be painted on its interior or exterior with convincing golden carp. But a Chelsea porcelain box, shaped and glazed in imitation of and the same size as an apple, with a lid-handle the size and shape of a caterpillar, has abdicated its pot-nature to the extent that it imitates in all its visual aspects a single overwhelming analogue. More important, it accepts the scale of the everyday world of reality in its detailing, losing the status of complex transformation image in favour of its one 'amazing' conceit. It induces no modifications of scale, does not extend its tentacles of meaning into other realms of significance not usually associated together, and rests all its aesthetic claims in the exchange of significance, the ceramic becoming a particularized apple. A more refined version of this procedure may produce such an object as the Worcester leaf-shaped pickle-dish, which is moulded with the image of a folded-back cut-out section within which a tiny picture is painted.

This distinction seems to be a crucial one in art. A banal naturalistic sculpture of a nude boy or girl used life-size without any supporting environment as a war memorial, for example, may look to say the least of it strange, a poor cold creature in the snow, because it is based upon the straightforward conceit of a change of one sensuous aspect of a reality—the visual—into another substance (cf. also Claes Oldenburg's 'soft' objects). A true sculpture of virtually the same subject would contain a multitude of many-valued metaphorical suggestions in the inflection of its forms, which might thus become completely 'unrealistic', or at least subordinated to that analogical mode which is the real definition of 'form' (cf. *Drawing*, pp. 24ff.). It would, theoretically, be possible to introduce into a conceit like the Chelsea porcelain apple a second layer of genuine metaphor. Such

things happened in China, where for example a glass peach-shaped snuff-bottle could be shaped as a peach which is itself shaped like a youthful female vulva. Such things must, however, have been difficult to realize within the ceramic traditions we know.

The essential basis of art is the transformation of a material entity, which has an existence as something in its own right, not into one thing but into a complex of sensuous analogies, each of which is rendered symbolically, not by imitation. This seems to be a most useful criterion in all sorts of ways. It is an important help in exploring those borderline regions where ceramics and sculpture meet, especially in the mode of space as environment, where problems of attitude and appreciation can become acute. For as the symbolic transformation

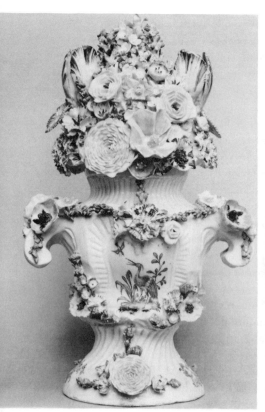 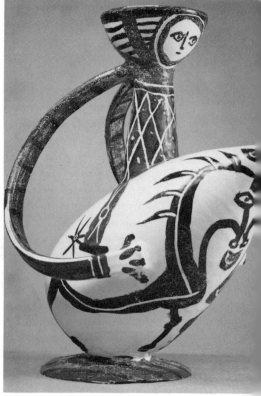

elements gradually impose their own symbolic entities, and their own space-scales, the nature of ceramic objects can be subtly changed.

CERAMICS
AND TOTAL
ENVIRONMENT In fact the conceit is one logical terminus of that process which has taken place in several sophisticated traditions, when an extravagance of metaphor overwhelms an entire artistic style. It gathers together all the different arts to transform the whole environment, and obliges each to extend its resources drastically. Under such circumstances ceramics has been compelled by the demands of fashion to work out forms which have no obvious connection with the life-use and intrinsic nature of pots as such. A conscious 'high style' of this kind may then establish norms which later craftsmen may continue to follow when the original environmental metaphor has vanished or changed.

The outstanding example is that complex mid eighteenth-century aristocratic style, South German and French, which has inspired so much of what Westerners take for granted as fine porcelain. It evolved as a consequence of the high social game which required palatial interiors to be transformed into allegories of Arcadian—and totally unrealistic—flower-entwined rusticity or shimmering, cloud-wrapped Paradise. The porcelains made to serve such an environment came thus to embody many fantasies. Even interior wall-decorations were sometimes made of porcelain, and figures and busts of ceramic were placed at focal points of the décor. Some were based on the cult of Chinoiserie which 'saw' things Chinese as representative of an idyllic country where sage-kings ruled without strife. Other fantasies no less potent followed the literary conceit that domestic utensils were made of leaves and flowers. And so we find, for example, tea-sets carefully modelled and cast in glossy, grandiose, expensive wares as if they were leafy extravaganzas coiled and twined with fruit pods and blossom, their spouts and handles twigs or animals with open mouths. Painted decoration bulging with ribbons, gilt, and piled with bloom, would continue and amplify the curls and twists of the underlying forms. In nineteenth-century provincial England this fantasy lingered on long after the austerity of Neo-Classicism had eliminated it on the Continent, in ceramics-without-environment; though there must indeed have been a genuine vein of rustic sentiment to keep it alive even so late as the late nineteenth-century American Belleek Lotus wares. This entire phenomenon raises interesting speculations about, among

*chrome vase, English,
gton Hall. c. 1755. A
t elaborate confection
oft paste. British
eum, London*

*her by Picasso, made
allauris, France.
lern. Painted with
te, black, and red.
toria and Albert
eum, London: Crown
right*

other things, the Japanese bourgeois cult of tea-ceremonial, and some aspects of modern environmental design.

A number of other relevant considerations spring from it. The special enclosed and transformed environment of ceremonial dining is what makes sense ultimately of the sculptural fantasies made at Meissen, Sèvres, Capodimonte, Bow, and many other centres in the eighteenth century. The miniature Rococo dramas acted out by Harlequin and Columbine, by Shepherd and Shepherdess, the allegories of the continents and seas performed in miniature ceramic sculpture, were produced for minds under the spell of inner fancies; they were not intended, as the images on Greek ceramic wares, or Italian or South German faiences were, to help and support directly and intimately the living of a life outside their world. They did not define what man *is* but what he wished at that time he was, or what he fancied it would be pleasant to be. This is in the nature of the conceit, rather than true metaphor.

It is interesting to speculate whether modern potters may be able to fit their work to a total environment of anti-organic abstract order. It has not happened yet; there have been too many disastrous and un-satisfying experiments with theoretically 'designed' ceramics which simply do not work either functionally or existentially. But why such situations came about, and their existential significance, cannot be understood merely in terms of history—although of course individual cases have their histories. They can perhaps be best understood by following out the steps in a gradually extending scale of transforma-tion, which may well also represent a descending scale of seriousness and existential value.

POTTER'S SPACE The crucial step is probably that by which something that is existen-tially a pot is given by its decoration, painted or plastic, an independent, quasi-organic or anthropoid presence. Such presence results from the pot defining and containing its own space—'potter's space'.

This transformation may—indeed usually does—have great seriousness; for one of the most important functions of such a trans-formed pot was either as a funerary vessel to contain the ashes of the dead, or to be dedicated as an icon meant to contain some sort of spirit. Impressive classic examples are: the pots painted either with faces alone, or with whole figures, worshipped as representing a named, powerful deity by Indian peasants; and superb painted jars from Peru, some used to store sacred temple objects. Picasso has

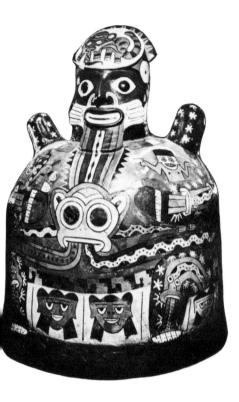

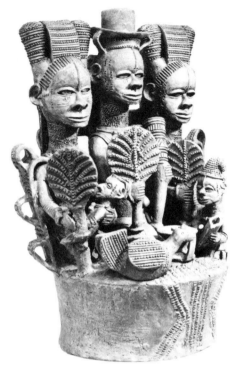

painted many pots with transforming figures in a similar vein,[190] attempting, no doubt, as he so often has, to capture a numinous presence; but of course his pots never had the seriousness of reality and use about them. Painted decoration, which gives to a pot a face and maybe rudimentary limbs, attributes to it an attitude of addressing the spectator. It 'looks' at him in the posture of another man. But although it occupies the same space as the spectator does, the 'potter's space' which it contains and which defines it can demonstrate that it is not of this world, but is rooted in another order of existence. It discloses and perhaps explains one of the most deeply hidden, pervasive, and often very tenuous intuitions about ceramic containers that people have, but can scarcely lift into their consciousness: that the very act of containing creates a special kind of cell or focus in space which is extra-ordinary, maybe even timeless.

When pots are given some kind of symbolic or figurative plastic projection into actual space this may have two kinds of significance, one being emblematic. Both represent modifications of the pot, again

Pottery figurine of a standing man in ceremonial robe, from Jaina island. Late Classic Maya. H. 9 in. *Museo Nacional de Antropología, Mexico City*

far right

Pottery figure of a woman. Style of Nayarit. Red body with black and white decoration. H. 21 in. *Diego Riviera Museum, Mexico City*

below left

Mochica portrait jar, stirrup spout, painted with red and a creamy white slip. Peru. *Museo Nacional de Antropología y Arqueología, Lima*

below right

Egyptian flask modelled in the shape of a squatting scribe. *c.* 1300 B.C. *British Museum, London*

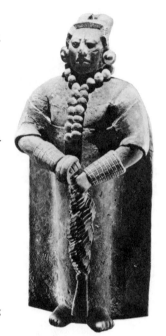
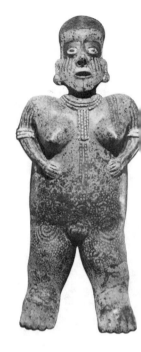
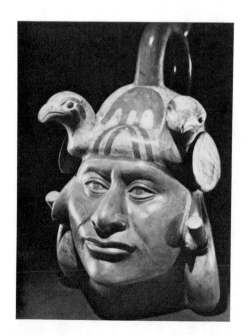
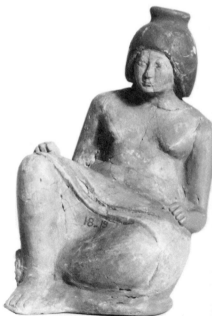

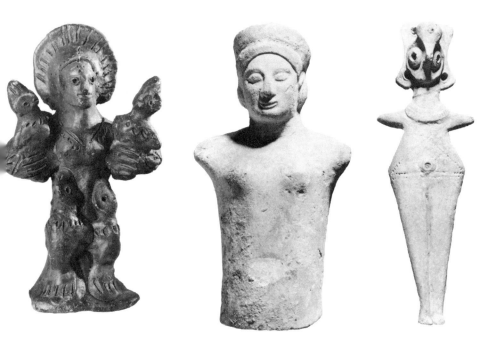

Terracotta offertory
figure of a woman with
children. Bengal, India.
Modern. These offertories
were made at village
shrines in certain places

Archaic Greek terracotta
doll, pale buff. 6th cent.
c. *Durham University
Oriental Museum*

Hittite mother-goddess
from Syria, terracotta.
2000 B.C.
*Durham University
Oriental Museum*

varying in their seriousness. For example emblematic handles re-
presenting the curved necks and heads of dragons which bite the lip are
given to Chinese T'ang amphorae, modelled dragons coiling round the
neck of Sung Lung-ch'üan celadon vases. The underlying symbolism
here is that of the male, celestial Yang (the dragon) uniting with the
female, dark receptive Yin (the jar). Together they constitute a kind of
universal Chinese charm, with both cosmic and sexual overtones. Such
emblems refer to ideas, serious certainly, but not to concrete facts
which can enhance the ideas they symbolize with their own existential
density. On the other hand the 'trophy-heads' added in relief to some
Peruvian Nazca pots have, like their painted analogues, a hard refe-
rence. Their owners probably looked on heads taken as powerful
status-symbols. The many figurines modelled and added to other
Peruvian Chimu and Recuay wares refer to realities (many erotic) 136
which must have had, for their enigmatic makers, special significance
of their own which was added to the general meaning of the vessel.
Parallel but more immediately intelligible dynastic and social signi-
ficance can be found incorporated into African pots which bear 193
modelled figures that can be called emblematic in intent.

It is, however, the non-emblematic developments of the ceramic container which take the most important strides in the direction of sculpture; for there is a whole range of degrees through which the pot-as-vessel can advance towards the point where it ceases to be a container of its own space and becomes simply a clay medium for a sculptured image, which may both 'exist' in its own symbolic space and be specially able to 'contain' an other-worldly or superhuman spiritual substance. Cases can also be discovered where the feeling for the value of pot-as-containing-form has been carried across from ceramics into stone or wood carving, even into painting. It is not possible here to give a comprehensive list, but only to offer a selection of instances where 'potter's space' based upon formed interior volumes plays an important sculptural role.

The Peruvian Mochica head or effigy vessels are outstanding 194 examples. The hand-modelled and burnished containing wall of the pot is worked around its contained volume, without any reference to an exterior setting, into a three-dimensionally mobile surface. This is given its plastic identity by its hollow interior and body substance, not by what one can feel as the impress of external forces. The same is true of the Mexican hollow-modelled Nayarit figures. With Classic Maya 194 dedicatory figures the 'potter's space' may be amplified by emblematic plastic additions and projections; and the strong verticals and horizontals they carry over into their forms give the positive impression that they were meant to match themselves to a severely rectilinear, perhaps confined, interior volume such as a temple or tomb cell.

In India there are still in the South villages where the approaches are guarded by large pottery animals, such as horses; where the shrines may contain icons whose arms, bodies, and legs are compounded of thrown pots, reshaped, cut, and luted together. Many small dedicatory figures offered at shrines, some perhaps as surrogates for live prototypes, such as horses and cattle, but also including women with children for fertility, are potter's work, although some may be modelled solid. This feeling for plastic volume on analogy with inner content has been carried over into Indian stone sculpture.[1] Many of the superb Japanese Jomon period (early Neolithic) figurines are modelled by methods typically connected with those used for ceramic containers, in which inner volume and emblematic external modelling both play a part. But in early Europe, too, the potter's hollow-ware techniques, based upon shaping the interior as well as the

[1] See the author's *Indian Sculpture*, London, 1966.

exterior, were used to create major icons in the Italian-Greek world, such as the well-known Etruscan Apollo of Veii (*c.* 500 B.C.). Again one may encounter from the same historical contexts carved stone images which incorporate a carried-over feeling for continuous inner volume as the basis for and image of sculptural 'life content'. Innumerable smaller images of clay, maybe modelled in the hand, have been made by men to incorporate in that pliable numinous substance their 'protective' spirits or deities, or to externalize as '*ex-rotos*' their deep desires, e.g. for children or health.

<div style="margin-left: 2em;">

FAR EASTERN CERAMIC SCULPTURE The special Chinese mode of 'space as environment' (pp. 183ff.) produced sculptures which were, in that mode, legitimate pieces of ceramic art, and were not at all of the order of the conceit. There were, certainly, many sculptural pieces, made either as funerary display and burial figures or as icons for shrines, which were modelled with a strong consciousness of continuous inner volume, probably derived by way of Buddhist images from Indian sculptural methods. There were also, however, many that were not, but which incorporated the pure native Chinese feeling for space as a fluid medium which ceramic material explored. This was achieved especially by that wet-hand pulling technique described earlier (p. 29). These two methods complemented each other in various ways; and their products were also cut and modelled from the exterior in the manner of pure sculpture. Objects such as houses and granaries made of clay were, in fact, literal 'models' of their real prototypes. However, the figures of live beings were made ultimately as tomb surrogates for the people once actually slaughtered to accompany royalty to the next world. Early Japanese sources describe how a certain king out of compassion decreed that the potters should be gathered to make Haniwa (pottery cylinders topped with likenesses of men, animals, and objects) to be set around his wife's tomb, substitutes for the creatures who had hitherto been slaughtered at royal burials. Such art-made forms, even at the long range of T'ang custom, must still have been felt to embody post-mortem or trans-human realities for the benefit of the dead, and not solely to serve as public 'face' for any family that could afford it. Chinese ceramic modellers from the seventeenth to eighteenth centuries may have made, say, Te-hua ivory-like (blanc-de-chine) figures of Taoist or Buddhist sages, either as enlightened beings on whom the scholar-official would have wished, more or less seriously, to model himself or as domestic

</div>

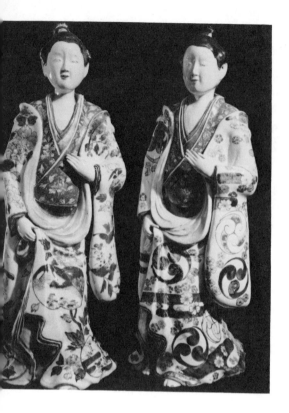

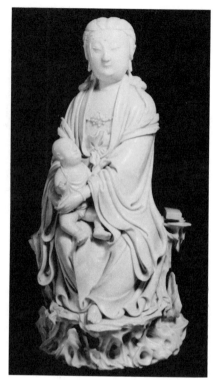

Pair of Japanese Imari figures, blue, orange-red, and gold on white. *c.* 1760. *Durham University Oriental Museum*

Chinese white porcelain (blanc-de-chine, Te-hua) figure of Kuan-yin. Mid 18th cent. A complex moulded and cut figure

shrines. Small ceramic versions of ancient ritual bronzes may have stood on his desk or table. All such works must have offered to their beholders a consistent imaginative world, reduced in size but not isolated into a frame or enclosed environment, which because of its peculiarly Chinese space-modality offers the imagination continuous glimpses of 'the unlimited' and the pure relativity of scale in reality. When such an Oriental space-mode was adapted to making 'frontally presented' figures to adorn the chimney-pieces, dressers, and cabinets of eighteenth-century European lesser society, as it was in many Chinese export wares, it could produce a strange and captivating ambivalence of scale.

CERAMIC
SCULPTURE AND
IMAGINARY
WORLDS

If the dead may desire to be surrounded by spirit-images of what was their life on earth, may not some of the living wish to make for themselves an environment which is not vitiated by the unpleasantnesses and insubordination of real life? The magnificence of the worldly

court which makes a king see himself for what he feels himself to be has always been subject in material fact to all kinds of unpleasant and taxing conditions such as intrigue, plotting, and politics, as well as dirt, disease, and death. There have been many ways in which courts and rulers, and men so wealthy as to claim a virtually superhuman status, have made visible for themselves what they conceived their own transcendent justification to be. From images of the family-sanctifying ancestors (early Rome) to grandiose Renaissance schemes of wall-painting illustrating the patron's 'astrological-being' and Indian or Cambodian temples in which a king's own spiritual identity and prototype is enshrined, men have made public proclamation of their claims. But this can be done on quite another scale, both of size and seriousness.

European aristocrats of the late seventeenth and eighteenth centuries, who could both afford to do so and who had the necessary culture, bought for themselves imaginary courts and pleasures populated by the deities and heroes of a literary tradition in whom no one really believed. Many of these imaginary beings have been translated into ceramic sculpture by the great modellers of the eighteenth-century factories who were descended from, among others, Meissen's great Kändler and Nymphenburg's Bustelli. These ceramic works seem to have been modelled originally in wax, cast in slip with the most complex plaster piece moulds, assembled and luted together before glazing and firing. They were produced initially, it seems, as a direct function of the elaborate dining ceremonial practised in great houses, and later in those less great, where aristocratic customs were carefully copied. The extremely complete three-dimensional modelling of fine small eighteenth-century figures and groups shows that they were meant to occupy a three-dimensional space where they would be seen at close enough range for all their qualities to be appreciated—in fact, on a table-top. For the dining ceremonials of the eighteenth century used not one but several tables. And perhaps the very finest services and figures were 'used' only in a nominal sense, being set out together to be seen, not scraped with knife and fork. These sculptural pieces which we now know as individual objects, the best and earliest certainly, were made as parts of complete table-settings, focused, perhaps, on an elaborate centrepiece, and arranged radiating around it towards the edges. The centrepiece might be modelled to present a significant impression from all sides, whereas subsidiary pieces might be made to address themselves to the

spectator from one side of the table; though they would be visible from all around. Their space, however, was not the unlimited space-as-environment of Chinese figurines (though we have evidence that imported Chinese figurines were used in Europe in this way); it was the same subdivided and enclosed, if animated, space defined by the Rococo interior, reduced to the table-top. The cabinet was only a place where the wares rested, admired maybe, when they were not fulfilling their ceremonial function. In fact this function was still related, however fanciful the iconography, to food and to the containing of food. The porcelain figurines had stepped, as it were, out of the picture-space on the tureen or cup, off the handle of the basket-dish, on to the open surface of the table. It was the bourgeois nineteenth century that broke up and isolated them on to shelves and cabinets, treating them as expensive bibelots and bric-à-brac.

Into the iconography of these figures have gone ingredients with a high status value, such as reminiscences of rare and difficult pleasures past (Italian tours for the French, German, and English), toy versions of the grandiose architectural trappings of royalty and power (pavilions with classical statues of pretty Roman deities or tribute-bearing Continents), intellectual games which could be indulged in only by those with money, social standing, and leisure (romantic love and masked balls), complaisant courtiers, entertainers (the Italian Comedy), and maybe foci of religious devotion (saints and crucifixions). The figures, where they are not joyously nude with bodies of idyllic perfection, are decked out in garments which are themselves symbolic of exalted status and glory. Many of the designs were based upon admired engravings, added to or expanded. How serious this was, and in what ways, is an interesting problem. Certainly there was an important element of lightness of heart in work done after about 1750, in France first of all; indeed it is of the essence of Rococo, though the idealizing focus shifts with the advent of the Neo-Classical vogue and the self-conscious Imperialism of the Napoleonic era. But such lightness can itself, as a whole, appear a most demanding symbolic requirement to those who understand the art; no musician would call Mozart a trifler. But it is, of course, possible to misunderstand and dismiss it as frivolous. We have seen that to the princes of the eighteenth century the light-veined magnificence which ceramics could add to their courtly status, expressing it in technique of the highest aesthetic quality, was a serious matter. And in such a setting the 'conceit' forms a vital element. It illustrates a 'god-like' freedom of

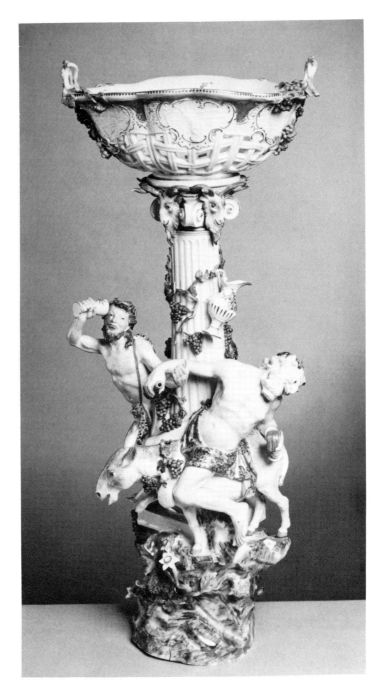

Meissen table-setting
made for Frederick the
Great, modelled by
Kändler. Glazed poly-
chrome porcelain. *c.* 1740.
*Victoria and Albert
Museum, London: Crown
Copyright*

the imagination to occupy itself with what it chooses rather than what it must, with highly emotional fantasy rather than the determined self-assertion demanded by a stern reality. It promotes, virtually, the décor of a secular Church dedicated to liberation from an oppressive world.

Underlying this whole Rococo complex there are, for us, questions of moral attitude involved. Political partisanship will naturally prejudice anyone's attitudes towards eighteenth-century ceramic modelled garnishings. It is, however, all too easy to overlook the fact that there were individual artists working in the ceramic medium during the eighteenth century in Europe who were by any standards great masters. Their figurative productions were designed both to create and to inhabit the symbolic three-dimensional environment of the dining tables which both is and is not the real world. It may have been to its patrons a most important kind of reality; but it is, in effect, an isolated and defined enclosure hemmed within its architectural framework of luxurious mirrored walls and gilt furnishings. While it is not co-extensive with outer actuality, it represents a world not reduced to the two dimensions of the frame of a picture or illustration, but symbolically separated in a rather similar fashion, an extreme ceramic transformation beyond which it is not possible to go further in the same direction.

Within this special kind of symbolic distance, an environment which sets its own scale and its own high key of sensuously ecstatic feeling, we have to try to assess what are the special virtues of each work of ceramic art. Certainly we must judge figurative porcelain modelling —as is too seldom done—by normal sculptural standards. For the early Meissen modellers were developing during the 1730s a vein of small-scale sculpture which was descended both from fine gold and silver craftsmanship and from the tradition of miniature but important South German wood and ivory carving. Indeed it was the ambitious monochrome table-confections and conceits—centre-pieces, salts, sauce-boats, jugs, candelabra, and dishes—of the precious metalsmiths which the ceramic artists of the aristocratic factories were rivalling in their brilliant enamel colours. The smiths, indeed, provided on occasion original models for ceramic works (e.g. Duplessis for Sèvres). One must look into these productions for a plasticity which does not limit and define the subject though it *is* restricted in its own symbolic frame, which defines its space by gestures and all the implied movement vectors which the figures

Pantaloon, a figure from the Italian Comedy, from a Nymphenburg table-setting modelled by Büstelli. Polychrome glazed porcelain. 1760. *Victoria and Albert Museum, London: Crown copyright*

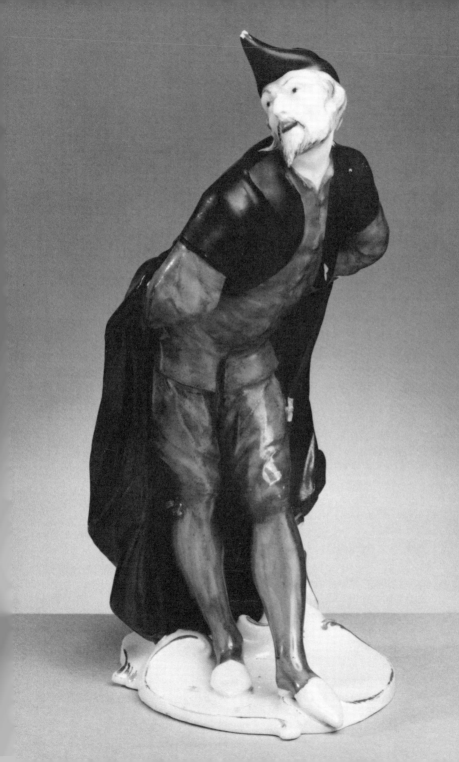

'scatter' about them into three dimensions. These are consummated in an endless mobility and variety of surface modelling analogous to that achieved by the great large-scale sculptors (e.g. Balthasar Permoser and J. A. Feuchtmayer). Varied and endlessly contrasted surface planes, from which the light breaks and reflects, can match the brilliance of the enamel colours, and contribute their own special kind of nervous exhilaration. They also help, by their refusal to define and enclose true 'potter's space', to extend their transforming power to the interior environment they adorn.

In contrast to this aristocratic tradition of thoroughgoing space transformation we must set the less exalted tradition of ceramic figure modelling in what is virtually relief, often on an oval base with no 'back-view' and no full three-dimensionality. Figures of all kinds were made in this vein at the aristocratic factories from the mid eighteenth century on, and in all the provincial potteries working for the lesser aristocracy and bourgeoisie during the later eighteenth to nineteenth centuries. Beside the major works they imitate they must appear as a less intensive, less permeating, even less irrational transformation of the interior. Seen on cabinet or mantel they reveal themselves as works of fancy, toys for the imagination to savour, as not intended to 'work' in the sphere of use and everyday existence, but to demonstrate the fashionable *persona* of the owner. They may appeal, as a kind of 'dressing up' for the house, curious and appealing to the eye, but not making the same kind of substantial artistic claims as their more exalted and expensive prototypes. This may be to some extent because once they left the table setting and ascended to the shelf they left behind their connection with the fundamental basis of ceramic art.

SCULPTURE IN CLAY
There remains one special European mode of ceramic space to be discussed which is not precisely that of eighteenth-century tableware, although works were made in it during the eighteenth and early nineteenth centuries. Many of its finest pieces were meant to be incorporated into furnishing schemes as culmination in the third dimension of figurative elements in the flat décor, paintings, tapestries, and rocaille fantasias. There were some fine relatively large ceramic pieces made to fulfil such a function at the major aristocratic factories, some fired in white biscuit to resemble the marble of true sculpture, some terracotta, some black. Most such work, in fact, lies at the very frontier between ceramics and sculpture. Its origin is probably in the

clay *bozzetti*, or small-scale studies, which Renaissance, Mannerist, and Baroque Italian sculptors used to make as a prelude to their full-scale works. Many were in clay, fired to terracotta. True *bozzetti* by good artists are rough, with the major transitions of plane, deep undulations of surface, and especially the protuberant lesser volumes, strongly emphasized. The point about them is that they were originally addressed not to the public eye but to the private imagination of the artist himself, and perhaps that of his assistants. Their scaling down, the conventions upon which their very existence was based, and their ultimate aspiration towards major sculptural expression demanded that they separate themselves from their environment, and that one look at them with a mind focused to their own scale of reality, perhaps even holding them in one's hand, almost as one looks at a drawing. They thus shared something with the table-bronzes of the same period; though the latter are usually worked to a far more thorough finish, with the surface inflections, which in *bozzetti* had been left as mere hints, developed into careful variations. With the rise in interest, especially in France during the later seventeenth century, in collecting, and particularly in preparatory or unfinished works such as drawn sketches, an interest grew in the vitality of small-scale terracotta sculpture. A whole series of artists throughout the eighteenth century met this interest with work in fired clay, important among them being Marin (1759–1834), Roubiliac (?1705–62), and Clodion (1738–1814). Their console and occasional sculptures were *not* environment in the same sense as the elaborate table services; they required exactly the same scaling down of focus as the sculptor's *bozzetto*. Above all they exploited the possible qualities and textures of raw wet clay with almost infinite resource. They used smear, knife cutting, a multitude of shaved cockles for hair and leaves, many kinds of impressing and twisting of the wet material, to produce a delicate, sensuous, and erotic texture which became itself an 'image'. No terracotta artist has ever rivalled it; and it can only work on the level of close, intimate attention. One may—indeed must—touch. But a great part of the invention lies on a scale beyond the reach of the fingers' sensitivity, resembling in this the finesse of the engraver.

CONCLUSION This whole book constitutes an effort to demonstrate the kind of artistic developments of which ceramics, the art based upon pottery, has been capable. It has stopped short where ceramics becomes sculpture and has not really dealt with true sculptures made in terra-

cotta, whose modes of invention pass far beyond the purview of the potter. With regard to the problems of both the studio and the commercial potter today it is meant to open up perspectives of possibility, and to suggest ways in which both can rediscover roots and redress balances. It may, perhaps, suggest how ceramics can re-establish its existential foundations. There is, of course, no reason at all why fired clay should not be used, as other sculptural materials are nowadays, to explore, so to speak, functions which have no basis in immediate life needs, with its own symbolic justification. But the basic elements of the potter's art will not vanish from our lives even if our 'pots' are to be made of plastic. Furthermore, another revolution in art may well demand that work be addressed to the whole multi-sensuous man, hands and all, to awaken those important and intensely valuable regions of feeling and sensuous order which pure visual-abstract work ignores, or even affronts. In this revolution a complete re-evaluation of the meaning of ceramics could play as vital a part as did the rediscovery of African sculpture in an earlier revolution. And there is no reason at all why lines of thought taking up from one or another of humanity's past ceramic achievements should not be picked up again, and developed along radical new lines.

Select Index and Glossary

Definitions of terms are indexed, or given here. Where only one index reference is given, the definition will be found there. The commonest names appear so frequently that they have not been indexed, e.g. China, Japan, Europe. Wares are indexed under their own names, save in the case of Peruvian, Persian, Greek, German, and Indian wares, which will be found indexed under the names of the countries. The only ceramic shape indexed is 'vase'. The colours are indexed for the places where they are discussed as part of colour theory.

Selected List of American Ceramic Artists

The selection of individuals represents those whose primary commitment as artists developed in response to ceramics. It reflects an edited, alphabetical list of individuals from the late nineteenth century to 1983 whose work has been sustained through ceramic education, the development and maintenance of an independent studio, and public exhibition. In a few cases the involvement was brief but intense. The list does not reflect the many artists and studios associated with the American art pottery movement and modern ceramic education in the United States, nor does it completely reflect the great proliferation of ceramic artists throughout the United States in recent years. The directory is meant to serve as an introduction for independent pursuits and study.

Charles E. Abbott (*b.* Portland, Maine, 1911–)
 Residence: Ogunquit, Maine
Jane Ford Aebersold (*b.* San Angelo, Texas, 1940–)
 Residence: Bennington, Vermont
Laura Andreson (*b.* San Bernardino, California, 1902–)
 Residence: Los Angeles, California
Robert Arneson (*b.* Benicia, California, 1930–)
 Residence: Benicia, California
Rudy Autio (*b.* Butte, Montana, 1926–)
 Residence: Missoula, Montana
Jan Axel (*b.* St. Louis, Missouri, 1946–)
 Residence: New York, New York
Victor Babu (*b.* New York, New York, 1936–)
 Residence: Overland Park, Missouri
Ralph Bacerra (*b.* Orange County, California, 1938–)
 Residence: Los Angeles, California
Arthur Eugene Baggs (*b.* Alfred, New York, 1886–*d.* 1947)
 Resided: Columbus, Ohio
Clayton Bailey (*b.* Antigo, Wisconsin, 1939–)
 Residence: Porta Costa, California
Douglas Baldwin (*b.* Bottineau, North Dakota, 1939–)
 Residence: Baltimore, Maryland

F. Carlton Ball (*b.* Sutter Creek, California, 1911–)
Residence: Tacoma, Washington

Leah Balsham (*b.* Philadelphia, Pennsylvania, 1915–)
Residence: Beverly Shores, Indiana

Wayne Bates (*b.* Winchester, Tennessee, 1937–)
Residence: Murray, Kentucky

Fred Bauer (*b.* Memphis, Tennessee, 1937–)
Residence: Garberville, California

Bennett Bean (*b.* Cincinnati, Ohio, 1941–)
Residence: Blairstown, New Jersey

Harriet Bellows (*b.* Philadelphia, Pennsylvania, 1946–)
Residence: Alfred, New York

Curtis Benzle (*b.* Lakewood, Ohio, 1949–)
Residence: Hilton Head, South Carolina

Christine Bertoni (*b.* Ann Arbor, Michigan, 1945–)
Residence: Pascoag, Rhode Island

David Best (*b.* San Francisco, California, 1945–)
Residence: San Francisco, California

Charles Fergus Binns (*b.* Worcester, England, 1857–*d.* 1934)
Resided: Alfred, New York

Ed Blackburn (*b.* New York, New York, 1947–)
Residence: Chico, California

Paul Bogatay (*b.* Ada, Ohio, 1905–*d.* 1972)
Resided: Columbus, Ohio

Thom R. Bohnert (*b.* St. Louis, Missouri, 1948–)
Residence: Flint, Michigan

Joseph Bova (*b.* Houston, Texas, 1941–)
Residence: Baton Rouge, Louisiana

Robert Brady (*b.* Reno, Nevada, 1946–)
Residence: Crockett, California

Karen Breschi (*b.* Oakland, California, 1941–)
Residence: San Francisco, California

Cynthia Bringle (*b.* Memphis, Tennessee, 1939–)
Residence: Penland, North Carolina

Regis C. Brodie (*b.* Pittsburgh, Pennsylvania, 1942–)
Residence: Saratoga Springs, New York

Bill Brouillard (*b.* Madison, Wisconsin, 1947–)
Residence: Cleveland, Ohio

Toby Buonagurio (*b.* Bronx, New York, 1947–)
Residence: New York, New York

Mark Burns (*b.* Springfield, Ohio, 1950–)
Residence: Philadelphia, Pennsylvania

Rose Cabat (*b.* New York, New York)
Residence: Tucson, Arizona

Nancy Carman (*b.* Tucson, Arizona, 1950–)
Residence: San Francisco, California

Scott Chamberlin (*b.* Orange, California, 1948–)
Residence: Ross, California

Tom Coleman (*b.* Amarillo, Texas, 1945–)
Residence: Canby, Oregon

Claude Conover (*b.* Pittsburgh, Pennsylvania, 1907–)
Residence: Cleveland, Ohio

Philip Cornelius (*b.* San Bernardino, California, 1934–)
Residence: Pasadena, California

Tony Costanzo (*b.* Schenectedy, New York, 1948–)
Residence: Oakland, California

R. Guy Cowan (*b.* East Liverpool, Ohio, 1884–*d.* 1957)
Resided: Syracuse, New York

Anne Currier (*b.* Louisville, Kentucky, 1950–)
Residence: Lewisville, Colorado

Edmund deForest Curtis (*b.* Brooklyn, New York, 1884–*d.*
Villanova, Pennsylvania, 1964)

Val Murat Cushing (*b.* Rochester, New York, 1931–)
Residence: Alfred, New York

William Daley (*b.* Hastings-on-Hudson, New York, 1925–)
Residence: Elkins Park, Pennsylvania

David Davison (*b.* Boston, Massachusetts, 1942–)
Residence: Dunstable, Massachusetts

Harris Deller (*b.* Brooklyn, New York, 1947–)
Residence: Carbondale, Illinois

Stephen De Staebler (*b.* St. Louis, Missouri, 1933–)
Residence: Berkeley, California

Richard Deutsch (*b.* Los Angeles, California, 1953–)
Residence: Santa Cruz, California

Richard E. Devore (*b.* Toledo, Ohio, 1933–)
Residence: Fort Collins, Colorado

Rick Dillingham (*b.* Lake Forest, Illinois, 1952–)
Residence: Santa Fe, New Mexico

Ruth Duckworth (*b.* Hamburg, Germany, 1919–)
Residence: Chicago, Illinois

Jack Earl (*b.* Uniopolis, Ohio, 1934–)
Residence: Lakeview, Ohio
Edward Eberle (*b.* Tarentum, Pennsylvania, 1944–)
Residence: Pittsburgh, Pennsylvania
Ramon Elozua (*b.* Stuttgart, Germany, 1947–)
Residence: New York, New York
William Farrell (*b.* Philipsburg, Pennsylvania, 1936–)
Residence: Chicago, Illinois
Kenneth Ferguson (*b.* Elwood, Indiana, 1928–)
Residence: Shawnee Mission, Kansas
Frank Fleming (*b.* Bear Creek, Alabama, 1940–)
Residence: Birmingham, Alabama
Robert Forbes (*b.* Pasadena, California, 1951–)
Residence: Philadelphia, Pennsylvania; Santa Cruz,
California
Robert Forman (*b.* Los Angeles, California, 1948–)
Residence: Mill Valley, California
Mary Frank (*b.* London, England, 1933–)
Residence: New York, New York
Viola Frey (*b.* Lodi, California, 1933–)
Residence: Oakland, California
Michael Frimkess (*b.* Los Angeles, California, 1937–)
Residence: Los Angeles, California
Verne Funk (*b.* Milwaukee, Wisconsin, 1932–)
Residence: Lubbock, Texas
David Gilhooly (*b.* Auburn, California, 1943–)
Residence: Shingle Springs, California
Andrea Gill (*b.* Newark, New Jersey, 1948–)
Residence: Kent, Ohio
John Gill (*b.* Renton, Washington, 1949–)
Residence: Kent, Ohio
Lukman Glasgow (*b.* Richfield, Utah, 1935–)
Residence: Los Angeles, California
John Parker Glick (*b.* Detroit, Michigan, 1938–)
Residence: Farmington, Michigan
Erik Gronborg (*b.* Copenhagen, Denmark, 1931–)
Residence: Solana Beach, California
Maija Grotell (*b.* Helsinki, Finland, 1899–*d.* Bloomfield
Hills, Michigan, 1973)
Chris Gustin (*b.* Chicago, Illinois, 1952–)
Residence: South Darmouth, Massachusetts

Dorothy Hafner (*b.* New Haven, Connecticut, 1952–)
Residence: New York, New York

Charles M. Harder (*b.* Birmingham, Alabama, 1889–*d.*
Beaumont, Texas, 1959)
Resided: Alfred, New York

Dick Hay (*b.* Cincinnati, Ohio, 1942–)
Residence: Brazil, Indiana

Otto Heino (*b.* East Hampton, Connecticut, 1915–)
Residence: Ojai, California

Vivika Heino (*b.* Caledonia, New York, 1909–)
Residence: Ojai, California

Ken Hendry (*b.* Rockford, Illinois, 1939–)
Residence: Ft. Collins, Colorado

Lois Hennessey (*b.* New York, New York, 1936–)
Residence: Baltimore, Maryland

Tony Hepburn (*b.* Manchester, England, 1942–)
Residence: Alfred, New York

Wayne Higby (*b.* Colorado Springs, Colorado, 1943–)
Residence: Alfred, New York

Charles Austin Hindes (*b.* Muskegon, Michigan, 1942–)
Residence: Iowa City, Iowa

Richard Hirsch (*b.* New York, New York, 1944–)
Residence: West Newbury, Massachusetts

Jan Holcomb (*b.* Washington, D.C., 1945–)
Residence: Pascoag, Rhode Island

Martha Holt (*b.* Chatham, New Jersey, 1945–)
Residence: Cambridge Springs, Pennsylvania

Margie Hughto (*b.* Endicott, New York, 1944–)
Residence: Syracuse, New York

Ka-Kwong Hui (*b.* Hong Kong, 1922–)
Residence: Caldwell, New Jersey

Clary Ilian (*b.* Sioux City, Iowa, 1940–)
Residence: Garrison, Iowa

Jun Kaneko (*b.* Nagoya, Japan, 1942–)
Residence: Bloomfield Hills, Michigan; Nagoya, Japan

Karen Karnes (*b.* New York, New York, 1925–)
Residence: Morgan, Vermont; Holly Holyhead, Gwynned,
Wales

Steven Kemeneffy (*b.* Budapest, Hungary, 1943–)
Residence: Edinboro, Pennsylvania

Howard Kottler (*b.* Cleveland, Ohio, 1930–)

Residence: Seattle, Washington
Eva Kwong (*b.* Hong Kong, China, 1954–)
Residence: Mercer, Pennsylvania
Charles Lakofsky (*b.* Cleveland, Ohio, 1922–)
Residence: Bowling Green, Ohio
Ron Lang (*b.* Philadelphia, Pennsylvania, 1949–)
Residence: Baltimore, Maryland
Bruno LaVerdiere (*b.* Waterville, Maine, 1937–)
Residence: Hadley, New York
James Leedy (*b.* McRoberts, Kentucky, 1931–)
Residence: Lake Lotowana, Missouri
Marilyn Levine (*b.* Alberta, Canada, 1935–)
Residence: Berkeley, California
Ken D. Little (*b.* Canyon, Texas, 1947–)
Residence: Missoula, Montana
Michael Lucero (*b.* Tracy, California, 1953–)
Residence: New York, New York
Glen Lukens (*b.* Cowgill, Missouri, 1887–*d.* 1967)
Resided: Los Angeles, California
Philip Maberry (*b.* Stamford, Texas, 1941–)
Residence: New York, New York
Robert McGowan (*b.* Nashville, Tennessee, 1947–)
Residence: Memphis, Tennessee
Harrison McIntosh (*b.* Vallejo, California, 1914–)
Residence: Claremont, California
Warren Mackenzie (*b.* Kansas City, Missouri, 1924–)
Residence: Stillwater, Minnesota
Leza McVey (*b.* Cleveland, Ohio, 1907–)
Residence: Cleveland, Ohio
Malcolm Magruder (*b.* Staten Island, New York, 1946–)
Residence: Potter Valley, California
James D. Makins (*b.* New York, New York, 1951–)
Residence: New York, New York
Kirk Mangus (*b.* Greenville, Pennsylvania, 1952–)
Residence: Mercer, Pennsylvania
Louis Marak (*b.* Shawnee, Oklahoma, 1942–)
Residence: Eureka, California
Graham Marks (*b.* New York, New York, 1951–)
Residence: Rochester, New York
Maria Martinez (*b.* San Idelfonso Pueblo, New Mexico, 1884–
d. 1981)

George Mason (*b.* Salem, Massachusetts, 1951–)
Residence: Walpole, Maine
John Mason (*b.* Madrid, Nebraska, 1927–)
Residence: New York, New York; Los Angeles, California
James Melchert (*b.* New Bremen, Ohio, 1930–)
Residence: Oakland, California
David Middlebrook (*b.* Jackson, Michigan, 1944–)
Residence: Los Gatos, California
Robert Milnes (*b.* Washington, D.C., 1948–)
Residence: Cambridge Springs, Pennsylvania
Randyll Miseph (*b.* Boston, Massachusetts, 1949–)
Residence: Falmouth, Massachusetts
Mineo Mizuno (*b.* Gifu Prefecture, Japan, 1944–)
Residence: Los Angeles, California
Judy Moonelis (*b.* Jackson Heights, New York, 1953–)
Residence: New York, New York
Jens Morrison (*b.* Palo Alto, California, 1944–)
Residence: Carlsbad, California
Joyce Moty (*b.* Aurora, Illinois, 1943–)
Residence: Seattle, Washington
Ron Nagle (*b.* San Francisco, California, 1939–)
Residence: San Francisco, California
Andrew Naisse (*b.* Pueblo, Colorado, 1946–)
Residence: Athens, Georgia
Gertrude Natzler (*b.* Vienna, Austria, 1908–*d.* Los Angeles, California, 1971)
Otto Natzler (*b.* Vienna, Austria, 1908–)
Residence: Los Angeles, California
Arthur Nelson (*b.* Denver, Colorado, 1942–)
Residence: Oakland, California
Donna L. Nicholas (*b.* South Pasadena, California, 1938–)
Residence: Edinboro, Pennsylvania
Richard Notkin (*b.* Chicago, Illinois, 1948–)
Residence: Myrtle Point, Oregon
George E. Ohr (*b.* Biloxi, Mississippi, 1857–*d.*1918)
Resided: Biloxi, Mississippi
William Parry (*b.* Lehigh, Pennsylvania, 1918–)
Residence: Alfred, New York
Mary Chase Perry (*b.* Hancock, Michigan, 1867–*d.* 1961)
Resided: Detroit, Michigan
Susan Peterson (*b.* McPherson, Kansas, 1925–)

Residence: South Pasadena, California; New York, New York

Mark Pharis (*b.* Minneapolis, Minnesota, 1947–)
Residence: Houston, Minnesota

Don Pilcher (*b.* Los Angeles, California, 1942–)
Residence: Champaign, Illinois

Lucian Octavius Pompilli (*b.* Washington, D.C., 1942–)
Residence: Davis, California

Henry Varnum Poor (*b.* Chapman, Kansas, 1888–*d.* Rockland County, New York, 1971)

Kenneth Price (*b.* Los Angeles, California, 1935–)
Residence: Taos, New Mexico

Anthony B. Prieto (*b.* Valdepeñas, Spain, 1912–*d.* Oakland, California, 1967)

Elsa Rady (*b.* New York, New York, 1943–)
Residence: Venice, California

Theodore Randall (*b.* Indianapolis, Indiana, 1914–)
Residence: Alfred, New York

Donald Reitz (*b.* Sunbury, Pennsylvania, 1929–)
Residence: Madison, Wisconsin

Marcus Aurelius Renzetti (*b.* Abruzzi, Italy, 1896–*d.* Arden, Delaware, 1975)

Daniel Rhodes (*b.* Fort Dodge, Iowa, 1911–)
Residence: Santa Cruz, California

Jacqueline Rice (*b.* Orange, California, 1941–)
Residence: Providence, Rhode Island

Harold Eaton Riegger (*b.* Ithaca, New York, 1913–)
Residence: Mill Valley, California

Tom Rippon (*b.* Sacramento, California, 1954–)
Residence: New Buffalo, Michigan

Adelaide Alsop Robineau (*b.* Middletown, Connecticut, 1865–*d.* Syracuse, New York, 1929)

John Roloff (*b.* Portland, Oregon, 1947–)
Residence: Oakland, California

Jerry Rothman (*b.* Brooklyn, New York, 1933–)
Residence: Laguna Beach, California

Herbert Sanders (*b.* New Waterford, Ohio, 1909–)
Residence: San Jose, California

Adrian Saxe (*b.* Glendale, California, 1943–)
Residence: Los Angeles, California

Jeff Schangler (*b.* New York, New York, 1937–)
Residence: New Rochelle, New York

Edwin Scheir (*b.* New York, New York, 1910–)
Residence: Oaxaca, Mexico

Mary Scheir (*b.* Salem, Virginia, 1910–)
Residence: Oaxaca, Mexico

Victor Schreckengost (*b.* Sebring, Ohio, 1906–)
Residence: Cleveland, Ohio

Norman Schulman (*b.* New York, New York, 1924–)
Residence: Columbus, Ohio; Penland, North Carolina

Robert Sedestrom (*b.* Detroit, Michigan, 1935–)
Residence: New Paltz, New York

Frances Senska (*b.* Batanga, Cameroon, West Africa, 1914–)
Residence: Bozeman, Montana

David Shaner (*b.* Pottstown, Pennsylvania, 1934–)
Residence: Big Fork, Montana

Sandra Shannonhouse (*b.* Petaluma, California, 1947–)
Residence: Benicia, California

Kathryn Kennedy Sharbaugh (*b.* Norwich, Connecticut,
1948–)
Residence: Holly, Michigan

Richard Shaw (*b.* Hollywood, California, 1941–)
Residence: Fairfax, California

Peter Shire (*b.* Los Angeles, California, 1947–)
Residence: Los Angeles, California

Ken Shores (*b.* Lebanon, Oregon, 1928–)
Residence: Portland, Oregon

Patrick Siler (*b.* Spokane, Washington, 1939–)
Residence: Pullman, Washington

Paul Soldner (*b.* Summerfield, Illinois, 1921–)
Residence: Aspen, Colorado; Claremont, California

Judith Solomon (*b.* Providence, Rhode Island, 1952–)
Residence: Cleveland, Ohio

Robert Sperry (*b.* Bushnell, Illinois, 1927–)
Residence: Seattle, Washington

Victor Spinski (*b.* Newton, Kansas, 1942–)
Residence: Newark, Delaware

Tom Spleth (*b.* Tulsa, Oklahoma, 1946–)
Residence: Alfred, New York

Rudolph Staffel (*b.* San Antonio, Texas, 1911–)

Residence: Philadelphia, Pennsylvania
John Stephenson (*b.* Waterloo, Iowa, 1929–)
 Residence: Ann Arbor, Michigan
Suzanne G. Stephenson (*b.* Canton, Iowa, 1935–)
 Residence: Ann Arbor, Michigan
Bill Stewart (*b.* Plattsburgh, New York, 1941–)
 Residence: Hamlin, New York
Lizbeth Stewart (*b.* Philadelphia, Pennsylvania, 1948–)
 Residence: Philadelphia, Pennsylvania
Toshiko Takaezu (*b.* Pepeekeo, Hawaii, 1922–)
 Residence: Quakertown, New Jersey
John Takehara (*b.* Sowan, Korea, 1929–)
 Residence: Boise, Idaho
Henry Takemoto (*b.* Honolulu, Hawaii, 1930–)
 Residence: Los Angeles, California
Byron Temple (*b.* Centerville, Indiana, 1933–)
 Residence: Lambertville, New Jersey
Irv Tepper (*b.* St. Louis, Missouri, 1947–)
 Residence: New York, New York
Jack Thompson (*b.* Los Angeles, California, 1946–)
 Residence: Chalfont, Pennsylvania
George P. Timock (*b.* Flint, Michigan, 1945–)
 Residence: Shawnee Mission, Kansas
Jack Troy (*b.* Towanda, Pennsylvania, 1938–)
 Residence: Huntingdon, Pennsylvania
Robert Turner (*b.* Port Washington, New York, 1913–)
 Residence: Alfred, New York
Chris Unterscher (*b.* Portland, Oregon, 1943–)
 Residence: Reno, Nevada
Albert Valentine (*b.* Cincinnati, Ohio, 1862–*d.* San Diego,
 California, 1925)
Artus Van Briggle (*b.* Cincinnati, Ohio, 1869–*d.* Colorado
 Springs, Colorado, 1904)
Peter Vandenberge (*b.* Voorburg, Holland, 1935–)
 Residence: Sacramento, California
Petras Vaskys (*b.* Lithuania, 1921–)
 Residence: Cheltenham, Pennsylvania
Ken Vavrek (*b.* Cleveland, Ohio, 1939–)
 Residence: Philadelphia, Pennsylvania
Victor Verbalaitis (*b.* Gary, Indiana, 1942–)
 Residence: Phoenix, Arizona

Peter Voulkos (*b.* Bozeman, Montana, 1924–)
Residence: Berkeley, California
Carl Walters (*b.* Fort Madison, Iowa, 1883–*d.* West Palm
Beach, Florida, 1955)
Resided: Woodstock, New York
Patti Warashina (*b.* Spokane, Washington, 1940–)
Residence: Seattle, Washington
Kurt Weiser (*b.* Lansing, Michigan, 1950–)
Residence: Helena, Montana
Frans Wildenhain (*b.* Germany, 1905–*d.* Rochester, New
York, 1980)
Resided: Pittsford, New York
Marguerite Wildenhain (*b.* France, 1896–)
Residence: Guerneville at Pond Farm, California
William Wilhelmi (*b.* Garwin, Iowa, 1939–)
Residence: Corpus Christi, Texas
Gerry Williams (*b.* Bengal, India, 1928–)
Residence: Goffstown, New Hampshire
Paula Winokur (*b.* Philadelphia, Pennsylvania, 1935–)
Residence: Horsham, Pennsylvania
Robert Winokur (*b.* Brooklyn, New York, 1933–)
Residence: Horsham, Pennsylvania
Beatrice Wood (*b.* San Francisco, California, 1893–)
Residence: Ojai, California
Nicholas Wood (*b.* San Francisco, California, 1946–)
Residence: Arlington, Texas
Betty Woodman (*b.* Norwalk, Connecticut, 1930–)
Residence: Boulder, Colorado; New York, New York
William Wyman (*b.* Boston, Massachusetts, 1922–*d.* Boston,
Massachusetts, 1980)
Resided: Situate, Massachusetts
Arnold Zimmerman (*b.* Poughkeepsie, New York, 1954–)
Residence: New York, New York

Philadelphia
1983

Compiled by
HELEN WILLIAMS DRUTT